UHLS-MAIN LIBRARY
ALBANY PUBLIC LIBRARY

THE HISTORIC RAILROAD

THE HISTORIC RAILROAD

A Guide to Museums, Depots and Excursions in the United States

by JOHN R. NORRIS
and JOANN NORRIS

McFarland & Company, Inc., Publishers
Jefferson, North Carolina, and London

Front cover: The Gettsyburg Railroad in Gettsyburg, Pennsylvania

British Library Cataloguing-in-Publication data are available

Library of Congress Cataloguing-in-Publication Data

Norris, John, 1944–
　　The historic railroad : a guide to museums, depots and excursions in the United States / by John R. Norris and Joann Norris.
　　　p.　cm.
　　Includes index.
　　ISBN 0-7864-0040-4 (sewn softcover : 50# alk. paper) ∞
　　1. Railroad museums—United States.　I. Norris, Joann, 1947-　.
II. Title.
TF6.U5N67　1996
625.1'074'73—dc20　　　　　　　　　　　　　　　　　　　　95-40179
　　　　　　　　　　　　　　　　　　　　　　　　　　　　　　　CIP

©1996 Joann Norris. All rights reserved

Manufactured in the United States of America

McFarland & Company, Inc., Publishers
　Box 611, Jefferson, North Carolina 28640

To Pat and Tommy
who encouraged us to write this book
so that they could find out
where all the great excursion railroads are.
Their enthusiasm turned into
a great adventure for us.

Acknowledgments

Thanks to the tourist bureaus in each state, plus all of the publicity people at each train site for such friendly and professional help. Many of the people who help with "public relations" for the trains included in this book do so on a voluntary basis, exhibiting a real love for their chosen avocation.

Table of Contents

Acknowledgments	vii
Preface	xi
Introduction	1
A Brief History of Railroading	3
Museums, Depots and Excursions (*Listed by state*)	5
Appendices	
A. Other Sites of Interest	183
B. Harvey House Restaurants	189
C. Associations and Publications of Interest to Rail Fans	191
Glossary of Railroading Terms	193
Index	197

Preface

The Historic Railroad: A Guide to Museums, Depots and Excursions in the United States is written for railroad buffs and new enthusiasts alike. It is meant to serve as a guidebook for those who want to spend at least part of their leisure time strolling down memory lane to a time when travel was first becoming easier and more glamorous, to a time when your vehicle actually moved slowly enough for you to enjoy the view along the way — when "getting there" was almost as much fun as "being there."

Before compiling this book, we searched exhaustively throughout the United States to identify all of the railroad museums, depots and excursions that are currently open to the public, as well as a few whose plans were in the works. Over 300 sites are listed. Each entry provides a comprehensive description of the site, a bit of historical information, a list of events at the site, hours of operation, entrance or excursion fees, and the address and phone number needed for obtaining further information. (Fax numbers are included when available.) Although there are numerous miniature train exhibits throughout the United States, these exhibits are listed only if they are a part of a historically significant depot, museum or excursion.

One hopes that there will continue to be new museums opening periodically (the best are likely to be situated in currently abandoned depots), but it would appear that the number of new excursions that will be offered in the future may be rather limited, as most of the excursions currently in existence run over formerly well-known railroad company lines which railroad buffs were fortunate enough to obtain from the companies before their destruction. Many old railways have been abandoned, but so many of these have had the actual rails removed that the possibility of opening a new excursion on an existing line seems highly unlikely. As the popularity of railroad excursions (especially dinner trains) increases,

however, the authors' hope is that railroad companies will continue to become even more creative with the types of excursions offered on existing railways.

If you have never taken a train excursion, here is your opportunity to explore all the possibilities. Use this guidebook to find descriptions and specifications, to compare prices and length of rides, to discover what other amusements are offered and so on. There is a wonderful variety of railroading things to see and do throughout the country—many large, many small—and we hope that readers will take every opportunity to explore even the smallest exhibits, for each one is a treasure of our American heritage.

*We do not ride on the railroad,
it rides on us.*
Henry David Thoreau, 1854

Introduction

Many of the train sites listed in this book are owned and operated by nonprofit organizations whose members man the trains and depots on a strictly voluntary basis. We have found most of them to be extremely professional in their dealings, but we do want potential passengers to realize that businesses run by volunteers may run a little more slowly than those who have people working full-time. Phones cannot always be manned, letters sometimes take a little time getting to the appropriate person, rides may have to be canceled or rescheduled.

Because of uncertain weather conditions and other unforeseen events, many of the railroads (nonprofit and "for profit") mention in their advertising that days of operation, schedules, fares, motive power (steam or diesel) and cars used are subject to change without notice. Also be aware that many of the more popular excursions are booked far in advance, but will occasionally offer passengers a "substitute" for equipment originally listed in their brochures. To insure passage on the equipment of your choice, try to book early.

Because of the conditions discussed above, we strongly suggest that you contact the train site(s) of your choice several weeks before your planned visit, and then again shortly before your trip. The railroads will not be held responsible for your disappointment if you do not plan (and take some action) ahead of time!

A Brief History of Railroading

Trains and railroads have held a fascination for people since their inception. Today, "riding the rails" or even thoughts of riding the rails stir up the wanderlust in most of us. For this generation, the powerful old locomotives and the elegantly refurbished train cars stir up memories (or dreams) of the "good old days" when things were simpler, but life was just beginning to get exciting. Progress was in the air. The growth of railroads, both in the States and in Europe, changed the face (and pace) of the world forever.

Nowhere else in the world did trains affect lifestyles so much as in the western United States. In the late 1800s there was a huge increase in railway lines, with more than a thousand railroads chartered in Kansas alone (although only about 200 of them ever laid track). Gradually, towns started springing up to provide services for the railroaders (many forts were built as protection for the workers). Trains did not need to go to the towns, the towns came to them. We generally think of "boom towns" sprouting up around gold strikes, but history shows that many towns "boomed" because of the influence of the railroads.

The outbreak of World War I and its demands for transporting men and goods put a strain on America's rail systems. So, in December of 1917, President Wilson seized the rail system under the Federal Possession and Control Act. All lines were then operated (not very profitably) by the U.S. Railroad Administration under the directorship of the Secretary of the Treasury. In 1920, federal control ended and a new era of growth and expansion began. Freight shipments helped the railroads to show an improved profit, even though passenger revenues declined considerably.

Trucking companies began to put a dent in railroad freight revenues in the 1930s, but since there was not a good highway system this threat was not too serious. A growth in sales of automobiles at this time did, however, more seriously threaten passenger revenues.

The outbreak of World War II caused a further decline in railroading revenues as required military discounts, along with higher taxes and higher wages, took their toll. Highway systems improved considerably after the war, increasing the competitive threat from long distance truck lines and decreasing profits even more.

Railroading is not what it used to be. Generations thrilled and excited by the possibilities railroading opened up to them eventually saw that new societal factors were putting such stress on the railroading industry that its death seemed imminent.

Great things do not, however, die easily and even though railroading is no longer the "king of transportation," the world's fascination with this bit of "royalty" has kept it alive. Today a resurgence of interest in tourist excursions has revived many shortlines previously abandoned by major railroads. Museums have bought or received donations of land and track, and private owners have purchased sections for establishing tourist excursion lines. Even though many of these excursions run on a limited schedule, a small and rather glamorous part of America's heritage is being kept alive and flourishing.

A number of states have even established state-run railroad excursions or museums to keep their railroading history alive. Although it may be too late to save some of the older rail lines, many of their depots have been saved and restored for various uses. Most restored depots have various displays (varying in size) depicting the history of railroading in that area.

The history of railroading is certainly important to our nation since, at one time, the railroads were the largest employer in the nation, supplying paychecks to over three million people. Although only half a million workers are officially employed by railroads today, most people are affected by the railroads in one way or another. Many consumer goods are still hauled by rail, and trucking firms move many of their loads over railroads at some point in their journey. Passenger services are still in existence, both for commuter travel and tourist excursions. Railroads are still "making history" today.

Museums, Depots and Excursions
(listed by state)

ALABAMA

NORTH ALABAMA RAILROAD MUSEUM, INC.
"Home of the Mercury and Chase Railroad"

This museum, located in Chase, Alabama, is "dedicated to the preservation of the Railroad History of North Alabama and South Central Tennessee." Features open or under construction include a depot, a walk-through passenger train, a real operating railroad, twenty-seven pieces of major rail rolling stock (including passenger and freight equipment and two locomotives), and exhibits showing railroad history throughout North Alabama and South Central Tennessee.

The depot is "the smallest union-station in the country." It has been restored and now contains the museum offices and special exhibits.

Outside the depot is the museum's walk-through passenger train that, when completely restored, will contain a railway post office car, day coach, diner, Pullman sleeper and caboose. An ice bunker refrigerator car has been renovated for use as an audio-visual room. A small concrete hut nearby was once used by the watchman at the Church Street rail crossing in downtown Huntsville and has now been restored.

The depot is located between two railroads, the Norfolk Southern (Southern Railway) and a branch of the N.C. & St. L. Railway. Several years ago service was discontinued by those railways and five miles of track were purchased by the museum. The line was named the Mercury and Chase Railroad after two stations on that section of track.

A 1926 Boxcab diesel electric locomotive (No. 484) is located on the track. It is one of only three in existence, and will be the only operational Boxcab in

existence when restoration is completed. Both Norfolk Southern and Mercury and Chase trains can be seen running past the museum. Excursions from the museum itself are scheduled to begin April 13, 1996.

Annual events held at the museum include the Railroad History Festival in May, the mainline steam train excursion to Chattanooga in the fall, the Santa train in December, and the Hobo Feast (for members only) in the fall.

Season: Year-round.

Hours: Open to visitors every day, but members are available on Wednesdays and Saturdays (except holidays) from 9:30 a.m. to 2 p.m. to explain and show equipment.

Cost: Donations are accepted at the museum. Scheduled excursion prices vary.

For further information write to North Alabama Railroad Museum, Inc., P.O. Box 4163, Huntsville, AL 35815-4163, or call (205) 851-NARM, or 851-6276 (for recorded information). Phones are manned each Saturday 9 to 10 a.m.

ALASKA

Regardless of which of the Alaskan tours you choose, nature provides the majority of the unparalleled "sightseeing" entertainment.

ALASKA RAILROAD

The historic Alaska Railroad, by providing both passenger and freight services, has become the last full-service railroad in the United States. Organized in 1903 by a group of Seattle business people, the Alaska Central Railway drove its first spike at the end of the Seward Dock on April 16, 1904, and began providing service to the interior. Unable to endure the financial problems they encountered, the group lost the 70-mile line to the Alaskan Northern Railway Company on April 15, 1910. It was then purchased by the Alaska Railroad in 1915. On April 10 of that year, President Woodrow Wilson appointed the Alaskan Engineering Commission who were to construct a railway link between Seward and the navigable waters of the Interior (with Fairbanks as its chosen end). Construction began at both Seward and Fairbanks and met at Broad Pass. On July 15, 1923, President and Mrs. Warren G. Harding were on hand at Nenana to drive the golden spike to commemorate completion of the Alaska Railroad. Regular passenger and freight services began a few weeks later and were so successful that the railroad became completely self-supporting by 1938.

Although most tours take place during the summer months, the Alaska Railroad does provide year-round passenger service with a multitude of tours and optional "adventures" offered. Most of the tours travel from one major city to another with the breathtaking scenic views providing the "entertainment" on board.

Season: Year-round (majority of tours are in the summer).
Hours and cost: Vary according to the tour and options chosen.
For further information contact your local travel agent or write to Alaska Railroad Corp., Passenger Services Dept., P.O. Box 107500, Anchorage, AK 99510-7500, or call 1-800-544-0552 or 907-265-2494 or FAX 907-265-2323.

MCKINLEY EXPLORER

The McKinley Explorer is the name of the train which began operating in 1987 on the Alaska Railroad between Anchorage, Denali National Park and Fairbanks. Although the engine pulling the rail cars holds no special historical significance, the rail cars themselves hold a special interest for train buffs.

Car #508 (Matanuska), Car #510 (Chulitna), Car #512 (Tanana), Car #513 (Talkeetna), and Car #554 (Eklutna) are five of the fourteen stainless steel, full-dome lounge cars which were built by the Budd Company in 1954 for the Atchison, Topeka & Sante Fe Railroad at an original cost of approximately $325,000 each. These "Big Domes" (so nicknamed by the Sante Fe) originally ran either on the "El Capitan," the "Chicagoan/Kansas Cityan" or the "San Francisco Chief."

Thirteen of the cars were sold in 1971 to Auto-Train Corporation. Auto-Train used them for runs between Lorton, Virginia, and Sanford, Florida, until the corporation went bankrupt in 1981. At that time the cars were auctioned off to other owners. Seven of the cars were sold to the Delaware Osego Corporation (NYS&W), which used them on their short-line railroad excursions in New Jersey and New York. Those cars were purchased in December of 1985 by Holland America Line-Westours Inc.

Car #511 (Nenana) (also one of the original fourteen Sante Fe stainless steel cars) was sold to Auto-Train which later sold it to Great Western Tours. Great Western partially refurbished the car and ran it around Eureka and Willits, California, during 1984-1985 until selling it to Holland America Line-Westours Inc. in 1986.

Seating capacity in the upstairs dome areas is 60 passengers per car, with 22-passenger seating capacity in the dining room areas.

The tours on these historic railway cars vary considerably according to length, destination and other options available.

Season: Year-round.
Hours and cost: Vary according to the tour and options chosen.
For further information contact your local travel agent or write to Holland America Line-Westours Inc., c/o Gray Line of Alaska, 300 Elliott Ave., West, Seattle, WA 98119, or call 1-800-628-2449 or FAX 206-281-0621.

MUSEUM OF ALASKA TRANSPORTATION & INDUSTRY

Many pieces of rolling stock are on display at this 10-acre museum, both outdoors and in. Equipment includes two former Alaska Railroad locomotives

(#1000 was the first diesel in Alaska and starred in the movie *Runaway Train*), several early 1900s boxcars, a former Bureau of Mines car, a Pullman car, several troop cars, a 1918 caboose and more.

Many other forms of Alaskan Transportation are also on exhibit at the museum. An open house is held every July 4th weekend, and an Antique Engine Show is held in mid-August. Both events feature actual demonstrations of many of their pieces of working equipment.

Season: Year-round.

Hours: Memorial Day through Labor Day: Mon.-Sat., 10 a.m. to 6 p.m. Remainder of the year: Tues.-Sat., 8 a.m. to 4 p.m.

Cost: Adults, $3; students, $1.50; family rate, $7.

For further information write to the Museum of Alaska Transportation & Industry, P.O. Box 870646, Wasilla, AK 99687, or call (907) 376-1211.

NENANA RAILROAD DEPOT

The name Nenana is taken from the Athabascan word "Nenashna," meaning "Point of Camping at Two Rivers." In 1915, the railroad began construction for its northern division with the first spike driven at Nenana. The railroad proceeded to build many of the buildings that made up the town, including the Nenana Railroad Depot (established 1923), which is listed in the National Register of Historic Places. From this location the railroad was then finished to the south and built to connect with the Tanana Valley Railroad outside of Fairbanks to the north.

As with most railroads, progress brought change, and the depot was officially closed in 1983. In 1985, the federal government transferred the railroad to the state of Alaska, and the ceremony was held in Nenana.

The most interesting site to see on this train tour is the "largest single-span expansion bridge on rollers ever built." The bridge actually moves as the waters underneath expand and contract.

For further information write to the Tripod Gift Shop, P.O. Box 419, Nenana, AK 99760, or call (907) 832-5272 or (907) 582-2776.

PRINCESS ALASKA LAND TOURS

These tour packages are offered separate from any sea cruise or can be combined with one. Land tours are available with 11 different itineraries ranging in length from 4 to 14 days.

In 1984, the original Midnight Sun Express cars, known as "Super Domes," fathered luxury rail travel in Alaska, and now all cruises feature a ride on one of six Ultra Domes. These railcars were built in 1988 or 1991/2 for Princess cruises.

Although none of the other equipment appears to have historical significance, we felt these "land-cruises" should be included in this book as the scenery viewed from the Ultra Domes is unbeatable. If a fantastic train ride is what you're after—you can get it here!

Season and hours: Most tours are in the summer months, but tours are offered year-round.

Cost: Varies according to tour.

For further information call your local travel agent or write to Princess Tours, Midnight Sun Express, 2815 Second Avenue, Suite 400, Seattle, WA 98121, or call 1-800-835-8907.

WHITE PASS & YUKON ROUTE
WHITE PASS DEPOT & VISITOR CENTER FOR THE KLONDIKE GOLD RUSH NATIONAL HISTORICAL PARK

On August 17, 1896, on a then unknown tributary of the Klondike River, George Washington Carmack, Tagish Charlie, and Skookum Jim Mason discovered gold and, by July of 1897, the gold rush was rushing. By 1898, construction had begun in Skagway on a railway leading to the goldfields, and 110 miles of track had been laid by July 29, 1900, under the name of WP&YR (White Pass & Yukon Route). The WP&YR changed hands several times over the years, and changed cargos, until the last combination freight-passenger train made its run on October 8, 1982.

Tourist business in Canada and Alaska began to boom in the mid-1980s and several groups wanted to re-open the line as a tourist attraction. Finally, on May 12, 1988, after a 5½ year suspension, the WP&YR re-inaugurated passenger service to White Pass Summit. Other trips have been added since then, and by 1993, this "Scenic Railway of the World" (as advertised beginning in 1901) was carrying over 120,000 passengers a year. (Many of the tours are in connection with a sea cruise package tour.)

Old Steam Engine #73 escorts most of the trains away from the depot and to the edge of town where a diesel engine takes over. All other steam engines were retired in 1964. White Pass & Yukon Route trains today still roll over one of the last remaining narrow gauges in North America.

The old White Pass Depot, which was at one time the northernmost point of the railway, now houses the Visitor Center for the Klondike Gold Rush National Historical Park. The new Rail Depot next door houses the White Pass Ticket Office, the Whistle Stop gift shop, WP&YR's "G" Scale LGB model railroad layout and a hand-painted wrap-around mural depicting the history of the WP&YR.

Season and hours: Daily (one trip), end of May through mid-September. Days and times vary according to which tour is chosen.

Cost: Prices range from $30 to $160 according to tour chosen.

For further information call your local travel agent or write to The White Pass & Yukon Route, P.O. Box 435, Skagway, AK 99840, or call (from the U.S.) 1-800-343-7373 or (907)983-2217 or Fax (907) 983-2734. From NW Canada, call 1-800-478-7373.

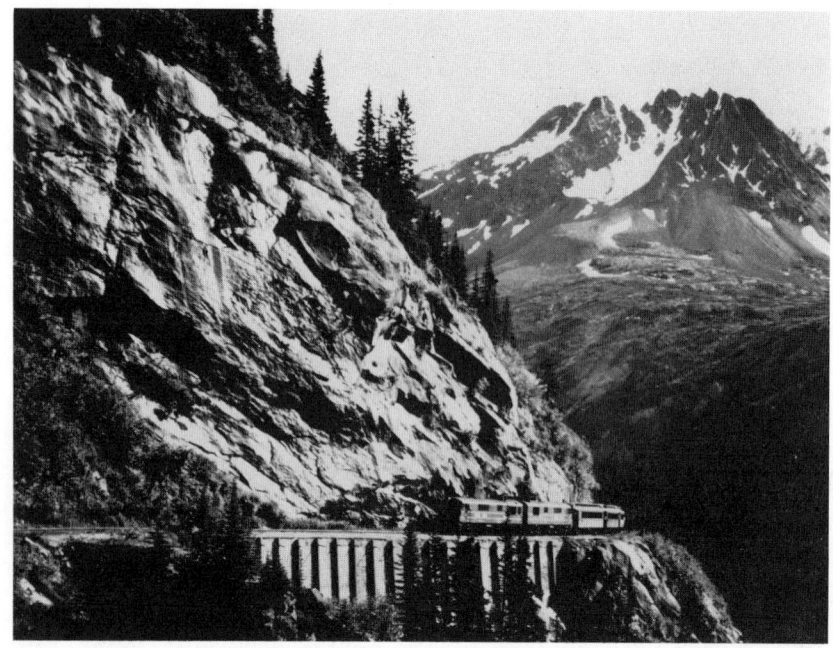

White Pass & Yukon Route

ARIZONA

THE ARIZONA RAILWAY MUSEUM

The museum is housed in a building which resembles an early Southwestern railway depot. Many of the pieces of equipment and memorabilia are from the Southwest, but pieces have been collected from all over the United States. Many pieces of rolling stock sit on trackage outside the museum. Some of these pieces include a 1906 Baldwin 2-8-0; a steam derrick and caboose (#413), both former Southern Pacific; a 1943 Plymouth gas-mechanical switch engine; a three-compartment tank car; Southern Pacific's tank car #60157; several cabooses; the "West Palm Beach" coach #2870, former Seaboard 10-6 sleeper; and more.

This non-profit organization is continually adding to their roster of equipment and list of memorabilia.

Season: Year-round. (Closed holidays.)

Hours: Weekends only, 12 p.m. to 4 p.m. Summer hours may vary: be sure to contact the museum.

Cost: No admission charge; donations are welcomed.

For further information write to The Arizona Railway Museum, P.O. Box 842, Chandler, AZ, 85224 or call (602) 821-1108.

GRAND CANYON RAILWAY & DEPOT
WILLIAMS DEPOT & GRAND CANYON RAILWAY MUSEUM

One of the best known railways is the Grand Canyon Railway. This vintage steam train offers white-gloved attendants, professional train crew, and professional musicians and entertainers on the 2-hour 15-minute trip from the historic Williams Depot through Arizona pine forests, small canyons and grassy plains, to the historic 1910 Grand Canyon Depot on the South Rim of the Grand Canyon. After a 3½-hour lay-over, which gives you time to explore the Canyon, more entertainment is provided on the return trip. Train conductors offer both facts and folklore about the Grand Canyon and the railway line, and every train features a strolling musician.

The Grand Canyon Railway carries more than 100,000 passengers each year. Three classes of accommodations are available: Coach Class, Club Class and Chief Class. Coach Class offers fully restored 1923 Harriman coach cars, with open windows, reversible seats, snacks, restrooms and entertainment. Club Class offers the same as the Coach Class plus air-conditioning and complimentary continental breakfast. Chief Class provides first-class seating aboard the Chief Keokuck, an authentic Pullman luxury parlor car built in 1927. The air-conditioned car was formerly part of the legendary Wabash Cannonball line. An open-air back platform, entertainment, snacks, complimentary continental breakfast and cocktail service are also available.

The Grand Canyon Depot is located just a few hundred feet from the Grand Canyon's South Rim. This National Historic Landmark (built in 1910) is the only log depot in the nation still serving an operating railroad.

The historic Williams Depot was built in 1908 and is listed on the National Register of Historic Places. The depot is part of a complex which includes the Grand Canyon Railway gift shop and the original Fray Marcos Hotel, which was one of the most prominent Harvey Houses in the nation at one time. The former dining room now houses the Grand Canyon Railway Museum.

Locomotive #20, built in 1910, and a 1923 Harriman coach car are on display outside the museum year-round. Wild-West cowboy performances and musical entertainment are offered on the platform along with a continental breakfast and gourmet coffee.

Season: Train: End of March through end of October, daily; March, Wednesdays–Sundays; February and November, Fridays–Sundays (plus Thanksgiving Day); December, weekends (except Christmas Eve and Christmas Day) plus daily December 26–January 1. William Depot & Grand Canyon Railway Museum: Year-round.

Hours: Train departs Williams at 9:30 a.m., arrives Grand Canyon at 11:45 a.m.; departs Grand Canyon at 3:15 p.m. sharp, returns Williams at 5:30 p.m. (It is suggested that passengers check in at the Depot ticket counter no later than 8:30 a.m.) Depot is open accordingly.

Cost: Train: (Coach Class) Adults $47, teen (13–19) $23.50, children (12 & under) $14.50; (Club Class) add $10 per person; (Chief Class) upgrade from

coach, add $30 per person. Does not include state and local taxes or National Park Service entry fee. Other options are available (check at depot). Reservations are suggested.

For further information check with your local travel agent or write to Grand Canyon Railway Business Office, 518 E. Bill Williams Ave., Williams, AZ 86046, or call 1-800-THE-TRAIN (843-8724) or FAX 602-635-4131.

VERDE RIVER CANYON EXCURSION TRAIN
ARIZONA CENTRAL RAILROAD

The Verde River Canyon Excursion train runs on a four-hour round trip into a designated wilderness area that is accessible only by rail, horseback or foot. Located about 20 minutes from Sedona, it is rapidly becoming one of Arizona's main tourist attractions.

Passengers board at the North Broadway station in Clarkdale for an historic and ultra-scenic trip through the Verde River Canyon. Sites include rugged high desert rock faces, cliff dwellings of the Sinagua Indians, distinctive flora and fauna, crimson cliffs, bridges, and one man-made tunnel. The turn-around point of the trip is located in Perkinsville (population: less than 10).

Passengers can purchase coach tickets or go first class in new first class "sleeper" cars complete with private sleeping berths, an outdoor barbecue and continental breakfast.

Equipment on the roster of the Verde River Canyon includes the Electo-Motive Division's No. 2278 GP-9 diesel locomotive, built in 1979. The coach cars are Pullman Standard cars built in 1946-47.

Season: Year-round, with additional days added in peak seasons.

Hours: Wed.–Sun., except during spring and fall when trains also run on Mon. Departure times vary with the seasons, with the earliest train leaving Clarkdale at 10 a.m.

Cost: Adults, $32.95; seniors (65+), $29.95; children (under 12), $17.95; first class, $49.95. Group rates and special excursion rates vary.

For further information write to the Verde River Canyon Excursion Train, 300 N. Broadway, Clarkdale, AZ 86324, or call (602) 639-0010. For reservations call 1-800-858-RAIL (7245).

ARKANSAS

ARKANSAS & MISSOURI RAILROAD
"Scenic Ozark Railway Journeys"

In 1986, the Arkansas and Missouri Railroad Company purchased 140 rail miles of trackage from Monett, Missouri, to Ft. Smith, Arkansas, from the

Burlington Northern Railroad. The track, originally laid in 1881, has been owned and or used by many small railroads, most of which were unsuccessful. Currently, A&M owns fifteen locomotives and operates five freight trains daily along with two passenger excursions. Excursion #1 runs from Springdale to Van Buren, reaching the top of the Ozark Mountain over trestles and through the Winslow Tunnel in climate controlled coaches. This 134-mile round trip tour includes an on-board breakfast buffet and a three-hour lay-over in Van Buren's historic district. Excursion #2 is a 70-mile scenic trip which runs from Van Buren to Winslow. Conductors provide historic information about the railroad and sites of interest along the journey. Complimentary soft drinks are provided.

Two of the cars used by the railway have historical significance. Car #102 was built in 1899 by the Boston and Main Railroad in Concord, New Hampshire, and eventually became a work car. Purchased in 1965 by A&M, it has been carefully restored as authentically as possible. It is slated to be donated to the Smithsonian Institution upon the retirement of Mr. Hannold.

Car #104 was built for the Delaware Lackawana & Western Railroad by the Pullman Company as one of a group made between 1914 and 1917. It was one of the first steel passenger cars built and was used to carry commuters in New Jersey until 1982. It was also used in 1987 in the filming of *Biloxi Blues*. The A&M purchased the car in 1990 and has restored it.

Other cars owned by the A&M include #102 – combination coach & baggage built in 1899 by Boston & Main Railroad; #104 – coach built by Pullman Company in 1917; #105 and #106 – coaches built by Harlin & Hollingsworth between 1924 and 1928. Several other pieces of historical significance are also owned by A&M.

Season: April through second week in November. Excursion #1's schedule varies, but does run every Wednesday and every Saturday. Excursion #2 runs some Fridays, every Saturday, and Sundays in October.

Hours: Excursion #1 boards 7:45 a.m. at Springdale depot and departs at 8 a.m., returning at 5 p.m. Excursion #2 boards at 11:00 a.m. at Van Buren depot and departs at 11:15 a.m., returning at 2:15 p.m.

Cost: Excursion #1: Tues., Wed., Fri. $38; Sat., Sun. $43.50. Excursion #2: Fri. $19, Sat. $21. (All rates are slightly higher in October.)

For further information write to Arkansas & Missouri R.R., 107 N. Commercial St., Springdale, AR 72764, or call 1-800-687-8600 or (501) 751-8600.

ARKANSAS RAILROAD MUSEUM

The Cotton Belt Rail Historical Society operates the Arkansas Railroad Museum, which offers a couple of steam excursions throughout the year. (Plans are in the works for increasing the number of excursions offered.)

The large roster of equipment includes Locomotive #819 (St. Louis South Western), Locomotive #336, Locomotive #5006, six coaches, a dome lounge car, two HEP power cars, baggage cars, an SSW wooden caboose, several motor cars and much more. A locomotive and car repair shop is also on the premises.

Season: Year-round.
Hours: Museum: Mon.–Sat., 9:30 a.m. to 2:30 p.m. Send for a schedule for actual excursion trips.
Cost: Museum admission is free; excursion prices vary.
For further information write to the Arkansas Railroad Museum, c/o Cotton Belt Rail Historical Society, P.O. Box 2044, Pine Bluff, AR 71613, or call (501) 541-1819.

EUREKA SPRINGS & NORTH ARKANSAS RAILWAY EUREKA SPRINGS DEPOT

Visitors to the historic Eureka Springs Depot, built in 1913, can still board a vintage steam engine train for a four-mile, 45-minute round trip excursion through the heart of the Ozarks. Passengers can watch the train being turned on a turntable at Eureka Springs or on a wye at the other end of the line. In Eureka Springs, after deboarding, passengers can take a ride on the city-operated trolley.

Equipment on the roster includes Locomotive #1 (a 1906 Baldwin), #201 (a 1906 ALCO), #226 (a 1927 Baldwin), six commuter cars, an 1896 smoker coach, two steam tractors and more.

Regular excursions are offered daily, along with special lunch and dinner train excursions.

Season: April through October.
Hours: Mon.–Sat.: Regular excursions run hourly from 10 a.m. to 4 p.m.; Lunch Trains run at 12 p.m. and 2 p.m.; Dinner Trains run at 5 p.m. and 8 p.m.
Cost: Regular excursions—Adults, $8; children (4–11 yrs.), $4; under 4, free. Lunch and dinner train prices vary. (Be sure to contact the railway.)
For further information write to the Eureka Springs & North Arkansas Railway, P.O. Box 310, 299 No. Main St., Eureka Springs, AR 72632, or call (501) 253-9623.

READER RAILROAD

The Reader Railroad is the oldest all-steam, standard gauge common carrier operating in the United States. Open platform wooden coaches, drawn by a vintage logging engine (#7, a 1907 Baldwin 2-6-2, former Victoria, Fisher & Western), take passengers on a seven-mile, one-hour round trip through the Arkansas countryside. Unscheduled special events are offered throughout the year, so be sure to contact the railroad before visiting.

Season and hours: Vary per season. Contact the railroad.
Cost: Adults, $6; children (4–11 yrs.), $3.60; under 4, free. Special events fares vary.

For further information write to the Reader Railroad, P.O. Box 507, Hot Springs, AR 71902, or call (501) 624-6881.

CALIFORNIA

CALIFORNIA STATE RAILROAD MUSEUM

Opened in 1981, the Museum of Railroad History has presented large numbers of changing exhibits, interpretive programs, publications and symposia. At this 100,000 square foot museum, growth is a constant goal; future plans include further expansion of the working railroad and an addition of a 114,000 square foot Museum of Railroad Technology, which will house exhibits, restoration facilities and more.

Excursion trains currently run along the banks of the Sacramento River to Miller Park, but should soon expand to 16 miles south of Sacramento where trains may connect with steamboats.

The museum currently exhibits 21 lavishly restored locomotives and cars, including a 1920s sleeping car and steam locomotives. The Central Pacific Railroad's 1876 Passenger Station can also be viewed along with the railroad research center and library.

Season: Year-round, except Thanksgiving, Christmas and New Year's Day.

Hours: 10 a.m. to 5 p.m. daily.

Cost: Varies according to excursion chosen.

For further information write to the California State Railroad Museum, 111 "I" St., Old Sacramento, CA 95814, or call (916) 552-5252 ext. 7245 or (916) 322-8485.

CALIFORNIA WESTERN RAILROAD
"Skunk Train"

The Skunk line of the California Western Railroad has run along the 40-mile long track from the coastal town of Fort Bragg to the town of Willits for over 100 years carrying logs, loggers, freight and other passengers. Steam passenger service started in 1904, but in 1925, the trains began to use little yellow self-powered railcars with gas engines, which prompted people to say, "You can smell 'em before you can see 'em," and thus the nickname was set.

One thing is still the same on the historic Skunk line—frequent stops are made to deliver mail and groceries to areas that are inaccessible by car. One thing that has changed, though, is that the California Western now also operates passenger trains called "Super Skunks," some of which are powered

by historic diesel locomotives. Steam is still a feature of the Super Skunks, however. Old No. 45, a 1924 Baldwin Steam engine, is frequently used in the summer along with the diesel locomotives and motorcars. Open observation cars provide a panoramic view from all trains.

Season: Year-round, but mostly weekends during the winter months. Be sure to send for a train schedule which clearly shows when the steam engines are being used.

Hours: Vary according to trip chosen.

Cost: Full-day trips: Adults, $26; children (5–11), $12. Half-day or one way trips: Adults, $21; children, $10; children under 7 yrs. are free unless occupying a revenue seat.

For further information write to the California Western Railroad "Skunk Train," 100 Laurel Street Depot, P.O. Box 907, Fort Bragg, CA 95437, or call (707) 964-6371. Reservations are recommended.

FEATHER RIVER RAIL SOCIETY

operator of the

PORTOLA RAILROAD MUSEUM

The Feather River Rail Society is the Historical Society of and for the Western Pacific Railroad. The Society leases the former Western Pacific diesel shop building and adjacent track area in Portola, California from the Union Pacific railroad for its museum site. The 39-acre site includes 12,000 feet of track (including a balloon track for turning equipment) and a 16,000 square foot shop building (with two tracks), which is used for repair and restoration and contains a gift shop, snack bar, display room, meeting room and rest rooms. Plans call for the building of a replica of a WP passenger depot to house the Society's collection of historical items.

The museum currently owns over 36 diesel locomotives and more than 85 pieces of freight, passenger and maintenance of way equipment, much of which is still being restored. Some of the locomotives include the DDA40X UP 6946, F7A WP 921D, WP805a (the last Zephyr unit), WP 501, an EMD SW-1 (built in 1939 and the first diesel on the Western Pacific line), the GP 30 UP 849 and more. The collection contains locomotives from General Motors, General Electric, Alco, Baldwin and Plymouth, representing the Western Pacific, Union Pacific and Southern Pacific, as well as industrial and military railroads.

A unique feature of this society is their locomotive rental program. For $75, one of the diesel locomotives can be rented for an hour, with instruction from a qualified engineer given to up to four people.

Season: Museum, year-round. Train rides in cabooses and vista flats are available weekends, Memorial Day through Labor Day, 11 a.m. to 4 p.m.

Hours: Museum open 10 a.m. to 5 p.m. daily, Memorial Day through Labor Day; 10 a.m. to 4 p.m. other days.

CALIFORNIA

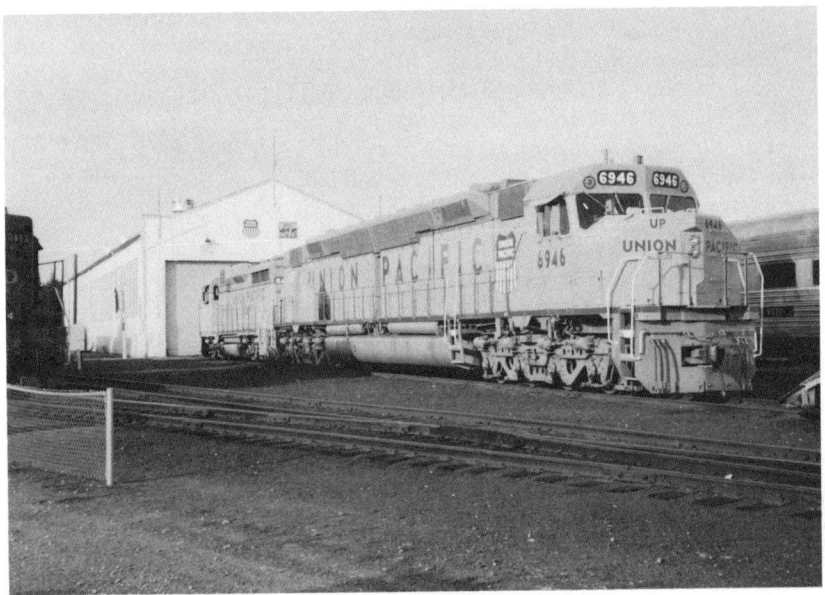

A locomotive from the Feather River Rail Society.

Cost: Museum, free (donations accepted). All-day train ride passes, $2; family $5. Locomotive rentals, $75 (for group of 4).

For further information write to the Feather River Rail Society, P.O. Box 608, Portola, CA 96122, or call (916) 832-4131. Reservations for the Locomotive Rental are recommended. Call (916) 832-4532.

FILLMORE & WESTERN RAILWAY

The Fillmore & Western Railway has an extensive collection of railroading equipment and is probably best known for the fact that many pieces of equipment from here have been used in over 130 movies, television shows and commercials. Visitors to the Railway may take a guided tour through many of these historic pieces and see props and sets used in those films, movies and commercials.

Locomotives listed on the equipment roster include #1 (an 1891 Porter 0-4-0 from the Rouge River Valley Railroad), #51 (a 1906 2-8-0 Baldwin from the Great Western Railway), and several more, both steam and diesel. Other pieces of equipment on the roster include wood and steel freight cars, several passenger cars (dating from 1910 to 1950), business cars, and several cabooses. More than 35 pieces are listed altogether.

Several special events held throughout the year are sponsored by the Santa Clara River Valley Railroad Historical Society. Be sure to write to the Railway or call the Society before visiting.

Season: End of April through end of Oct.
Hours: Weekends and holidays, 10 a.m. to 4 p.m.
Cost: Adults, $2; seniors, $1.75; children (6–12 yrs.), $1; Family fares, $5; under 6, free. Special events prices vary.

For further information write to the Fillmore & Western Railway, 351 Santa Clara Ave., Fillmore, CA 93015, or call (805) 524-0330 or call the Santa Clara River Valley Railroad Historical Society at (805) 524-1201.

LAWS RAILROAD MUSEUM HISTORICAL SITE

The first train to Laws, California, was completed on April 1, 1883. Laws was once an important outfitting center for the farming and livestock industry, and an important mining center during the early 20th century. A narrow gauge railway, the Mina (Nevada) to Keeler Branch of the Carson and Colorado was originally built to serve the area mines. This railroad was the life link serving both Eastern California and Western Nevada. In addition, the Laws-Keeler Branch of the Southern Pacific railroad was the last operating narrow gauge public carrier west of the Rockies, with Laws as its northern terminus.

The Laws Railroad Museum (listed in the National Registry of Historic Places) sits on more than 11 acres of land which was originally the right-of-way and railroad yards for the Carson-Colorado Railroad (later the Southern Pacific). It was given by the Southern Pacific to the "People of Inyo County" by Gift Deed on April 30, 1960, on the final day of operation for the narrow gauge branch between Laws and Keeler. The railway also donated "The Slim Princess" (Locomotive No. 9), a string of cars, the tracks, the Depot building (built in 1883), the Agent's House and all other facilities used by the railroad before it abandoned the line. Several other buildings are located at the Laws Historical Site, most of which were donated by Paramount Pictures after filming "Nevada Smith" on the grounds.

The Depot contains many articles of railroad memorabilia as well as historical information about the community. The other buildings house various exhibits, also.

The train consists of Locomotive No. 9 (a ten-wheel Baldwin) and the string of cars which were still in use up until 1960. The last car (#401), a combination caboose, passenger and baggage car, is of great historical significance, and has been noted in many books on narrow gauge railroading.

Another caboose at the museum, the only caboose with twin cupolas still in existence, was donated by the Southern Pacific. Other cars include passenger cars such as the "Blue Goose," a narrow gauge car built by the Brill Company and used on the Death Valley Railroad from about 1912 to 1931 and by the U.S. Potash Co. in New Mexico, and a passenger coach on "permanent loan" from Richard Datin, Jr.

Another unique feature of the museum is the hand-operated gallows type Turn-table (built 1883) which was part of the Laws-Keeler Branch. It was the last remaining one of its kind in use by a public carrier west of the Rockies.

Season: Year-round.
Hours: 10 a.m. to 4 p.m.
Cost: Donations accepted.
For further information write to the Laws Railroad Museum & Historical Site (or Bishop Museum & Historical Society), P.O. Box 363, Bishop, CA 93514, or call (619) 873-5950.

NAPA VALLEY WINE TRAIN

Located in historic California wine country, this 36-mile, three-hour excursion takes you non-stop from historic Napa through beautiful wine valleys to the quaint village of St. Helena, then back. An elegant on-board classic continental style brunch, breakfast, lunch or dinner is served. Other luxuries include souvenir photos, choice of 100 varieties of wine, liquor or cocktails, with a narration describing historic and scenic bits of information.

Lounge cars are lavishly restored 1915 vintage Pullman carriages. The dining car is a 1917 Pullman Dining Car. If you want an elegant and unique dining experience, this is it.

Season: Year-round.
Hours: Vary according to meal chosen.
Cost: Varies according to meal chosen, but ranges in price from $57 to $72, plus tariffs and taxes. Reservations and deposits are required.
For further information ask your travel agent or write to Napa Valley Wine Train, 1275 McKinstry St., Napa, CA 94559 or call (707) 253-2111 or 1-800-427-4124.

NILES CANYON RAILWAY

This railway offers passengers a 10½-mile, one-hour round trip through scenic Niles Canyon on trackage built in the 1860s as part of the original transcontinental railroad. Passengers may ride aboard a vintage coach, open excursion car, or a 1926 diesel railbus. Various train configurations are used at different times throughout the year.

Actual equipment used or on display includes: Locomotives #1 and #5, 3-truck Heislers; Locomotives #7 and #12, 3-truck Shays; plus seven other locomotives from various lines; a 1911 Harriman coach, former Southern Pacific; a 1910 open excursion car; a homemade coach and more.

Regularly scheduled excursions are offered along with Special Events in the Spring, Fourth of July, and Fall.

Season: Year-round, first and third Sundays, plus special events.
Hours: Hourly, 10 a.m. to 4 p.m.
Cost: Donations only (suggested: Adults, $5; children [3–12 yrs.], $2).
For further information write to the Niles Canyon Railway, P.O. Box 2247, Niles Station, Fremont, CA 94536-0247, or call (510) 862-9063.

ORANGE EMPIRE RAILWAY MUSEUM

Located in Perris, California, the Orange Empire Railway Museum features a variety of displays which depict the eras of steam and electric railroading. On display are several pieces of equipment and numerous pieces of memorabilia. Actual rides on streetcars and interurbans are also available.

The museum offers several special events throughout the year, including the Annual Rail Festival in April, a Fall Festival in October and bi-annual swap meets.

Season and hours: Museum: Daily, 9 a.m. to 5 p.m., except Thanksgiving and Christmas. Excursions: Weekends only from 11 a.m. to 5 p.m.

For further information write to the Orange Empire Railway Museum, P.O. Box 548, Perris, CA 92370-0548, or call (909) 943-3020 or Fax (909) 943-2676.

RAILROAD PARK RESORT

Although not a museum or depot, this resort is mentioned in this book because of the large number of railroad cars and railroad memorabilia on display. The resort is built around a "caboose motel," with cabooses from the Southern Pacific, Santa Fe and Great Northern having been refurbished and now being used as motel rooms. The restaurant and lounge are refurbished railroad cars with numerous pieces of railroad memorabilia on display.

A water tower, locomotive and track are also on the premises.

For further information write to Railroad Park Resort, 100 Railroad Park Road, Dunsmuir, CA 96025, or call 1-800-974-RAIL or Fax (916) 235-4470.

RAILTOWN 1897 STATE HISTORIC PARK
SIERRA RAILWAY COMPANY OF CALIFORNIA

The Sierra Railway Company was established for the transportation of gold and lumber from Tuolumne County in California. In more recent years, it has served as a site for almost 200 movies, commercials, and television shows including *Petticoat Junction* and *High Noon*.

Railtown 1897 State Historic Park is located in Jamestown and offers educational tours that cover both its railroading and Hollywood histories. Excursion train rides and a gift shop are also features of the park.

Season: The park is open year-round, while train rides are available daily from the first weekend in March through Thanksgiving.

Hours: Park and gift shop: 9:30 a.m. to 5 p.m., daily.

For further information write to Sierra Railway Dept., P.O. Box 1250, Jamestown, CA 95327, or call (209) 984-3953 or Fax (209) 984-4936.

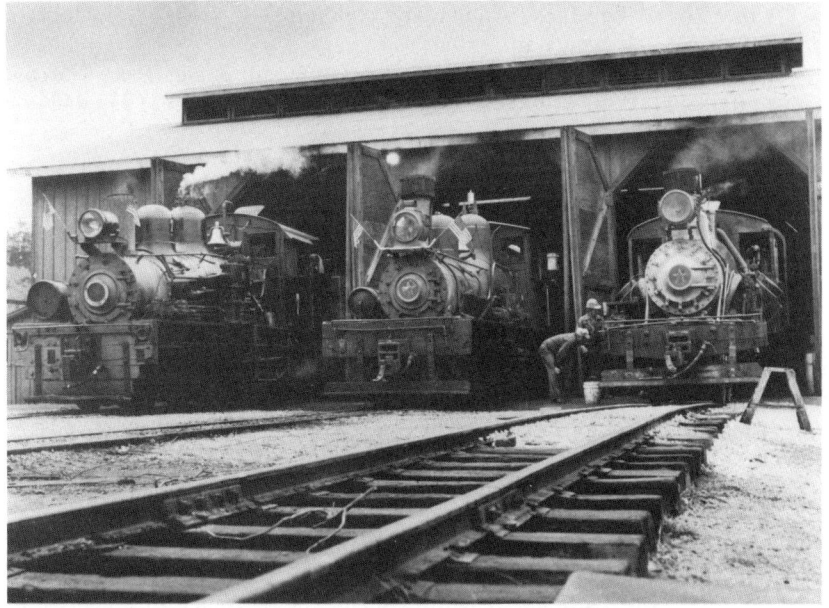

One hundred-forty tons of pure locomotive power stand ready at the Roaring Camp & Big Trees Narrow Gauge Railroad's Engine House to take passengers on a steam train excursion through the redwoods in the Santa Cruz Mountains.

ROARING CAMP & BIG TREES NARROW GAUGE RAILROAD

Climbing the steepest narrow gauge railroad grade in North America, the Roaring Camp & Big Trees Narrow Gauge Railroad takes passengers on a 1½-hour trip through a giant Sequoia Semperviren (Coastal Redwoods) forest, the first privately purchased (1867) forest to be preserved. A conductor-historian is on each train to tell of the natural and manmade history of the mountain area, which includes the stop at the top of Bear Mountain.

In Roaring Camp itself, where the trip begins and ends, sightseers can explore the old buildings in the 1880s logging town (including the old depot), watch more steam trains pass, or take a walk through the Henry Cowell Redwoods State Park next door.

Historic engines used on these trips include the Dixiana, No. 1 (42-ton, 1912 Shay), the Senora, No. 7 (60-ton, 1910 Shay), and the Tuolumne (1899) the world's oldest operating Heisler locomotive.

Season: Year-round, except Christmas Day. Days vary almost monthly, as do special events offered. We suggest you send for a Time-Table before planning a trip here. There are plenty of choices.

Hours: Most trips start at 11 a.m., 12 p.m., 1:30 p.m. or 3:00 p.m. (Holiday schedules do apply, and special events take place at other times.)

Cost: Round Trip fares: Adults, $12; children (3-15 yrs.), $8.75; under 3 years, free. Special events and group rates vary.

For further information write to Roaring Camp & Big Trees Narrow Gauge Railroad, P.O. Box G-1, Felton, CA 95018, or call (408) 335-4484 or Fax 408-335-3509.

SAN DIEGO & ARIZONA RAILWAY
SAN DIEGO RAILROAD MUSEUM

Built between 1907 and 1919, the San Diego & Arizona Railway became known as "the Impossible Railroad" because of the difficulty the railworkers had in cutting the railway through the mountains to the Carriso Gorge.

The San Diego Railroad Museum now operates restored vintage trains on the line.

Season: Every weekend and on major holidays except Thanksgiving and Christmas.

Hours: Museum: 10 a.m. to 5 p.m.; guided tours at 11 a.m. and 1:30 p.m. every day but Sunday. Train: Noon and 2:30 p.m. during the season.

For more information write to the San Diego & Arizona Railway, c/o San Diego Railroad Museum, 1050 Kettner Blvd., San Diego, CA 92101 or call (619) 595-3030 or Fax (619) 595-3034.

SANTA CRUZ, BIG TREES &
PACIFIC RAILWAY COMPANY

In 1875 a small (7-mile) narrow gauge railway was built from the wharf at Santa Cruz through the winding San Lorenzo River Canyon and on to an open meadow called Felton. Initially built as a freight line, the railway's potential for passenger service soon became obvious and, in 1880, James Fair built the South Pacific Coast narrow gauge railway from Alameda over the Santa Cruz Mountains to connect with the SC&F at Felton. The route was soon nicknamed the Picnic Line because passengers often picnicked in the forest or continued their trip to debark at the sandy beaches of Monterey Bay at Santa Cruz. Narrow gauge steam locomotives were first used, but later, standard gauge steam powered trains such as the Daisy Flyer, the San Francisco Limited, the Scenic Local and the famed Suntan Special made their way over what became known as the Mountain Division.

All service came to a halt in 1940 after a bad storm damaged the line, and the railway was dormant for 45 years. Fortunately, the visionary railroad buff F. Norman Clark bought the railroad, changed the name to Santa Cruz, Big Trees & Pacific Railway, and reinstituted passenger service on October 12, 1985.

Equipment now used on the line includes wooden cars from the 1900s,

steel coaches from the 1920s and open vista cars from other eras. A round-trip excursion takes about two hours, but several stops give the passengers a wide choice of tours to choose from. (Tickets can be purchased on the train or at the Roaring Camp/Felton depot.)

Season: Spring: May 21 through June 12, Sat., Sun. and holidays; Summer: June 13 thru Sept. 5, daily; Fall: Sept. 6 thru Oct. 30, Sat., Sun., & holidays; Sat. of Thanksgiving weekend; other special excursions are also available.

Hours: Suntan Special (south to the beach): leaves Roaring Camp 10:30 a.m. and 2:30 p.m., arrives Beach & Boardwalk 11:30 a.m. and 3:30 p.m. *Redwood Express* (north to the Redwoods): leaves Beach & Boardwalk at 12:30 p.m. or 4:30 p.m., arrives Roaring Camp 1:30 p.m. or 5:30 p.m.

Cost: Round trip fares: Adult, $14; child (3–15 yrs.), $8.95; under 3 years, free.

For further information write to Santa Cruz, Big Trees & Pacific Railway Company, P.O. Box G-1, Felton, CA 95018 or call (408) 335-4400.

WESTERN RAILWAY MUSEUM

The Western Railway Museum located between Suisun City and Rio Vista (35 minutes from Contra Costa County) provides a living history tour explaining the history of rail transportation. It is especially dedicated to preserving the history of the electric railroad. The Bay Area Electric Railroad Association was founded in 1945 to collect, preserve and operate surviving examples of the region's streetcars and interurbans. The Association bought the land at Rio Vista Junction in 1960 to house their growing inventory of rolling stock. A natural outgrowth was to open a museum where this equipment could be displayed. Great pains have been taken to restore a variety of equipment from ordinary street cars to luxury interurban cars. Also on display are vintage steam and diesel locomotives, freight and passenger cars, with more than 100 pieces of equipment on exhibit all together.

The Museum has 10 historic Oakland electric railway cars in operating condition, including a streamlined train from the Bay Bridge and a 100-year-old wooden rail car. This makes the largest collection of equipment in existence from the Key System. Some of the pieces on the roster include Key System's No. 352 car (built 1911), Electric Locomotive No. 1001 (built 1910, which carried President Taft), Key System's No. 833 car (built 1887), Key System's "articulated" cars No. 182, 186 and 187. Other pieces include the Blackpool Corp. Transit No. 226 "Boat Car" (built 1934), an open-air electric street car so named because it is shaped like a boat; Western Pacific's Observation Car No. 653 (built 1931) as "The Scenic Limited," later renamed "Exposition Flyer" for the 1939 World's Fair; Sacramento Northern Railway Company's No. 62 "Birney" Car (one of the first mass-produced cars); the Petaluma & Santa Rosa Car No. 63 (built 1904 by Holman of San Francisco); Car No. 1003, a Muni "Magic Carpet," one of five experimental streetcars built for the 1939 World's Fair (so nicknamed because they were extremely streamlined and quiet); and the Circumnavigator's Club Car (built 1916). The latter was one of the first

railway cars to be air-conditioned, although it required 7,000 lbs. of block ice to keep it that way. President Roosevelt used it during one of his World War II inspections.
Season: Museum is open every weekend but train schedules vary.
For further information write to the Western Railway Museum, (5848 St. Hwy 12), 560 Railroad Ave., Hercules, CA 94547, or call 1-800-290-2313.

YOSEMITE MOUNTAIN-SUGAR PINE RAILROAD

The Yosemite Mountain-Sugar Pine Railroad runs on a four-mile section of track which was used from 1899 until 1931 by the Madera-Sugar Pine Lumber Company high in the Sierra Nevada Mountains. The excursion now offers a variety of scenic views including Horse Shoe Curve, Honey Hill Junction, Cold Spring Crossing, Lewis Creek Canyon and Shady Slab Creek (where passengers may disembark, picnic, then catch a later train to return).

Two of the original five historic Shay locomotives (No. 5 and No. 10) owned by the Madera-Sugar Pine Lumber Company are now being used by the Yosemite Mountain-Sugar Pine Railroad. The Shays are unique locomotives designed and built especially for the logging industry with each articulated wheel a drive, giving the engine much more power than a normal locomotive. Model "A" Jenny railcars are also in use by the railroad.

Season: March through October and on a limited basis in winter. Special excursions are available at other times.
Hours: Vary according to season.
Cost: Varies according to excursion chosen.
For further information write to the Yosemite Mountain-Sugar Pine Railroad, 56001 Hwy. 41, Fish Camp, CA 93623, or call (209) 683-7273.

YREKA WESTERN RAILROAD

The Yreka Western Railroad has been in continuous operation since 1889. This historic short line railroad offers scenic three-hour steam train excursions aboard the "Blue Goose" Steam Train through the Shasta Valley, where magnificent views of Mount Shasta can be seen.
Season: Memorial Day through mid-October.
For more information write to the Yreka Western Railroad, P.O. Box 660, Yreka, CA 96097, or call (916) 842-4146 or Fax (916) 842-4147.

COLORADO

THE COLORADO RAILROAD MUSEUM

The Colorado Railroad Museum, established in 1958, has the largest collection of historic records, mementos, artifacts, photos and stock of Colorado

Yosemite Mountain-Sugar Pine Railroad

roads depicting Colorado's colorful railroad history. Over 50,000 artifacts are housed in a replica of an 1880s masonry depot. More than 50 narrow and standard gauge locomotives, cars and other rolling stock are on display somewhere on the 12-acre grounds.

The museum has its own spur where "steam-ups" are held throughout the year. Locomotives and cars come from various Colorado railroads, including the Colorado Midland, the South Park, the Florence & Cripple Creek, the Denver Boulder & Western, and the Manitou & Pikes Peak. Historically significant stock includes the Rio Grande Southern 1931 Galloping Goose No. 2, a meticulously restored Rio Grande 1881 Baldwin 2-8-0 engine, a huge Burlington CB&Q 4-8-4 locomotive, and the "Navajo" steel observation car which was built in 1937 and used on the Santa Fe Super Chief.

The Railroad Book Store (and gift shop) is also on the premises.
Season: Year-round, except Thanksgiving and Christmas.
Hours: Daily 9 a.m. to 5 p.m. (to 6 p.m. June-August).
Cost: Adults, $3; children $1.50.
For further information write to The Colorado Railroad Museum, 17155 W. 44th, Denver, CO 80202, or call 1-800-365-6263 or (303) 279-4591.

CRIPPLE CREEK & VICTOR NARROW GAUGE RAILROAD

Authentic steam locomotives lead the way on this four-mile excursion through one of the most historic gold fields in Colorado. Cripple Creek legalized casino gambling in October of 1991 and now features over 20 casinos with slot machines, poker and blackjack.
Season: Train: Daily, May–October.
For further information call (719) 680-2640.

CUMBRES & TOLTEC SCENIC RAILROAD
"America's Longest & Highest Narrow Gauge Steam Railroad"

Spiked down in 1880 as the San Juan Extension of the Denver & Rio Grande railroad, the Cumbres & Toltec was built to serve the mining camps in the San Juan Mountains. Today, the scenic 64-mile trip aboard the narrow gauge rail offers some beautiful views of awesome Rocky Mountain peaks and valleys, tunnels, gorges and trestles. Ownership has changed over the years, with the line currently owned by the states of Colorado and New Mexico. It is a Registered National Historic Site and is operated as a tourist attraction by Kyle Railways, Inc.

COLORADO 27

Cumbres & Toltec Scenic Railroad

Equipment on the line still includes old coal-powered steam engines, an open sightseeing car, old semi-enclosed cars and newer, fully enclosed cars. (Be aware that the train is not heated.)

Season: Daily from Memorial Day weekend through mid-October.

Hours: Most trains leave their stations before 10 a.m. Send for a Timetable for full information.

Cost: Tickets range in price from $16 for children to $43 for adults. Prices vary according to trip chosen.

For further information write to The Cumbres & Toltec Scenic Railroad, Box 668, Antonito, CO 81120 (or Box 789, Chama, NM 87520), or call (719) 376-5483 and in Chama, (505) 756-2151.

THE DURANGO & SILVERTON NARROW GAUGE RAILROAD

The Denver & Rio Grande Railway established the town of Durango in 1879 as a central point for construction of their railroad to Silverton. Construction began in Durango in the fall of 1881 and was completed in July of 1882. The railroad itself was to be used to haul mine ores, primarily gold and silver, from the San Juan mountains. In 1921, after several name and ownership changes, the Denver & Rio Grande Western Railroad (D&RGW) took over. They later sold the Silverton Branch to the Durango & Silverton Narrow Gauge Railroad Company (D&SNG), which operates that branch as a tourist attraction.

The train excursions wander through the San Juan National Forest, serving Tall Timber Resort, Needleton and Elk Park. The trains stop twice northbound and once southbound for water, and occasionally at other places to load or unload freight.

Many historic pieces of equipment are maintained by the D&SNG. Locomotives currently in service are of the 2-8-2 Mikado type, although two other classes of steam engines are owned by the D&SNG. All engines are coal-fired steam locomotives and bear the same numbers and class designations that they did when owned by the D&RGW. Engines currently in service are No. 473 (built 1923), No. 476 (built 1923), No. 478 (built 1923), No. 480 (built 1925), No. 481 (built 1925) and No. 482 (built 1925). Engines not in service but on display include No. 42 (built 1887), No. 493 (built 1902), No. 498 (built 1902) and No. 499 (built 1902). Thirteen passenger cars built in the 1880s are currently in use, mostly on the rail. Eight other coach cars (built in 1963 or 1964) are also in use, along with 16 open-observation cars, many built by Pullman in 1916. Seven other "special cars" can be seen at the depot site. The D&SNG has quite a history, as detailed in the book *Cinders & Smoke* by Doris B. Osterwald (available through D&SNG).

Two unique services are offered by the D&SNG. One of the narrow gauge boxcars has been completely refurbished and equipped to function as a wilderness RV. Equipped for up to four people, the special car will be set out at Cascade Canyon Wye in a secluded area next to the Animas River. A special train called the "RailCamp Train" takes the "RailCamp" car to the site. This train consists of a locomotive, the RailCamp and a caboose. Available mid-May through mid-September, the RailCamp adventure lasts Mondays through Fridays. The other unique service is the Private Car rental. The Cinco Animas, Nomad and Alamosa Parlor Cars can be rented to run as the last car on one of the Silverton Trains.

Season: End of April through end of October. A "Winter Holiday Train" runs from Thanksgiving week to New Year's Day.

Durango & Silverton Narrow Gauge Railroad

Hours: Depot hours are from 7:45 a.m. to 8:45 a.m., then 9:45 a.m. to 4:15 p.m. For train departure times, write for a Train Schedule.

Cost: Round trip fares range in price from $18.05 for children to $73.40 for adults, depending on excursion chosen.

For further information write to Durango & Silverton Narrow Gauge Railroad Co., 479 Main Ave., Durango, CO 81301, or call (303) 247-2733.

FORNEY TRANSPORTATION MUSEUM

All forms of transportation are exhibited at the Forney Transportation Museum, including three locomotives, 100 antique and classic automobiles, and 400 other items. One of the locomotives is the Big Boy #4005, the world's largest steam locomotive. Other pieces of rolling stock are on exhibit along with a large "N" scale model layout.

Season and hours: Open daily, 9 a.m. to 5 p.m. Mon.-Sat., May through September, 10 a.m. to 5 p.m. Mon.-Sat., October through April, 11 a.m. to 5 p.m. Sunday, year-round. Closed Thanksgiving, Christmas and New Year's Day.

Cost: Adults, $4; youth (12–18 yrs.) $2; children (5–11 yrs.), $1.

For further information write to Forney Transportation Museum, 1416 Platte Street, Denver, CO 80202, or call (303) 433-3643.

THE GEORGETOWN LOOP RAILROAD

The Georgetown Loop Railroad is a reconstruction of one of Colorado's most famous railroads. The original railroad reached Georgetown in 1877. A planned extension of the line to Leadville was never completed, but another section was added, taking the tracks to Silver Plume two miles away. To go those two miles, however, the railroad had to twist and turn four and a half miles, making 2½ complete circles and crossing over itself on a 90-foot-high trestle dubbed the Devil's Gate Bridge.

By 1939, with the mining industry collapsed and the automobile increasing in popularity, the railroad had closed and the bridge and rails were torn up for scrap metal. The grade lay undisturbed for 35 years until the Colorado Historical Society took over. By 1975, steam had returned to the valley, and the Devil's Gate Bridge was reopened in 1984. The open air viewing cars on the train may now be boarded in Georgetown or Silver Plume for a 1-hour and 20-minute round-trip ride.

The old Georgetown Station with exhibits and a railroad gift shop is located downtown in Georgetown, while the working station is outside of town.

Season: Mid–May through end of September with a special run at Christmas time.

Hours: Send for a train schedule.

Cost: Round-trip fare: Adults, $10.50; children (4–15 yrs), $6; under 4, free. An optional tour of the Lebanon Silver Mine costs $3.

For further information write to The Georgetown Loop Railroad, Georgetown, CO 80444, or call (303) 569-2403.

LEADVILLE, COLORADO & SOUTHERN RAILROAD CO.

This tourist excursion leaves Leadville (the highest incorporated city in the nation) from its century-old depot and travels over the old Colorado & Southern high line, following the headwaters of the Arkansas River up to a spectacular view of Fremont Pass. From there the train heads down to French Gulch water tower and a short stop to view Mt. Elbert, Colorado's highest peak.

For further information write to LC&S RR, P.O. Box 916, Leadville, CO 80461.

THE MANITOU & PIKE'S PEAK RAILWAY COG WHEEL ROUTE

Zamon Simmons (Simmons Mattresses) was the power and financial backer behind the Manitou and Pike's Peak Railway incorporated in 1888 to take passengers to Pike's Peak. The Abt rack system was chosen for the central rail. A gear under the locomotive engages the teeth in the central rack rail pulling the locomotive upwards without slippage on the steepest grades (a climb of 25 feet for each 100 feet of forward motion).

The first set of passengers road to the Halfway House in August of 1890. The railroad was completed on October 20, 1890, but the first group did not reach the peak until June 30, 1891.

The railroad was sold to Spencer Penrose in 1925. He modernized the railroad by constructing a gasoline railcar. By 1955, five new streamlined diesel trains were in use, with the steam engine being used only occasionally. In 1968, four red Swiss-made diesel railcars replaced the streamliners, and in 1976, two giant Swiss-made articulated trains (hinged in the middle) joined the team. Passing sidings were built shortly thereafter, and these amenities, along with the original 1890 depot, are what make up the Cog Wheel Route today.

Season: Year-round. (Reservations are recommended.)

Cost: Average cost of an adult ticket is $20.50.

For further information write to Cog Wheel Route, Mountain Automation Corp., P.O. Box 6020, Woodland Park, CO 80866, or call (719) 685-5401.

RIO GRANDE SKI TRAIN

"America's only exclusive ski train," the Rio Grande Ski Train, leaves Denver's Union Station on winter weekends and travels 56 miles up into the Rockies, traveling through 34 tunnels, including the sixth longest tunnel in the world, Moffat Tunnel. Passing through the Moffat Tunnel takes the train underneath the Continental Divide and to the base of the Winter Park Ski Area. Besides skiing, the area offers heated snowcat rides and horse-pulled sleigh rides.

The two locomotives used on the 14-car train were originally used by the Canadian Pacific Railway. The train holds 750 passengers and has a bar and refreshment services.

Season: Early season, December through January; Regular season, through first weekend in April.

Hours: Leaves Union Station at 7:15 a.m. (trip takes 2 hours); Leaves Winter Park at 4:15 p.m.

Cost: Early Season: Coach, $25; first class, $40. Regular season: Coach, $30; first class, $45.

For further information write to Rio Grande Ski Train, Union Station, Denver, CO 80202, or call (303) 296-I-SKI (4754).

TINY TOWN

Tiny Town was started in 1915 at the site of an old stage coach stop just outside of Denver. George Turner began erecting a one-sixth sized building layout for his young daughter. In 1920, the town was opened to the public and soon became one of Colorado's top five tourist attractions. By 1939, a miniature railway had been added, but changing economic conditions and a couple of natural disasters soon forced the attraction to close.

In 1988, volunteers began reconstructing the miniature town, and today, over 100 colorful, beautifully handcrafted buildings can be seen (many with full interiors). The Tiny Town Railway, a mile-long run with open-air cars pulled by an authentic steam locomotive again circles the town.

Season and hours: Memorial Day through Sept., 10 a.m. to 7 p.m.; weekends in May and Oct., 10 a.m. to 5 p.m.

Cost: Adults, $2 to enter the village; $1 for train rides.

For further information call (303) 790-9393.

PERMANENTLY PARKED NARROW GAUGE RAILROADS IN COLORADO

IDAHO SPRINGS has a park with a train near the center of town. Idaho Springs is 32 miles west of Denver on I-70.

CENTRAL CITY currently has a narrow gauge railroad in town and is working constantly to upgrade it. Many of the casinos here (and in neighboring Black Hawk) use a railroad theme.

BOULDER's Central Park features a narrow gauge train next to a stream in the middle of the park at Broadway and Canyon Road.

CONNECTICUT

ESSEX STEAM TRAIN & RIVERBOAT RIDE
VALLEY RAILROAD COMPANY
THE CONNECTICUT VALLEY LINE

The Valley Railroad Company began operating as a tourist attraction in 1971, exactly 100 years after the line's original run. It operates on property leased from the State of Connecticut Dept. of Environmental Protection and leaves the old Essex Station.

Several excursions each day are offered, with the Broadway Limited being the first train of the day running to the end of the restored track. The North Cove Express offers brunch, lunch or dinner on separate two-hour excursions.

A separate Murder Mystery Train is also offered monthly. Many of the excursions include a scenic riverboat cruise on the Connecticut River as well.

The two main engines used by the line include Engine No. 40 (a 2-8-2 "Mikado" type built in 1920 by the American Locomotive Company's Brooks Works) and Engine No. 97 (a 2-8-0 "Consolidation" type built in 1923 by the same company's Cooke Works). All together, the Valley Line offers steam train rides, riverboat cruises, a working railroad yard, vintage rail cars, exhibits, steam and diesel locomotives, gift shop, snack bar and dinner train along with their beautiful scenery.

Season: End of April through end of October.

Hours: Spring: April 30 through June 8, Sat., Sun. & Memorial Day, 10 a.m., 12 p.m., 1:15 p.m., 2:45 p.m., 4:15 p.m.; Wed. 2 p.m., 3:30 p.m. Summer: June 11 through September 5, Sat. & Sun., 10 a.m., 12 p.m., 1:15 p.m., 2:45 p.m., 4:15 p.m., 5:30 p.m. (also July 4th and Labor Day); Sat. only, 5:30 p.m. train is Summer BBQ Special. Last Sat. train 6:45 p.m.; weekdays, 10 a.m., 12 p.m., 1:15 p.m., 2:45 p.m., 4:15 p.m. Fall: September 7 through October 30, Wed.–Sun. (and Columbus Day) 10 a.m., 12 p.m., 1:15 p.m., 2:45 p.m., 4:15 p.m.

Cost: Train & boat (2½ hrs.): Adults, $14; children (2–11 yrs.), $7; under 2, free. Train only (1 hr.): Adults, $8.50; children (2–11 yrs.), $4.25; under 2, free. Saturday night BBQ: $4.24 extra. (Prices include tax; parlor cars are extra; senior discount available.)

For further information write to The Valley Railroad Co., Railroad Avenue, P.O. Box 452, Essex, CT 06426, or call 1-800-762-1411 (in Connecticut) or (203) 767-0103. For dinner train call (203) 621-9311.

RAILROAD MUSEUM OF NEW ENGLAND

The Connecticut Valley Railroad Museum in Essex, Connecticut, operates the Railroad Museum of New England. This museum owns the largest collection of historic railroading equipment in New England and displays part of it at the Essex site.

Season: May through October.

Hours: Weekends only.

Cost: No admissions charge; donations accepted.

For further information write to the Railroad Museum of New England, P.O. Box 97, Essex, CT 06426, or call (203) 395-0615.

DELAWARE

QUEEN ANNE'S RAILROAD
"Royal Zephyr Dinner Train"

The Queen Anne's Railroad offers both regular 1½-hour excursions and special 2½-hour Dinner Train excursions. The regular excursions take passengers

through southern Delaware countryside on the former Pennsylvania Railroad Lewes Line in open-air coaches and vintage cabooses. The Dinner Train runs on the same route, but uses the fully refurbished "Royal Zephyr," formerly from New Haven, and offers first class accommodations, elegant dinner services and entertainment. A murder mystery "dinner theater" is offered occasionally — be sure to contact the railroad for information.

Many excursions are pulled by steam, but diesel engines are also on the roster, so be sure to contact the railroad if you want to ride behind a steam engine.

Season and hours: May through December (dates and times vary greatly, so be sure to write to the railroad for a schedule.) Regular excursions generally run at 11 a.m., 12 p.m. or 2 p.m.; dinner trains depart at 7 p.m.

Cost: Regular excursions: Adults, $7; children (13 & under), $5; under 3, free. Royal Zephyr excursions: Adults, $39.95; children $32.95; (not recommended for children under 6).

For further information write to Queen Anne's Railroad, 730 King's Hwy., Lewes, DE 19958.

WILMINGTON & WESTERN RAILROAD
"Delaware's Working History Museum"

First chartered in 1867 to move goods between the mills on the Red Clay Creek and the Port of Wilmington, the Wilmington & Western Railroad began passenger and freight service on October 19, 1872. As in many cases, poor management and a changing economy forced the line to be sold in 1877, and the new line was called the Delaware Western Railroad. The Baltimore & Philadelphia Railroad purchased it in 1883, making that line the longest branch line on the B&O's Royal Blue Route (then renamed the Landenberg Branch). Due to the still-changing economy, the line was shortened a couple of times and now retains 10.2 miles of track.

Historic Red Clay Valley, Inc. leased the branch from the B&O in May of 1966, planning to operate steam powered tourist trains between Greenbank and Mt. Cuba. In the mid-1970s the B&O filed for abandonment of the Landenberg Branch and HRCV, Inc. purchased the line in August of 1982, renaming it the Wilmington & Western Railroad. It has become one of Delaware's top twenty tourist attractions.

Steam Locomotive No. 98 operates every Sunday on this line from the first of May to the end of November. A diesel locomotive pulls the train most of the rest of the time (be sure to contact the railroad before planning your trip). Several excursions are available, along with Holiday specials and charter availability.

Season: March through December.

Hours: As several trips are available, we suggest you write for their System Timetable.

Cost: Normal fares range in price from $4 for children to $12 for adults. Many specials are offered. Reservations are suggested.

For further information write to Wilmington & Western Railroad, c/o Historic Red Clay Valley, Inc., 1601 Railroad Avenue, P.O. Box 5787, Wilmington, DE 19808, or call (302) 998-1930 (Mon.-Fri., 9 a.m. to 5 p.m.).

FLORIDA

The historic Georgia, Florida and Alabama Railroad (GF&A), commonly referred to as the old "*G*opher, *F*rog and *A*lligator railroad," ran from Richland, Georgia, to Carrabelle, Florida, from 1893 to 1946. It passed through Tallahassee, Springhill, Hilliardville, Arran, Sopchoppy, McIntyre, Lanark Village and Carrabelle, bringing tourists (and freight) to the gulf coast port there. Most of these railways have been abandoned since 1970, or will be soon. The Florida "Rails to Trails" program is now acquiring and preserving these historic rights-of-way for conversion to recreational trails for walking, bicycling, horseback riding, jogging and nature study. By 1994, there were 10 rail-trails, with 17 more under acquisition or development.

FLORIDA GULF COAST RAILROAD MUSEUM, INC.

The Florida & West Indies Railroad and Steamship Company began operations in 1903 as a subsidiary of the Seaboard Air Line Railway. It became the SAL's Sarasota Branch in 1905, and the first railroad to link Tampa with Venice, Bradenton and Sarasota. Artifacts from this railroad are now on display at the Florida Gulf Coast Railroad Museum which is basically a "rolling museum" with on-board displays. Passengers take a 12-mile round trip from Parrish to Willow through Florida farmland. An annual "Heritage Day" festival is held in March.

Equipment owned by the railroad includes: two RS3's (former Amtrak); an ALCO S3 No. 1, former Florida Portland Cement; #12, a 0-6-OT, former Brooklyn Eastern District Terminal; a wood-burning steam locomotive; two cabooses, a refrigerator car, a tank car and two boxcars. Equipment actually used by the railroad includes: two open-window coaches (#3518 and #3572), former Delaware, Lackawanna & Western MU cars; the "Kentucky Club," an air-conditioned lounge car, formerly Louisville & Nashville; "Cape Tormentine," an air-conditioned sleeper-lounge, formerly Canadian National; and three cabooses.

Season and hours: Year-round, weekends and holidays.

Cost: Adults, $6; children (2-12 yrs.), $4; under 2, free.

For further information write to the Florida Gulf Coast Railroad Museum, Inc., P.O. Box 355, Parrish, FL 32419, or call (813) 776-3266 or (813) 859-9434.

HENRY FLAGLER MUSEUM
FLAGLER'S PRIVATE CAR NO. 91

Henry Morrison Flagler's historic Florida home is located in Palm Beach. Flagler was the founder of the Florida East Coast Railroad and was personally responsible for developing much of Florida's east coast from Jacksonville to Key West. His Private Car No. 91, built around 1886 by Jackson & Sharp of Wilmington, Delaware, is displayed on the grounds. The car still contains its original woodwork and interior fittings. It was used by Flagler on his trips to Florida and on inspection trips during the construction of the FEC Railroad's Key West extension.
Season: Year-round. Closed Christmas and New Year's Day.
Hours: Tues.-Sat., 10 a.m. to 5 p.m.; Sun. 12 p.m. to 5 p.m.
Cost: Adults, $5; children (6–12 yrs.), $2; under 6, free.
For further information write to the Henry M. Flagler Museum, P.O. Box 969, Palm Beach, FL 33480, or call (407) 655-2833.

SEMINOLE GULF RAILWAY

The Seminole Gulf Railway offers passengers a choice of rides aboard either the "Excursion Train," the "Dinner Train," or the Sunday "Brunch Train." The Excursion Train leaves Metro Mall Station for a two-hour narrated round trip on the railway's original trackage between Ft. Myers and Bonita Springs. The Dinner Train leaves Ft. Myers on a 60-mile, three-hour round trip. Three vintage dining cars named after Sanibel, Marco Island, and Gasparilla are used on this trip, which features a five-course meal. The Sunday Brunch Train leaves Ft. Myers and crosses the Caloosahatchee River, heading toward Punta Gorda for a three-hour round trip which includes a brunch. Several special events are also held throughout the year, including Murder Mystery Dinner Trains, Christmas Lights Canal Trips, and more.

Equipment used by the Railway includes Locomotives #571-577 (GP-9, former Baltimore & Ohio or Chesapeake & Ohio) or #578 (GP-10, former Illinois Central Gulf). Three Budd passenger cars, a kitchen car and several dining cars are also on the roster.
Season: Year-round.
Hours: Excursion Train: Wed.-Sat., 9:30 a.m., 12:30 p.m. and 2:30 p.m.; Sun., 12 p.m. and 2:30 p.m. Dinner Train: Wed., Fri., Sat., 6:30 p.m. Brunch Train: Sun. 10:30 a.m.
Cost: Excursion train: Adults, $12.50; children $7.50. Dinner train: $39.75 plus tax. Brunch train: $39.75 plus tax. Murdery Mystery excursion: $49.75 plus tax. Saturday trains require an additional $5 fare. Special events fares vary.
For further information write to the Seminole Gulf Railway, 4110 Centerpointe Dr., Suite 207, Ft. Myers, FL 33916, or call (813) 275-8487.

GEORGIA

BIG SHANTY MUSEUM

The Big Shanty Museum is the home of the famous "General," the steam locomotive which played such a big role in the historic Andrews Raid and the Great Locomotive Chase of the Civil War in 1862. The "General" and its tender sit in a museum located approximately 100 yards from the spot where they were originally stolen. Also on display are other train and Civil War memorabilia and a video depicting the Great Locomotive Chase.
Season: Year-round.
Hours: March through November: Mon.–Sat., 9:30 a.m. to 5:30 p.m.; Sun., 12 p.m. to 5:30 p.m.; December through February: Mon.–Fri., 10 a.m. to 4 p.m.; Sat., 9:30 a.m. to 5:30 p.m.; Sun., 12 p.m. to 5:30 p.m.
Cost: Adults, $3; seniors, $2.50; children, $1.50; under 7, free.
For further information write to the Big Shanty Museum, 2829 Cherokee Street, Kennesaw, GA 30144, or call 1-800-742-6897 or (404) 427-2117.

"THE CABOOSE"

While not boasting a working piece of equipment, Jesup, Georgia, does claim a caboose manufactured in 1954 and purchased from the CSX Railroad. Although the caboose was restored for office use, many of the original pieces of equipment have been maintained.
Also in Jesup stands one of the original "section houses" which has been restored by the "Heritage Center" Historical Society.
Season: Year-round.
Hours: 8 a.m. to 5 p.m.
Cost: Free.
For further information write to "The Caboose," c/o Wayne County Beautification Committee, 101 East Cherry St., Jesup, GA 31545, or call (912) 427-3892 or 427-3233.

CENTRAL OF GEORGIA RAILROAD SAVANNAH'S HISTORIC RAILROAD SHOPS & ROUNDHOUSE COMPLEX

Operated by the Coastal Heritage Society, the Savannah Railroad Shops are a National Historic Landmark. The complex has 13 original railroading structures still standing, including a roundhouse and turntable and a 25-foot tall brick smokestack, making it the oldest and most complete antebellum railroad repair facility in existence in the United States. Exhibits include two of the

oldest stationary steam engines in America, a locomotive and railroad rolling stock, and other antique machinery. Built in 1860, the Central of Georgia was Georgia's first railroad and the first chartered railroad in the United States.

The movie *Glory* was filmed at the complex in 1988.

The old Central of Georgia Railway passenger station (303 Martin Luther King Jr. Blvd.), also owned and operated by the Coastal Heritage Society, now houses the Savannah History Museum. An original 1890 steam locomotive still sitting on pieces of the original Central of Georgia tracks can be found there.

Savannah is also home to the River Street Train Museum (315 W. River St.) which features antique toy trains from the 1930s to the present.

Season: Year-round.

Hours: Shops: Mon.–Sat., 10 a.m. to 4 p.m., Sun., noon to 4 p.m. Museum: 9 a.m. to 5 p.m.

Cost: Shops: Adults, $2.50; children, $2; seniors, $2. Museum: Adults, $3; children, $1.75; seniors, $2.50.

For further information write to Historic Railroad Shops, 601 W. Harris St., Savannah, GA 31401, or call (912) 651-6823 or Savannah History Museum, 303 Martin Luther King, Jr., Blvd., Savannah, GA 31401, or call (912) 238-1779.

THE OLD DEPOT

Built in the late 1800s, the building has been moved to a position on a working railroad line in Lavonia. The depot has been remodeled and is currently being used as a Chamber of Commerce office. Care has been taken to leave the exterior as it was when built.

For further information write to The Old Depot, c/o Lavonia Chamber of Commerce, 1269 East Main, Lavonia, GA 30553, or call (706) 356-8202.

SOUTHEASTERN RAILWAY MUSEUM

This outdoor museum sits on 12 acres of land donated by the Southern Railway in 1966. The site includes a half-mile standard gauge loop track, six yard tracks, a shop, a 7.5-inch gauge rail system operated by North Georgia Live Steamers, a commissary car, a library car, and 70 pieces of rolling stock presenting both steam and diesel locomotives, vintage wood cars, coaches, Pullman sleepers, private cars, and a club car. Visitors are allowed to "board" much of the equipment.

Diesel power is used to run the trains most of the time, but steam power is used on the third weekend of each month. The steam locomotive pulls cars over the 7.5-inch gauge system, while the diesel pulls cabooses on the standard gauge half-mile loop. Special excursions sponsored jointly with other organizations are also offered periodically.

The principal pieces of rolling stock on view at the museum include: A&WP #290, a 4-6-2 Heavy Pacific, built in 1926 by Lima (featured in the

movie *Fried Green Tomatoes*); S&A #750, a 4-6-2 Light Pacific, built in 1910 for FEC (featured in the movie *Biloxi Blues*); Southern #1509, a 0-4-4T built in 1880; Southern E8 #6901, built in the early 1950s by EMD; the Private Car "Superb," built by Pullman in 1911 and used by President Warren G. Harding for his western trip in 1923, and then to carry his body from San Francisco to Washington, D.C. to Marion, Ohio, when he died on that trip; Club Car "Washington Club," built by Pullman in 1930; Central of Georgia #651, a semi-streamlined coach built in 1937 by Bethlehem Steel (the sole survivor of its type); Central of Georgia X92 Wood Caboose built in 1925, and more.

Season: April through Nov.

Hours: Sat. from 10 a.m. to 6 p.m.; third Sun. of each month from noon to 5 p.m.

Cost: Adults, $4; seniors, $2; children, $2.

For further information write to the Southeastern Railway Museum, Atlanta Chapter, National Railway Historical Society, P.O. Box 1267, Duluth, GA 30136, or call (404) 476-2013.

HAWAII

HAWAIIAN RAILWAY SOCIETY

The Hawaiian Railway Society was formed in 1971, dedicated to preserving the history of railroading in Hawaii. The Society operates a train ride which runs on the same right of way where track was laid down 100 years ago by the Oahu Railway & Land Company. The ride goes past the Barbers Point Naval Air Station (soon to be closed), and through sugar cane fields (soon to be phased out), to end at a new multi-million dollar resort. Plans call for a six-mile addition in the near future.

Equipment owned by the Society includes a 45-ton B-B Whitcomb diesel-electric locomotive that was built in 1944 for the U.S. Navy on Oahu. Several cars are former U.S. Army flat cars built in 1945. Four out-of-service steam locomotives can be seen, the oldest built in 1889, and three diesels are on the roster, with two running occasionally. A gift shop and mini-museum are also at the railyard and open when rides are given.

Season: Year-round.

Hours: Sundays, 1 p.m. and 3 p.m. only. Weekday trips are available for schools and special groups.

Cost: Adults, $7; children (2–12 yrs.), $4; seniors (62+), $4.

For further information write to the Hawaiian Railway Society, P.O. Box 1208, Ewa Station, Ewa Beach, HI 96706, or call (808) 681-5461.

IDAHO

NORTHERN PACIFIC DEPOT RAILROAD MUSEUM

The railroad reached Wallace, Idaho ("Silver Capital of the World"), in September of 1887 via a narrow gauge line originating at the Cataldo Mission. This Coeur d'Alene Railway and Navigational Co. branch line connected to a Northern Pacific branch at Coeur d'Alene by means of steamboats. Standard gauge railroads came to Wallace through the Oregon Railroad and Navigation Co. (a UPRR Subsidiary) in 1889.

The first Wallace depot was built in November of 1887. Replaced by a Northern Pacific Depot in 1901, the original depot was torn down in 1974 after having served as a freight house for many years. The new depot was built in a Roman style with buff-colored bricks imported from China. Because of the depot's rich history, it was listed on the National Register of Historic Places in 1976, while still operating as a railroad station. In 1979, it was the setting for a portion of the Michael Cimino movie *Heaven's Gate,* filmed in 1979 with Kris Kristofferson. The Depot and site were donated in 1986 by the Northern Pacific Depot to the city of Wallace for use as a railroad museum, which now features an Idaho Northern velocipede, a 13-foot-long lighted glass map of the Northern Pacific route, photos of early railroading days in Wallace, and more.

Season: Spring, Summer and Fall, daily; Winter, Tues.-Sat.

For further information write to the Northern Pacific Depot Railroad Museum, P.O. Box 469, Wallace, ID 83873, or call (298) 752-0111.

BONNER COUNTY HISTORICAL MUSEUM

Known in the railroad community as the "Funnel," Sandpoint, Idaho, sits at the converging points of the Burlington Northern (formerly the Great Northern and Northern Pacific mainlines from northern and central Montana), the Union Pacific, Montana Rail and others. For many years it has been possible to see all the principal locomotive models used by Burlington Northern and other lines at this point.

Because of this great railroading history, the Bonner County Historical Museum was built, and it now features antique and modern railroading photos and memorabilia, along with Spokane International Railroad caboose.

Season: Year-round.

Hours: Tues.-Sat., 10 a.m. to 4 p.m.

Cost: Modest admission charge.

For further information write to Bonner County Historical Museum, Lakeview Park, 609 S. Ella Street, Sandpoint, ID 83864, or call (208) 263-2344.

ILLINOIS

GALESBURG RAILROAD MUSEUM

The Galesburg Railroad Museum features early 1900s railroading equipment and memorabilia. The museum complex consists mainly of various pieces of railroading equipment from that era—a Locomotive, Railway Post Office and Railway Express Agency car, two inspection cars and a caboose—located in one area and open for public viewing. Across the street is a restored engine, three cars built in the 1920s and '30s and a 1923 Pullman car (the "Meath"), which contains most of the railroading memorabilia and displays.

Season: Year-round.
Hours: June 1 through Labor Day, Tues.–Sun., 12 p.m. to 5 p.m. After Labor Day through end of May, tours by appointment only.
Cost: Adults, $1; children (school age), $.50; under 6, free.
For further information write to the Galesburg Railroad Museum, c/o Galesburg Convention & Visitors Bureau, P.O. Box 631, Galesburg, IL 61402-0631, or call (309) 343-1194.

ILLINOIS RAILWAY MUSEUM
"A Museum in Motion"

The Illinois Electric Railway Museum was originally formed between 1941 and 1957 "to preserve one important piece of rolling stock"—the interurban railway. Over the years, development and expansion of the museum required the name to be changed to the Illinois Railway Museum, and it now has one of the largest operating demonstration railroad showcases in North America.

The museum's trackage was laid on the vacated right-of-way of the Elgin & Belvidere Electric Railway, and the rest of the buildings and track were built around it on adjoining farmland.

The museum's operating demonstration railroad consists of two distinct divisions: the five-mile long mainline running steam, diesel and heavy electric trains, and the mile-long streetcar loop. Although the street car curves are too sharp for the conventional railroad equipment to run on and the streetcars are too slow for mainline service, the interurbans and elevated ("L") trains can operate on either division. The mainline trains depart from the Museum's East Union Depot, while the Interurban and elevated trains depart from the 50th Avenue rapid transit station. Streetcars, of course, run on their own carlines and make stops at the major display buildings.

The main passenger boarding and alighting area is built around an 1851 depot from Marengo, Illinois. It is the oldest continuously operating passenger station west of Pittsburgh. The 50th Avenue rapid transit station was built in 1910 and moved to the museum from Cicero, Illinois.

The museum has an extensive collection of historic railway equipment ranging in styles from a diminutive horse car built in 1859 to a 400-ton steam

engine. The oldest operating diesel locomotive in the United States is operating here. In addition, the museum advertises over a mile of historic equipment under cover, including vintage coaches and modern streamliners. Some of the historic names recognized here include the Nebraska Zephyr, the Electroliner, the Chicago Surface Lines 1374 salt-spreader, the Frisco 1630, Burlington Route 637 (ten-wheel type steam locomotive, Rogers 1892), Union Pacific 428 (consolidation type steam locomotive, Baldwin 1900), Chicago Aurora & Elgin 431 (heavyweight interurban, Cincinnati 1927), the Milwaukee Electric Railway 972 (streetcar, St. Louis Car Co., 1927), North Chicago Street Railroad 8 (horsecar, John Stephenson, 1859), Ingersoll-Rand 91 (ex-DL&W 3001 oil-electric, Alco-GE-IR, 1926), the Chicago & North Western 1518 (First GP7 ever built, EMD 1948), and so much more. Over 11 major collections are on display (although not necessarily grouped together) and a detailed roster of rolling stock is available at the Museum Store.

The IRM has been the site of several movie scenes, including *Any Friend of Nicholas Nickleby Is a Friend of Mine* starring Fred Gwynne, *Under the Biltmore Clock, The Babe* and *A League of Their Own*. Several commercials have also been filmed here.

Season: April through October. (Operation of any equipment is subject to mechanical conditions of the trains. Generally, Electric cars run every day, steam and diesel trains run on weekends and holidays, and the Burlington Zephyr runs only on Memorial Day Weekend, Independence Day, rail fan weekend (Sept. 4 & 5), and Member's Day (Sept. 25).

Hours: Sundays: April through October, 11 a.m. to 5 p.m. Saturdays: May through second weekend of October, 11 a.m. to 5 p.m. Weekdays: Memorial Day through Labor Day, 10 a.m. to 4 p.m.

Cost: On days when steam or diesel trains operate: Adults, $7; children (5-11 yrs.), $5. All other weekend days: Adults, $6; children, $4. Week days: Adults, $5; children, $3. Special events days: Adults, $8; children, $6. Seniors receive $2 off adult fares; maximum family admission $25.

For further information write to the Illinois Railway Museum, 7000 Olson Road, P.O. Box 427, Union, IL 60180, or call (817) 923-4391.

SILVER CREEK & STEPHENSON RAILROAD

The Stephenson County Antique Engine Club purchased its 1912 Heisler steam logging locomotive in 1982 and displayed it in their building on the Stephenson County Fairgrounds until 1983. At that time, the Chicago, Milwaukee, St. Paul & Pacific Railroad went bankrupt and the club was able to purchase 1.72 miles of their right-of-way (no track included). After the club purchased rails and ties from various places, they laid track in 1985. Improvements to the property included the building of a railroad shed (which now houses the gift store and lunch stand) and the addition of the Silver Creek Depot, used for ticket sales and railroading memorabilia display.

Equipment on the roster includes the 1912 Heisler gear-driven steam locomotive; an 1889 Hannibal and St. Joseph caboose (reportedly the oldest in the state); a 1941 bay-window caboose built for the Chicago, Milwaukee, St. Paul & Pacific Railroad; a flat car; and a 1948 Illinois Central caboose.

The Silvercreek Museum & Cooper Corliss Steam Engine is located just west of the railroad and is open the same dates and hours as the railroad.

Season: Memorial Day weekend through end of Oct., holidays and special events only. (Be sure to send for a "Days of Operation" Schedule.)

Hours: 10 a.m. to 5 p.m.; Trains depart on the hour.

Cost: No admission charge. Train rides: Adults, $3; children (under 12), $1.50.

For further information write to the Stephenson County Convention & Visitors Bureau, 26 South Galena Ave., Freeport, IL 61032, or call 1-800-369-2955 or (815) 235-2198.

INDIANA

CARTHAGE, KNIGHTSTOWN & SHIRLEY RAILROAD

The CK&S Railroad offers a one-hour, ten-mile round-trip excursion on tracks (laid 1890) which were originally part of "The Big Four Railroad"—the Cleveland, Cincinnati, Chicago & St. Louis. Passengers board vintage coach #7102 (built 1926 for the Pennsylvania Railroad), covered open-platform car (former boxcar rebuilt into a transfer caboose by Grand Trunk Western Railroad), or caboose #916 (built 1947 and used by the Sante Fe Railroad) at the former New York Central freight and passenger station on Carey Street in Knightstown, then travel south, crossing U.S. 40 (The National Road), passing under the old "Pennsy" railroad bridge, riding through scenic countryside and over the Big Blue River. The halfway mark is at the Carthage railyard where rail equipment displays (including Caboose #318) can be viewed while the engine (1951) is "run around" for the return trip.

Season: May through October.

Hours: Sat., Sun., and major holidays: 11 a.m., 1 p.m. and 3 p.m. Fridays: 11 a.m. Several special events are offered throughout the year and weekday trips can be chartered.

Cost: Round-trip fares: Adults, $6; children (3-11 yrs.), $4; under 3, free.

For further information write to the Carthage, Knightstown & Shirley Railroad, 112 W. Carey Street, Knightstown, IN 46148, or call 1-800-345-2704 (Indiana only) or (317) 345-5561.

FRENCH LICK SCENIC RAILWAY
"The Tunnel Route"
INDIANA RAILWAY MUSEUM

Officially named the French Lick, West Baden & Southern Railroad, its 1¾-hour train trip runs through 20 miles of Hoosier National Forest, limestone rock-cuts and the 2200-foot Burton Tunnel, one of the longest railroad tunnels in the state. "Train robberies" often occur on holidays and other weekends throughout the summer. Indiana Railway Museum volunteers serve as train and station crew members.

The museum features several pieces of railroad equipment, including several diesel and steam locomotives, a rare railway post office car and a 1951 dining car, along with a snack bar and gift shop.

The Springs Valley Electric Railway, Trolley Car #313, built in Portugal in 1930 also runs from French Lick to West Baden and back from the Museum "depot."

Season: Train: April through November, Sat. and Sun. plus some holidays. Trolley: June through October, daily; weekends in April, May and Nov.

Hours: Train: Departs 10 a.m., 1 p.m. and 4 p.m. Trolley: Daily from 10 a.m. to 4 p.m. (send for more detailed schedule).

Cost: Adults, $8; children (3-11 yrs.), $4; under 3, free.

For further information write to the Indiana Railway Museum, P.O. Box 150, French Lick, IN 47432, or call 1-800-74-TRAIN or (812) 936-2405.

HESSTON STEAM MUSEUM
Iron-Horse Train Rides

One of the most varied collections of steam equipment in the country is on display at LaPorte County Historical Steam Society at Hesston, Indiana. Most of the equipment is in operation just as it was in its original state. Antique cars and gasoline engines are also on display.

A genuine coal-fired steam locomotive pulls the "Iron-Horse Train Rides" through 155 acres of meadows and forests on this two-mile railway line through northern LaPorte County. Also available are rides on a 14-inch railway and rides on a 1½-inch scale railroad known as Little Trains.

Equipment on the Big Trains roster includes "The India" locomotive built in 1899 and more.

Season: Memorial Day through Labor Day, weekends; Sept. & Oct., Sundays only.

Hours: Passenger trains leave at frequent intervals between noon and 5 p.m.

Cost: Big Trains: Adults, $3; under 12, $2; other trains, $2. Infants in arms, free.

For further information write to the LaPorte County Historical Steam Society, Inc., 2946 Mt. Claire Way, Long Beach, Michigan City, IN 46360, or call (219) 872-7405 or 872-5055.

INDIANA TRANSPORTATION MUSEUM

The museum offers many pieces of railroading equipment both for display and for riding. On display are Henry M. Flagler's business car No. 90 from the Florida East Coast Railway, and several cabooses, boxcars and passenger cars.

The working train carries passengers on a 37½-mile trip through Indianapolis and rural Hamilton and Tipton counties, or on shorter trips along a similar route. Visitors can also ride aboard vintage trolleys or interurbans on a 20-minute trip through Forest Park.

Equipment used by the railroad includes restored Budd coaches, a former Sante Fe combine, dining cars, Pullman coaches and cabooses from the Chesapeake & Ohio/Nickel Plate railroad. Several other locomotives and trolleys are also used or on display, including an 1898 Singer electric locomotive.

Besides the regular excursions, the Museum offers special events such as the Magic Train Ride in June, the Indiana State Fair Train in August, and the Ghost Train in October. Be sure to call ahead for reservations.

Season and hours: Weekends, April 1 through end of May and after Labor Day through end of Oct., 10 a.m. to 5 p.m. Tues.-Sun., Memorial Day through Labor Day, 10 am. to 5 p.m. Be sure to contact the Museum for accurate schedule.

Cost: Museum only: Adults, $3; children (3-12 yrs.), $2. Steam excursions: Adults, $12; children, $5. Diesel excursions: Adults, $7; children, $5. Fares include train ride, trolley ride and museum admission.

For further information write to the Indiana Transportation Museum, P.O. Box 83, Noblesville, IN 46060-0083, or call 1-800-234-TRAIN or (317) 773-6000.

LITTLE RIVER RAILROAD

This steam-operated railroad offers a regular eight-mile, 80-minute round trip excursion over the tracks of the Michigan Southern Railroad from Coldwater to Batavia. Special trips include a two-hour trip from White Pigeon to Sturgis and a five-hour trip from Coldwater to Sturgis. (The railroad is fairly new at this location and their schedule is in the process of change, so be sure to contact them before visiting.)

Equipment on the roster includes the smallest standard gauge Pacific locomotive ever built—#110, a 1911 Baldwin 4-6-2, former Little River Railroad.

For further information write to the Little River Railroad, 13187 SR 120, Middlebury, IN 46540, or call (219) 825-9182.

MADISON RAILROAD STATION

Built in 1895, the Madison Railroad Station featured a two-story waiting room, which has been called "one of the handsomest public rooms in southern

Indiana." When the Jefferson County Historical Society re-opened the Station in 1988, they had completed a massive restoration project, which included the guidelines set up by the original blueprints. Railroad artifacts and memorabilia are currently on display along with exhibits that change throughout the year. Madison can claim a major part of railroading history in Indiana.

Although there is currently no roster of equipment, the Society does have an antique caboose set up on display on a siding next to the station.

Season: Year-round.

Hours: April 1 through Thanksgiving, Mon.-Sat., 10 a.m. to 4:30 p.m.; Sun. 1 p.m. to 4 p.m. Rest of the year: Mon.-Fri., 10 a.m. to 4:30 p.m.

For further information write to the Madison Railroad Station, c/o Jefferson County Historical Society, Inc., 615 West First Street, Madison, IN 47250, or call (812) 265-2335.

OLD WAKARUSA RAILROAD

Located on the grounds of the Amish-style Come & Dine Restaurant, the Old Wakarusa Railroad tracks were laid between April and July of 1989. The ride lasts approximately 10 minutes, taking passengers over nearly a mile of track on a mile and a half ride over bridges, through a tunnel, past the miniature water tower, and around several curves.

The engine used by the Old Wakarusa is a ⅓ scale replica of the famous General Locomotive of 1862. Built in 1957 by Norman Sandley of Wisconsin Dells, #98 was sold to the Hoot-Toot and Whistle Railway in Elgin, Illinois. In the early 1980s a group of businessmen bought the railroad to be used at the 1982 World's Fair. They then sold it to the city of Knoxville, which ran it on the rails of the Knoxville Zoo until the engine was purchased by the Schrock Brothers of Wakarusa for use on the Old Wakarusa Railroad.

Season: April through October.

Hours: Mon.-Sat., 11 a.m. to dark.

For further information write to the Old Wakarusa Railroad, c/o Come & Dine Restaurant, St. Rd. 19, Wakarusa, IN 46573, or call (219) 862-2714.

UNION CITY COMMUNITY RAILROAD MUSEUM
UNION CITY HISTORIC DEPOT

The Railroad Museum in Union City is a new organization currently being developed in the old Sentry Hardware building in the town. Currently, the group has a sizable amount of railroading memorabilia (much of which has come from storage at the old Union City Depot), as well as two model train layouts on display. Plans call for more activities as time and funds allow.

The Historic Depot was built in 1913 and was restored in 1981. It currently houses the Art Association of Randolph County.

For further information write to the Chamber of Commerce, 105 N. Columbia, Union City, IN 47390.

WHITEWATER VALLEY RAILROAD
"The Canal Route"

Engine No. 25 pulls 4 or 5 coaches carrying passengers on a 32-mile round-trip excursion from Connersville to Metamora and back (or from Metamora to Connersville and back). Leaving Connersville, passengers are given a two-hour layover in Metamora to shop at the more than 150 unique shops and to see the working water-powered grist mill. The town itself dates back to the early 1800s. Along the train route passengers can see the towpath of the Whitewater Canal, the Laurel Feeder Dam and remnants of the old locks.

A Dinner Train excursion is offered every first and third Friday, May through October. Other special trips occur throughout the year, and the train is available for charter.

Railroad Training Classes are held once a year in February to instruct volunteers how to run or work on the trains.

Season and hours: First Sat. in May through last Sun. in Oct., Memorial Day, Labor Day and Fourth of July—departs Connersville at 12:01 p.m.; Wed., Thurs., and Fri. in May; Thurs. and Fri. in Oct.—departs Connersville 10 a.m.

Cost: Round-trip: Adults, $11; children, $5. One-way: Adults, $9, children, $4. Dinner train: $18 per person (includes train ride, meal, tax and tip. Prepaid reservations required.).

For further information write to the Whitewater Valley Railroad, P.O. Box 406, Connersville, IN 47331, or call the Station & Gift Shop at (317) 825-2054.

IOWA

BOONE & SCENIC VALLEY RAILROAD

On February 12, 1982, the Chicago & Northwestern Railroad held an abandonment meeting in Boone and, from that event, a group of rail fans instituted the beginnings of the Boone & Scenic Valley Railroad. The railroad now runs on the remains of the Fort Dodge, Des Moines & Southern Line, taking passengers on a nearly two-hour ride into the beautiful Des Moines River Valley.

One truly unique feature of this excursion train railroad is the steam engine used to pull most of the trains. "The Iowan," JS #8419, is the first Chinese Steam Locomotive imported into the U.S., and the only engine of its class here today.

Before boarding, passengers can get a closer look at this unique locomotive, and see the new depots, water towers, passenger cars, and the electric and diesel locomotives on display on the grounds. The Iowa Railroad Museum and gift shop are located inside one of the depots. Trolley rides are also offered most weekends.

Season: Memorial Day weekend through end of Oct., with extra trains on July 4th, Labor Day and Pufferbilly Days. Trains run "rain or shine." (Steam trains run holidays and weekends only.) Charters are also available.

Hours: Train departures: Weekdays, 1:30 p.m.; Sat., Sun., & holidays, 11 a.m., 1:30 p.m. and 4 p.m.

Cost: Steam: Adults, $10; children (5-12 yrs.), $4. Diesel: Adults, $8; children, $4.

For further information write to the Boone & Scenic Valley Railroad, P.O. Box 603, Boone, IA 50036, or call 1-800-626-0319 (IA) or (515) 432-4249.

IOWA STAR CLIPPER DINNER TRAIN WAVERLY DEPOT

In 1985, the "Iowa Star Clipper" became the first train to operate as a Tourist Dinner Train and it has been running ever since. The 3-hour train ride departs from the historic Waverly depot and runs through the rolling Iowa countryside. Entertainment is offered along with the elegantly served dinner. Potential passengers should contact the Dinner Train in advance to find out what type of entertainment is being offered on each trip, as it could be one of a variety of musical offerings or a murder mystery.

Locomotives used on the train are diesel-electrics #407 and #416. Pullman passenger cars (built in the 1950s) have been converted to dining cars and a full-service kitchen car. The ambiance of the 1950s has been retained.

Season: Year-round.

Hours: 11:30 a.m. and 7 p.m.

Cost: $42.50 (plus state tax).

For further information write to the Iowa Star Clipper Train, 311 East Bremer Ave., Waverly, IA 50677, or call 1-800-525-4773 or (319) 352-5467.

THE KATE SHELLEY MEMORIAL PARK & RAILROAD MUSEUM

One vintage passenger car serves as a railroading museum in Mongoinia, Iowa. To see the railroading memorabilia from the area, visitors must obtain the key from the Boone County Cultural Center.

For further information call (515) 432-1907.

RAILSWEST RAILROAD MUSEUM

This museum is housed in an 1899 former Rock Island Depot. Although mainly an HO model railroad museum, there are several pieces of actual rolling stock

displayed there. Some of these pieces include a 1963 Budd RPO car, former Union Pacific #5908; a 1967 Union Pacific caboose #24548, former Rock Island #17112; a 1969 UP boxcar #462536; and a Burlington route handcar.

Season: Memorial Day through Labor Day.

Hours: Mon.-Sat., 10 a.m. to 4 p.m. (closed Wed.); Sun., 1 p.m. to 5 p.m.

Cost: Adults, $2.50; seniors (60+), $2; children (6-12 yrs.), $1.25; under 6, free.

For further information write to the Railswest Railroad Museum, 72 Bellevue Ave., Council Bluffs, IA 51503, or call (712) 323-5182.

TRAINLAND U.S.A.

Trainland U.S.A. is an operating toy train museum displaying Lionel trains and accessories depicting the development of the railroad across the United States. Three eras of time are represented: frontier, steam and diesel. The display area covers the size of two average ranch style homes and includes more than 60 operating Lionel accessories still in their original state. It takes four control panels to run the system.

Although the emphasis of this site is not actual railway equipment, a few pieces of original railroad equipment are on display, including a Rock Island passenger train car (purchased in 1985) which serves as snack bar and exhibit area. New items are added each year.

Season and hours: From Memorial Day weekend through Labor Day: Daily 9 a.m. to 7 p.m.; Sept.: weekends only; Thanksgiving weekend (not Thanksgiving Day): 12 p.m. to 6 p.m. (Santa visits from 2 p.m. to 4 p.m.).

Cost: Adults, $3.50; children (3-12 yrs.), $1.50; under 3, free; seniors (55+), $3.00.

For further information write to Trainland U.S.A., R.R. 2, Colfax, IA 50054, or call (515) 674-3813.

TRI COUNTY HISTORICAL MUSEUM

Built in 1879, the Narrow Gauge Railroad and its artifacts are now on display at the Tri County Historical Museum in Cascade, Iowa. Rail fans can see restored narrow gauge cars and hundreds of artifacts from the now extinct line which ran between Cascade and Bellevue.

For further information write to the Narrow Gauge Railroad, c/o the Tri County Historical Society, 608 2nd Ave. S.W., Cascade, IA 52033, or write to the Cascade Economic Development Corp., 260 1st Ave. West, Cascade, IA 52033, or call (319) 852-7214.

KANSAS

ABILENE & SMOKY VALLEY RAILROAD

The Abilene & Smoky Valley Railroad offers passengers a 12-mile, 1½-hour round trip out of Abilene, Kansas, through historic Kansas cattle country. The standard gauge diesel train runs over former Chicago, Rock Island & Pacific trackage.

Equipment on the A&SV roster includes former Atchison, Topeka & Santa Fe locomotive #3415 (a 1921 Baldwin 4-6-2), Locomotive #4 (an ALCO-S1, former Hutchinson & Northern), an AT&SF business car #5 (an 1891 Barney & Smith car), a former Missouri-Kansas-Texas coach/diner #2002, an open gondola car, and a former Union Pacific caboose (built in 1944).

Before boarding, passengers might wish to visit the Dickinson County Heritage Center, adjacent to the railroad, and President Eisenhower's Presidential Library, museum and home nearby.

Season: May through October.

Hours: Daily, June through August; Weekends, May and Oct.

For further information write to the Abilene & Smoky Valley Railroad, P.O. Box 744, Abilene, KS 67410, or call (913) 263-1077.

ATCHISON RAIL MUSEUM

The Atchison Rail Museum is owned and operated by the North East Kansas Railroaders, Inc. Established as the North East Kansas Model Railroad Club in 1986, it soon became apparent that the name needed to be changed to its present form.

In 1988, the club leased some property from the city and bought more property from the Santa Fe Railway at the site of the Santa Fe Depot Museum. The restored Santa Fe Freight Depot sits adjacent to the museum.

The museum features a 12-inch gauge railroad ride as well as several pieces of rolling stock. On display are #811 (a 1902 Baldwin 2-8-0 Steam Engine), vintage box cars, a snow plow, flat cars, tank cars and a caboose. There are also several stainless steel 1940 era passenger cars, a railway post office car and baggage cars. The museum gift shop is located in a Missouri Pacific Caboose, and two railroad cars house a variety of railroad memorabilia.

Season: Weekends and holidays.

Hours: Sat., 10 a.m. to 5 p.m.; Sun. & holidays, 12 p.m. to 4 p.m.

Cost: No admission charge (donations appreciated).

For further information write to the North East Kansas Railroaders, Inc., Atchison Rail Museum, 200 South 10th St., Atchison, KS 66002, or call (913) 367-2427.

GREAT PLAINS TRANSPORTATION MUSEUM, INC.

Sponsored by the Wichita Chapter of the National Railway Historical Society, Inc., the Great Plains Transportation Museum currently has twelve pieces of rolling stock on exhibit. Other pieces of equipment are owned by the museum, but not currently on display. These include an interurban car and two vintage buses. Plans call for the building of a walk-through display area.

Equipment on the roster includes an AT&SF 3768 4-8-4 built by Baldwin in 1938, a B.N. 421 (NW2) #6872 built by E.M.D. in 1949 (diesel-electric), a K.G.&E. 603 built by McGuire-Cummings before 1914, an A.V.I.7 built by St. Louis Car Co. in 1911, an AT&SF 2312 built by AT&SF in 1931, an S.L.S.F. 876 built 1910 (wood caboose), as well as seven other coaches, cabooses and locomotives built after 1932.

Season: Year-round on Saturdays only.
Hours: 9 a.m. to 3 p.m.
Cost: Admission is free, donations are appreciated.
For further information write to the Great Plains Transportation Museum, Inc., P.O. Box 2017-C, Wichita, KS 67201-5017, or call (316) 263-0944.

HISTORICAL MUSEUM OF ANTHONY, INC.

The Santa Fe Railroad Depot in which the Historical Museum of Anthony currently resides was built in 1928 and served as a depot until 1982. The museum moved in in 1984.

The eight rooms in the building are filled with memorabilia about Anthony and the surrounding area from the late 1800s and early 1900s. Although there is only a small collection of railroad memorabilia at the present time, pieces are being added frequently.

Season: Year-round.
Hours: Thurs., Fri., Sat., 9 a.m. to 5 p.m. (other days by appointment).
Cost: Admission is free. Donations are appreciated.
For further information write to the Historical Museum of Anthony, Inc., P.O. Box 185 (502 W. Main), Anthony, KS 67003, or call (316) 842-3852.

KANSAS MUSEUM OF HISTORY

The Kansas Museum of History has on permanent exhibit a static railroad display which includes the Atchison, Topeka and Sante Fe locomotive #132, its tender and two cars.

Engine #132 was one of the first locomotives the Sante Fe had built especially for that railroad. Built in 1880 by the Baldwin Locomotive Works of Philadelphia, the #132 saw service over the Raton Pass until 1905 when it was reassigned to Kansas City's Argentine Yards for use as a switch engine. In

1939, the AT&SF began using it for public relations work, and used it as such for the next 25 years, along with the two coaches that the Museum also now owns.

AT&SF's Superintendent's Car #410 was built as a passenger coach in the Topeka shops in 1880. In 1893 it was converted to a business car, and then remodeled again in 1910. In 1929 it was again converted for use as a drover's car. That was its use until it became part of the promotional train.

Drover's Car #D-911 was built in 1881 as a passenger coach by the Barney & Smith Manufacturing Co. of Dayton, Ohio. It was used by the Gulf, Colorado and Sante Fe. The AT&SF acquired it in 1886 and eventually used it as a Superintendent's Car until it was converted to a Drover's Car in 1927.

Both railroad cars were restored to their latest use by the museum in the 1980s—one a 1910 Superintendent's Car and the other a 1927 Drover's Car.

The museum's main emphasis is to maintain the history of the state of Kansas, and it therefore offers much more than railroad memorabilia.

Season: Year-round.
Hours: Mon.-Sat., 9 a.m. to 4:30 p.m. Sun., 12:30 p.m. to 4:30 p.m.
Cost: Admission is free.
For further information write to the Kansas Museum of History, 6425 S.W. Sixth, Topeka, KS 66615-1099, or call (913) 272-8681.

MIDLAND HISTORIC RAILROAD

The Midland Historic Railroad began operation in August of 1987 with a restored 1946 diesel engine, a 1923 Rock Island commuter coach and a 1960 caboose. More equipment and excursions have been added through the years, including the popular Prairie Pioneer Dinner Train. Other historic sites of interest are nearby, including part of the Santa Fe Trail.

Excursions begin at the historic Santa Fe Depot in Baldwin City. The depot was built in 1906 and is the only remaining depot of Kansas' first railroad south of the Kaw: the Leavenworth, Lawrence & Ft. Gibson. The building is listed on the National Register of Historic Places and now belongs to the Sante Fe Trail Historical Society.

The Leavenworth, Lawrence & Ft. Gibson Railroad was built with government land grants and bonds from Douglas and Franklin counties. It was the only railroad to operate for two years without a terminus at either end, due to the fact that there were no bridges over the Kaw.

Season: Weekends and holidays from Memorial Day to Nov. 1. Dinner Train runs Sat. evenings only.
Hours: 11:30 a.m., 2 p.m., 3 p.m.
Cost: Dinner Train: $34.95 plus tax and gratuity.
For further information write to Champion Publishing, Rt. 3, Box 88, Baldwin City, KS 66006, or call (913) 371-3410 (excursions) or (816) 358-8707 or 1-800-637-1693 (dinner train).

OLD DEPOT MUSEUM

The Old Depot Museum in Ottawa, Kansas, displays various rotating exhibits throughout the year along with a continual railroading display.
Season: Sat. and Sun.
Hours: 1 p.m. to 5 p.m.
Cost: $1.00.
For more information write to the Old Depot Museum, Ottawa, KS or Champion Publishing, Rt. 3, Box 88, Baldwin City, KS 66006-5063, or call (913) 594-3734 or Fax (913) 594-3381.

SANTA FE DEPOT MUSEUM

The Santa Fe Depot in Atchison, Kansas, has been restored and now houses a museum and visitors' center. Steam Locomotive #811 and other vintage railcars are on display. Adjacent to the Depot Museum is the Atchison Rail Museum which also has several units of rolling stock on display, along with a miniature train ride.
Season: Year-round.
For further information write to the Santa Fe Depot Visitors' Center, 200 South 10th, P.O. Box 126, Atchison, KS 66002, or call 1-800-234-1854 or (913) 367-2427 or Fax (913) 367-2485.

KENTUCKY

BIG SOUTH FORK SCENIC RAILWAY

In 1974, the Big South Fork River Basin and the surrounding areas became part of the Big South Fork National River and Recreation Area. In 1989, the Big South Fork was turned over to the National Park Service.

The Big South Fork Scenic Railway now takes visitors on a 6.5-mile track through beautiful McCreary County, stopping at the Blue Heron Outdoor Historical Museum for a tour of an historic mining camp. Passengers board the train at Stearns, an historic Kentucky town now under historic redevelopment for showcasing in 1995. The complete train ride and tour take about three hours.
Season: Mid-April thru Oct.
Hours: Departs 11 a.m. on weekdays, 11 a.m. and 3 p.m. on weekends. (Special excursions are offered at other times.)
Cost: Adults, $8.95; children (3-12 yrs), $4.95; under 3 free when not occupying a seat.
For further information write to the Big South Fork Scenic Railway, P.O. Box 368, Stearns, KY 42647, or call 1-800-GO-ALONG (462-5664).

BLUEGRASS SCENIC RAILROAD
BLUEGRASS RAILROAD MUSEUM, INC.

Located 15 miles from Lexington, the Bluegrass Scenic Railroad, owned by the Bluegrass Railroad Museum, offers a 90-minute excursion through the "Bluegrass" region of central Kentucky. The 5.5 miles of track between Versailles and the Kentucky River is the middle section of the Norfolk Southern line between Lawrenceburg and Lexington. Formerly known as the "Lexington Extension," it was built in 1889 by the Louisville Southern Railroad (a front company for the Louisville, New Albany & Chicago Railroad, which later became the "Monon"). (At Lawrenceburg the track connects with NS's Western Division, and at Lexington it connects with NS's Kentucky Division. The ends of the line are still owned and operated by Norfolk Southern.) At the midpoint of the excursion, passengers disembark for a short walk to "Young's High Bridge," an historic railroad trestle built in 1888. The museum purchased the segment of the Lexington Extension between Versailles and the Kentucky River in 1988.

The coaches used on the excursions were built in the 1920s for the Central Railroad of New Jersey by the Pressed Steel Company and used as high speed commuter cars in the New York City area. When diesel power came into use some of the cars were modified to have a "control cab" on one end. This saved time on commuter runs because instead of moving the locomotive from one end to the other at the end of the line, the engineer walked through the train to the control cab (the last car) and controlled the locomotive by remote control. The last car on the Bluegrass is a "control cab." The open air car is an ex–Army heavy flatcar built to carry armored combat vehicles.

Locomotives used by the Bluegrass include the #1849, #B-2043 and #B-2086. #1849 is a Fairbanks-Morse H-10-44 switch engine built in 1953 and used by the US Army. Both #B-2043 and #B-2086 were Military Road Switcher Mark 1 models built by the American Locomotive Company for the US Army in the 1950s. (An interesting point of fact about these locomotives is that the gauge of their wheels can be changed.)

At the museum itself visitors can walk through a 1960s caboose used by the L&N Railroad and see a restored H.K. Porter Steam Engine, as well as iron "strap" rail and limestone sills from the first railroad built in Kentucky, several original railroad buildings and hundreds of other bits of equipment and memorabilia.

Season and hours: Weekends May thru Oct.; trains run on Saturday at 10:30 a.m., 1:30 p.m. and 3:30 p.m.; on Sundays at 1:30 p.m. and 3:30 p.m.

Cost: Adults, $6; children (2–12 yrs.), $4; under 2, free. (Special events costs vary.)

For further information write to the Bluegrass Scenic Railroad & Bluegrass Railroad Museum, P.O. Box 27, Versailles KY 40383, or call 1-800-755-2476 or (606) 873-2476.

ELKHORN CITY RAILROAD MUSEUM

This is a small museum which displays mostly old railroad memorabilia and equipment. By 1994 they had one caboose, all sorts of signals, tools, motor cars and motor car trailers, as well as hundreds of pictures of both steam and diesel engines, and telegraph and telephone equipment.

For more information write to the Elkhorn City Railroad Museum, Pine Street, Elkhorn City, KY 41522, or call (606) 432-1391.

KENTUCKY RAILROAD MUSEUM, INC.

This museum houses more than 4,000 square feet of exhibits showing artifacts, memorabilia and a model-railroad exhibit to depict the history of railroading in Kentucky. More than 50 pieces of rolling stock and 10 locomotives are on display, stored or under restoration. The new building replicates the original New Haven depot.

Excursions are offered on this standard gauge trackage on weekends, alternating between steam and diesel-powered locomotives. The excursion is a 20-mile, 1½-hour ride through scenic Rolling Fork River Valley from New Haven to Boston, KY, over former Louisville & Nashville trackage initially constructed in 1857. Special events are also sponsored by the museum, including a Murder Mystery weekend in the Fall, Christmas and Halloween trains, Rolling Fork Iron Horse Festival and Kentucky Bourbon Festival.

The equipment roster includes the following locomotives: No. 152, 1905 Rogers 4-6-2; No. 770 (first diesel for the Pan-American); 1925 Alco 0-8-0; No. 2152 (former L&N stock); No. 32, 1948 EMD BL-2, former Monon; CF-7 No. 2546, former Santa Fe; 1952 Fairbanks-Morse, former USA No. 1846; No. 11, 1923 Vulcan 0-4-OT, former Louisville-Cement; No. 2716, 1943 Alco 2-8-4, former C&O. Passenger cars include former L&N and other open and closed window cars; the diner "Kentucky Colonel" formerly owned by Southern Pacific; the Pullman solarium-lounge "Mt. Broderick"; a 1910 Jackson & Sharp, "Itsuitsme," formerly Bangor & Aroostook No. 100.

Season: Museum: Year-round; Train: Weekends, April, May & Sept. thru Nov.; Tues.–Fri., June thru Aug.; charters available.

Cost: Museum: Free (donations welcome). Train: fares vary.

For further information write to Kentucky Railway Museum, P.O. Box 240, New Haven, KY 40051-0240, or call 1-800-272-0152 or (502) 549-5470.

MY OLD KENTUCKY DINNER TRAIN

This train operates on the Bardstown Branch of the Louisville & Nashville Railroad. Built in the 1850s, it is one of the earliest branches of the L&N Railroad. In 1986, the remaining 20 miles of track from Bardstown to Bardstown Junction (where the line intersects with the mainline now owned by CSX Railroad) was purchased as a shortline railroad. The line began freight

operations in 1987, then started "My Old Kentucky Dinner Train" excursions in 1988.

The Depot, which was built in 1860, is the last remaining "drylaid" limestone depot in the state of Kentucky. It is listed in the National Register of Historic Places. Evidence of the two fires that changed the original looks of the depot can be seen on the ceiling and beams of the building. Other necessary changes have been made, but parts of the building have been kept intact just as they were when built.

The train is now pulled by two diesel engines. The renovated vintage dining cars, built by the Budd Company after World War II, provide an elegant dining atmosphere with polished mahogany walls, brass fixtures, specially designed sodium vapor lights and historic artifacts displayed. The three cars are: the RJC-007, built for the Pennsylvania Railroad in 1947 as a sleeper coach; the RJC-011, built for the Chesapeake & Ohio Railroad in 1948 as a dining car; and the RJC-777, built in 1946 as a day coach. The RJC-011 served as the dining car with full kitchen service on President Eisenhower's funeral train.

The two-hour Dinner Train excursion is one of the most popular in the US, offering lunch and dinner excursions on a seasonal basis. Reservations are recommended, especially for the fall excursions.

Season: April thru Dec. (closed Mondays)

Hours: Lunch & Dinner trains offered. Contact the railroad for exact schedules, as they vary according to demand.

Cost: Adults: Luncheon, $54.95; dinner, $59.95. Youth (5-11 yrs.): $5 less than adult prices. Rates include meal, excursion, tax and parking.

For further information write to My Old Kentucky Dinner Train, 602 N. 3rd St., Bardstown, KY 40004, or call (502) 348-7300.

THE RAILWAY EXPOSITION CO., INC. MUSEUM

Located three miles south of Cincinnati, Ohio, the Railway Exposition is an outdoor museum dedicated to the restoration and preservation of historic railroad cars and engines featuring guided tours of the grounds and occasional train rides—at Christmas time and a few other times during the year.

The roster of equipment includes four locomotives and over 50 cars from various time periods. Some of the most famous cars include the "Lake Moreau," a 10-section, two-bedroom, drawing room sleeping car typical of the late 1920s and '30s; the "Cascade Gardens," a six-bedroom sleeping car from the 1940s; the "Overdale," a 1928 Pullman built for the Overland Limited; a Troop Sleeper used for transporting troops during World War II; a special diesel engineers' training car; "El Comedor" diner built in 1947 by Pullman as a diner for Rock Island's Golden Rocket; a Rail Post Office Car built in 1910, and much more. (The Dining Cars are often rented for business and social events.)

Season: May thru Oct., Sat. & Sun.
Hours: 12:30 p.m. to 4:30 p.m.
Cost: Adults, $3; children, $2.
For further information write to The Railway Exposition Co., Inc., P.O. Box 15065, Covington, KY 41015-0065, or call (606) 491-RAIL.

LOUISIANA

DEQUINCY RAILROAD MUSEUM

In 1895, DeQuincy, Louisiana, was established as a townsite at the intersection of two major railroads. The city has tried to sustain its turn-of-the-century ambiance by maintaining the All Saints Episcopal Church and the 1923 Kansas City Southern Depot (which now houses the DeQuincy Railroad Museum). Both buildings are listed on the National Register of Historic Places.

At the museum, visitors can see a 1913 steam locomotive, a vintage caboose, and other railroad artifacts and memorabilia. Also, every year on the second weekend in April, the town hosts its annual DeQuincy Railroad Days Festival, which draws visitors from around the world.
Season: Year-round.
Hours: Mon.–Fri., 8 a.m. to 5 p.m.; Sat.–Sun., 1 p.m. to 5 p.m.
Cost: No charge (donations appreciated).
For further information write to the DeQuincy Railroad Museum, c/o DeQuincy City Hall, P.O. Box 968, DeQuincy, LA 70633, or call (318) 786-8241.

LOUISIANA STATE RAILROAD MUSEUM
GRETNA RAILROAD STATION
(*See also* **Southern Pacific Depot**)

The Gretna Railroad Station was built by the Texas-Pacific Railroad in 1905. This beautiful brick building now houses the Louisiana State Railroad Museum, whose members are dedicated to collecting and displaying railroading memorabilia and restoring various units of rolling stock.

The museum also supports a satellite museum located in the red caboose behind the Southern Pacific Depot in town. It is operated by the Gretna Historical Society.

For further information write to the Gretna Railroad Station, c/o Louisiana State Railroad Museum, City of Gretna, P.O. Box 404, Gretna, LA 70054, or call (504) 363-1580.

SOUTHERN PACIFIC DEPOT

(*See also* **Louisiana State Railroad Museum, Gretna Railroad Station**)

The Visitors Center is located in the old Southern Pacific Depot in the heart of downtown Gretna's National Historic District (just 10 minutes from New Orleans). The Louisiana State Railroad Museum also supports a satellite museum located in the red caboose behind the Depot. It is operated by the Gretna Historical Society.

For further information write to the Visitors Center, City of Gretna, P.O. Box 404, Gretna, LA 70054, or call (504) 363-1580. (Mon. thru Fri., 8 a.m. to 11:30 a.m.).

MAINE

BOOTHBAY RAILWAY VILLAGE

The Boothbay Railway Village is a re-creation of an early New England village and an antique auto exhibit. Visitors may take a ride on a narrow-gauge steam train through the village to the Antique Auto Display. Special events are also held throughout the year.

Situated on eight acres of ground, the village features 27 exhibit buildings, showing all aspects of small town living in early New England. The Depot is an authentic depot originally built in Freeport, Maine, in 1911 and moved to the Village in 1964. Passengers board the coal-fired steam train at the Depot, then take a 1½ mile, 20-minute ride through woods, railroad yards, past the "kissing bridge" to "Summit Station." Here visitors may detrain and take a short walk to the Antique Auto and Truck display, which features over 60 restored vehicles.

Season and hours: Memorial Day to mid-June, weekends, 9:30 a.m. to 5 p.m.; mid-June thru Oct., daily, 9:30 a.m. to 5 p.m. (Trains run every half hour).

For further information write to the Boothbay Railway Village, Route 27, Boothbay, ME 04537, or call (207) 633-4727.

COLE LAND TRANSPORTATION MUSEUM

The Cole Land Transportation Museum offers a huge display of transportation history of all kinds. Part of that display includes a small display of railroad equipment—a BLs, 1919 Freight car and a caboose.

We found the "purpose" of this museum, as stated in their brochure, to be an interesting one: "To preserve and display a full cross section of Maine's early land transportation vehicles. To honor the hard work, ingenuity and

discipline of Mainers who built, maintained and used these vehicles. And to challenge young people to consider what old-timers accomplished for Maine and what they, too, can accomplish for themselves and their communities." We note that their "purpose" is carried out in their admission prices (see below).

Season and hours: Every day 9 a.m. to 5 p.m., May 1 thru Nov. 11.

Cost: Ages 18 and under, free; adults, $2; seniors, $1.

For further information write to the Cole Land Transportation Museum, 405 Perry Road, P.O. Box 1166, Bangor, ME 04402-1166, or call (207) 990-3600.

FORT FAIRFIELD RAILROAD MUSEUM

The Fort Fairfield Railroad Museum is a unit of the Fort Fairfield Frontier Heritage Society. The museum focuses on the important role the railways played in the eventual establishment of Fort Fairfield as the "potato capital" of the world. Housed in the original Canadian Pacific station built in 1904, the museum houses many artifacts and is the ticket office for the museum's Motor Car rides.

Motor cars from the Canadian Pacific railroad, the BAR and Canadian National are used on the museum's half hour rides which take passengers along the Aroostook River. (Motor Cars were often used by railroad track workers.) The rail line used was built in 1875 by the New Brunswick Railway and paid for by town citizens. It provided transportation between Aroostook County and other parts of the state, nation and Canada.

The museum offers a small static display for visitors to view. Units on display include a rare RS-23 locomotive #8032, donated by CP Rail System (and once run on these tracks); a new replica of the cab of a large diesel road locomotive (with actual items from a CP M-630); and a Bangor and Aroostook mechanical refrigerator car.

Season: End of June thru end of Sept.

Hours: Wed., Sat., Sun., noon to 4 p.m. (Other times by appointment.)

Cost: No admissions charge (donations appreciated).

For further information write to the Fort Fairfield Railroad Museum, Box 269, Fort Fairfield, ME 04742, or call (207) 473-4045.

LOCOMOTIVE 470

Locomotive 470 is a static display located on Route 201 in Waterville, Maine, at the site of the Maine Central Railroad on College Avenue.

Season: Year-round.

Hours: Daily, during regular business hours.

Cost: No admissions charge.

For further information write to the Waterville Chamber of Commerce, Waterville, ME 04901, or call (207) 873-3315.

MAINE COAST RAILROAD

Passengers aboard the Maine Coast Railroad ride in restored former Delaware & Lackawanna and Central New Jersey coaches on a 14-mile round trip along the scenic Sheepscot River. Diesel engines used to pull the trains include a Maine Central ALCO S-1 No. 958, a Norfolk & Western ALCO RS-11 No. 367, and a former Washington Terminal ALCO RS-1 No. 46.

Regular excursions run seasonally, and special events such as the Bath Heritage Days, Fall Foliage, Halloween Trains and Santa Trains are offered throughout the rest of the year. Be sure to check with the railroad for exact dates and times.

Season: End of May thru mid-Oct. plus other special events.
Hours: Hours vary according to season and excursion chosen.
Cost: Adults, $10; seniors, $9; children, $5; under 5, free; family fare, $25. Special events fares vary.
For further information write to the Maine Coast Railroad, P.O. Box 614, Wiscasset, ME 04578, or call 1-800-795-5404 or (207) 882-8000.

MAINE NARROW GAUGE RAILROAD COMPANY & MUSEUM

The Museum features a ride on the railroad's 24" gauge, steam-driven train aboard vintage locomotives, coaches and cabooses. The route runs on the beach beside Casco Bay.

Equipment on the roster includes the "Rangeley" parlor car (built in 1884, former Wiscasset & Quebec #3), Railbus #4 (former Sandy River), several cabooses from Sandy River & Rangeley Lakes, tank cars, boxcars, a snowplow and more. Some of the units are used on the train, others are on display at the museum.

The museum also exhibits a number of railroad artifacts, photos and other pieces of memorabilia.

Besides the regular excursions, special events are offered a few times each year. Be sure to contact the museum for exact information.

Season: Mid-May to mid-Sept.
Cost: Museum: Adults, $3; children, $1. Excursions: Adults, $5; children, $3.
For further information write to the Maine Narrow Gauge Railroad Co. & Museum, 58 Fore St., Portland, ME 04101, or call (207) 828-0814.

MOOSEHEAD LAKE RAILROAD

The Moosehead Lake Railroad track runs over the original route laid by General Joshua Chamberlain (who led a successful charge at Bull Run even though his men had no ammunition) shortly after the close of the Civil War in

1867. The railroad offers passengers a choice of a 2½-hour round trip from Belfast to Brooks and back or a 1½-hour round trip from Unity to Branham Junction and back, passing 100-year-old depots and stopping at historic shopping areas along the way.

Equipment on the roster includes a 1906 Steam Engine, a 1948 GE Diesel, a 1920 Pullman coach, and a 1960 Diner car. Special events are offered throughout the year.

Season: Mother's Day to Halloween.
Hours: Daily. (Check with the railroad for specific boarding times.)
For further information write to the Moosehead Lake Railroad, 1 Depot Square, Box 555, Unity, ME 04988, or call (207) 948-5500.

OWLS HEAD TRANSPORTATION MUSEUM

Located close to the Owls Head Lighthouse, two miles south of Rockland, Maine, and less than an hour from Boothbay Harbor, this museum includes antique autos, aeroplanes and engines. A restoration workshop, gift shop, films, nature trails and other displays are on the premises.

Season: Year round.
Hours: Daily.
For further information write to the Owls Head Transportation Museum, P.O. Box 277, Owls Head, ME 04854, or call (207) 594-4418.

PITTSFIELD HISTORICAL SOCIETY DEPOT HOUSE MUSEUM, INC.

The depot itself holds the most interest for railroad history buffs. It was built around 1886 by a forerunner to the Maine Central Railroad, now known as Guilford Transportation Industries of Bellrica, MA. Also, currently in the restoration process is a 1920 Maine Central Railroad wooden body caboose (or crummy, hack or buggy as they were sometimes called). This Coupla-type crummy is thought to have served on all branches of the old Maine Central system at one time or another. Other railroad artifacts including a telegraph key, lanterns and photos are also on display.

For further information write to the Pittsfield Historical Society Depot House Museum, Inc., One Railroad Plaza, P.O. Box 101, Pittsfield, ME 04967.

SANDY RIVER & RANGELY LAKE RAILROAD

The Sandy River & Rangely Lake Railroad is a narrow-gauge (2') railroad which takes passengers on a .6-mile trip through the scenic Maine countryside outside of Phillips, Maine.

Season: May thru Oct.

Hours: 11 a.m., 1 p.m. and 3 p.m.; 1st and 3rd Sundays only.
For further information write to the Sandy River & Rangely Lake Railroad, P.O. Box B, Phillips, ME 04966, or call (207) 639-3352.

SEASHORE TROLLEY MUSEUM
"The Oldest and Largest Transit Museum in the World"

Located in Kennebunkport, the Seashore Trolley Museum exhibits more than 225 transit vehicles. Walking tours of the museum grounds allow visitors to see the first horse-drawn trolley, refurbished parlor cars, a trolley with snow brooms, a San Francisco Cable Car, a double-decker from London, cars from Italy and Germany, and an active Restoration Shop with many other trolleys in storage.

Visitors can also take a four-mile trolley ride on a number of restored cars, including Trolley Car #31 and a Philadelphia & Westchester Traction Co. car. Part of the track belongs to the original Atlantic Shoreline Railway. Uniformed conductors explain the routes, the trolleys and their colorful history.

Back at the visitors' center, visitors can see photos and exhibits of this bygone era, shop for souvenirs, watch miniature train exhibits or wait for one of the many rides to board. Regular excursions run seasonally, while a large number of special events are offered throughout the year.

Season: May thru Oct.
Hours: Vary according to season or special event.
Cost: Museum: Adults, $6; seniors, $5; children, $4. Special events fares vary.
For further information write to the Seashore Trolley Museum, Log Cabin Road, Box A, Kennebunkport, ME 04046, or call (207) 967-2800.

Other trains/depots in Maine: The Belfast & Moorsehead Lake Railroad, Belfast, ME. An operating tourist line.

The Depot Restaurant, Gorham, ME. Ex-passenger depot now operating as a restaurant.

MARYLAND

THE B&O RAILROAD MUSEUM

This museum houses a collection of locomotives, cars, archives and railroading memorabilia and artifacts centering on the history of the B&O Railroad, the first main-line railroad in the United States, beginning operations in 1828.

Visitors to the museum can look at the variety of equipment and exhibits

on display including model railroads and toy train exhibits, or visit one of the many buildings also open to the public. These buildings include the 1851 Mt. Clare Station, the 1884 Annex Building, the 1884 covered passenger-car roundhouse, and a large car shop (built in 1870) now used for equipment storage.

On the weekends, excursion trains depart from the Mt. Clare Station for a two-mile round trip running over original B&O track. All-day excursions are offered four times each year. Dining cars can be rented.

Some of the rolling stock on display includes: 9 original locomotives from the 1800s; 2 replicas; 12 original steam locomotives; 14 diesel-electric locomotives; the oldest passenger car in North America; 5 passenger cars built in the 1800s; 15 passenger cars from the 1900s; several cabooses and much, much more.

Season: Year-round. (Closed Christmas and Thanksgiving.)
Hours: 10 a.m. to 5 p.m., daily.
Cost: Museum: Adults, $5; seniors, $4; children (5-12 yrs.), $3; under 5, free. Train rides cost an additional $2 per passenger (under 5 ride free).
For further information write to the B&O Railroad Museum, 901 West Pratt Street, Baltimore, MD 21223-2699, or call (410) 752-2464 or (410) 752-2490.

ELLICOTT CITY B&O RAILROAD STATION MUSEUM

The Ellicott City Depot was the first passenger terminus of the B&O Railroad (built in 1831), and currently houses a railroading museum and visitors' center. Several pieces of railroading memorabilia and model railroads are on the premises, including a restored 1927 caboose.

Season: Year-round.
Hours: 11 a.m. to 4 p.m.
For further information write to the Ellicott City B&O Railroad Station Museum, 2711 Maryland Ave., Ellicott City, MD 21043, or call 1-800-288-8747 or (410) 461-1944.

THE ENTERTRAINMENT LINE
THE CATOCTIN MOUNTAIN LIMITED
ROMANCE ON THE RAILS

Running over the former main line of the Western Maryland Railway, the EnterTrainment Line offers passengers a choice of casual dining on the daytime Catoctin Mountain Limited or more elegant fares on the nighttime "Romance on the Rails" excursion. Trains are pulled by a standard gauge diesel locomotive.

The Catoctin Mountain Limited is a three-hour, 50-mile round trip from Union Bridge, Maryland, to Blue Ridge Summit, Pennsylvania, offering a

choice of regular excursion, lunch or dinner all-you-can-eat buffet, or luxury meals aboard an eight-passenger private dining car.

Romance on the Rails is a three-hour, 50-mile round trip from Westminster to Thurmont, Maryland. It is restricted to adults, and features a casual dinner buffet and dancing.

Murder Mystery and Matinee Mystery excursions are offered several times each month.

Season: Year-round.

Hours: Catoctin Mountain Limited: Sundays and some Saturdays and weekdays. 1 p.m. Romance on the Rails: Fridays and Saturdays, 7 p.m.

Cost: Coach: Adults, $18; children (under 12), $11. Dinner Train and Special Events fares vary from $20.95 for children to $49.95 for adults on the Murder Mystery Special.

For further information write to The EnterTrainment Line, P.O. Box 478, Union Bridge, MD 21791, or call 1-800-553-3115 or (410) 875-2814 (Baltimore area).

WESTERN MARYLAND SCENIC RAILROAD

This tourist train takes passengers on a three-hour 32-mile round trip from Cumberland to Frostburg and back over former Western Maryland Railway and Cumberland & Pennsylvania Railroad trackage through scenic Maryland countryside, passing through a tunnel, around Horseshoe Curve and past spectacular mountain views. In Frostburg, passengers can deboard for a 1½-hour layover to visit the many historic sites, including the Old Depot Restaurant and Shops and an active turntable. At the Cumberland end, passengers can also visit many historic sites, including the Transportation and Industrial Museum, visitors' centers and other museums.

Season: May thru Sept. with special events in Oct. and Nov.

Hours: May thru Sept., Tues–Sun., 11:30 (Diesel runs on Tues.); Oct.: Tues.–Sun., 11 a.m. and 4 p.m.; end of Nov. thru mid–Dec., weekends only. Other special events are held throughout the year.

Cost: May thru Sept. and Nov.: Adults, $12.75; seniors (60+), $11.25; children (2-12 yrs.), $7.50. Oct.: Adults, $14.75; seniors, $14.25; children, $8.50. Special Events fares vary.

For further information write to the Western Maryland Scenic Railroad, Canal Street, Cumberland, MD 21502, or call 1-800-TRAIN-50 or (301) 759-4400.

MASSACHUSETTS

BERKSHIRE SCENIC RAILWAY MUSEUM

This restored 1902 Lenox Station, a national historic place, serves as museum (featuring two operating model railroads and railroading exhibits), gift shop

and depot for the Berkshire Scenic Railway Museum's "Short Shuttle" train ride. The trackage sits on museum grounds and the ride on authentic vintage cars comes complete with narration. Special events are also held throughout the year.

Season: Open Sat., Sun. and holidays, Memorial Day weekend thru Oct.
Hours: 10 a.m. to 4 p.m. (Trains run every hour.)
Cost: Admission to museum is free. Train rides: Adults, $1.50; children, $1, seniors, $1.
For further information write to the Berkshire Scenic Railway Museum, P.O. Box 2195, Lenox, MA 01240, or call (413) 637-2210.

CAPE COD SCENIC RAILROAD

The Cape Cod Scenic Railroad offers two main excursions: one a regular scenic tour, the other a Dinner Train. Special events are also offered throughout the year.

The Scenic Tour offers two hours of vintage train riding, traveling through Old Cape Cod, with stops in Historic Sandwich Village and Cape Cod Canal, where passengers may disembark to shop, then return on a later train. An on-going commentary accompanies the tour.

The Dinner Train is a three-hour elegant culinary journey which requires reservations. Jacket or tie is required, and it is suggested that children under 14 do not participate.

Season: Excursions: Weekends and Holidays in May, daily except Mondays from early June to late Oct. Dinner Train: daily, except Mondays, mid-June thru mid-Sept.; Wed., Fri., Sat. and Sun. in Spring and Fall; Weekends only in Winter; closed Jan.
Hours: Excursions: Four trips are made daily. Times vary according to season with the earliest train leaving at 10 a.m. and the latest departing at 9:30 p.m. Dinner Train: Departs Hyannis depot at 6:30 p.m. daily, except Fri., 7 p.m.
Cost: Excursions (round-trip): Adults, $9; children (3-12 yrs.), $5; seniors (65+), $8. Dinner Train: $43.95 (does not include cocktails or gratuities).
For further information write to the Cape Cod Scenic Railroad, 252 Main St., Hyannis, MA 02601, or call (508) 771-3788.

WESTERN GATEWAY HERITAGE STATE PARK

This park contains a variety of restored railroad freight buildings. It is also the home of a museum depicting local historical events, including the construction of the Hoosac Tunnel.

For further information write to the Western Gateway Heritage State Park, c/o OCD, City Hall, North Adams, MA 01247.

MICHIGAN

THE COOPERSVILLE & MARNE RAILWAY COMPANY

This diesel-powered train (#7014, former Grand Trunk Western EMD SW-9 locomotive) pulls two "el" commuter coaches, three former Canadian National heavy coaches, and two cabooses (one circa 1895) on a 13-mile, ½-hour round trip through western Michigan farmland. The route was formerly a Grand Trunk Western route to the Muskegon and Grand Haven car-ferry boats.
 Season: June thru Sept., Sat. only; Oct. & Dec., weekends.
 Hours: Times vary. Be sure to contact the Railway Company.
 Cost: June thru Sept.: Adults, $7; children, $4. Oct. & Dec.: Adults, $9; children, $6.
 For further information write to the Coopersville & Marne Railway Company, P.O. Box 55, Coopersville, MI 49404, or call (616) 949-4778.

CROSSROADS VILLAGE & HUCKLEBERRY RAILROAD

Crossroads Village began in 1968 with the relocation of the Buzzell House to the Genesee Recreation Area. The Village officially opened in 1976 with 13 buildings on display, and is adding more each year. There are currently more than 30 buildings on display. The Village's goal is to duplicate the lifestyles of the late 1800s. Costumed craftspeople perform their folk arts, trades and daily chores of the period.
 The highlight of a Village visit is a trip aboard the steam-powered Huckleberry Railroad whose railroad bed was originally constructed in the mid-1800s by the Peré Marquette Railroad. The eight-mile, 35-minute trip runs through the scenic Genessee Recreation Area. The restored Baldwin coal-fired locomotive pulls wooden passenger cars (one dating back to 1875) that were originally used on railroads located in the western and southwestern United States and Mexico.
 In 1994, the Village acquired the Peré Marquette Caboose A621. The caboose, built in the 1920s, is standard gauge and now sits on original rails from the Peré Marquette line. It ran in Canada and Michigan and was in service until the 1960s.
 Locomotives currently on display at the Village (some running, some being restored) include the HRR#2, Baldwin 4-6-0 locomotive (originally U.S. #152), used by the Alaska Engineering Commission of Fairbanks, Alaska, on the Chatanika Branch of the Alaska Railroad; HHR#4, Baldwin 2-8-0, built 1904 No. 24306 and used in Mexico; HHR#464, Baldwin 2-8-2, originally used by the Denver & Rio Grande Railroad; Q&TL #3, Books 2-6-0, built 1894 for

HRR#2 engine from Crossroads Village.

Quincy & Torch Lake Railroad (this engine has the distinction of being one of a rare few which were built with canted steam chests); HRR#1203, H.K. Porter, C&C Trucks, six axles, 660 h.p., used by U.S. Gypsum, Plaster City, California; MW#5 (locomotive #5503, Plymouth Model JCD 4 Wheel, 36" gauge, built for American Smelting & Refining Co. in 1950).

Other pieces of railroad equipment on display include Coaches #8, built in 1875 by the Kimball Mfg. Co. for Northwestern Pacific Railroad; No. 9, built in the 1920s as No. 10 for the Camino, Cable & Northern Railroad; No. 20, built in the 1920s for the San Bernardino Orange Show and the Antelope & Western Railroad; No. 30 (built with No. 20); No. 40, built before 1880 by Harmond Car Company for the United Railways of Yucatan, Mexico; No. 42, built during the 1890s for the Orange Show and Early West Railways; No. 100, built late 1800s; No. 102, built in the 1890s; No. 260, built in 1896 for the Rio Grande Southern Railroad (the only new one they ever had); No. 306, built in 1881 by Jackson & Sharp for the Denver & Rio Grande Railroad; No. 320, built in 1882 by Jackson & Sharp; an unnumbered caboose, built in the 1890s; an 1890s Baggage RPO car; cars No. 104, 112, 114 built in 1979 and 1980 by the Huckleberry Railroad Shop on frames dating back to the 1920s; Caboose #0526, built in 1880; and more.

An interesting bit of folklore: the Fostoria Branch of the Flint and Peré Marquette Railroad has nearly always been known as the Huckleberry Line due to the rumor the train traveled so slowly that the passengers could get off, pick a handful of huckleberries and then reboard without being left behind.

Season: Summer, Fall (Mother's Day to end of Sept.) & Christmas season.

Hours: Summer, daily; Fall, weekends; Christmas, times vary. Museum is open 10 a.m. to 5:30 p.m. weekdays or 11 a.m. to 6:30 p.m. weekends and holidays. Train departures start at 11 a.m.

Cost: (Includes both Village and Railroad): Summer & Fall: Adults, $8.25; seniors (60+), $7.25; children (4–12 yrs.), $5.50; under 3, free. Fall & Christmas events are usually less.

For further information write to the Genessee County Parks & Recreation Commission, 5045 Stanley Road, Flint, MI 48506, or call 1-800-648-PARK or (810) 736-7100.

HENRY FORD MUSEUM & GREENFIELD VILLAGE RAILROAD

The Henry Ford Museum actually contains a variety of collections offered as one museum. One of the collections is the huge transportation museum containing railroading memorabilia. Greenfield Village is an outdoor museum covering more than 80 acres on which sit more than 80 historic buildings and the Greenfield Village Railroad and tracks.

Passengers ride the steam railroad around the grounds on a 20-mile, 2½-hour trip aboard their choice of a specially constructed open excursion car or an 1890 wooden coach.

Other equipment on display at the Village includes an 1858 Rogers 4-4-0 Locomotive; an 1876 Henry Ford Motor Co. 4-4-0 Locomotive #1; a 1902 Schenectady 4-4-2 Locomotive; a 1941 Lima 2-6-6-6 #1601 Locomotive; an 1893 replica of the "DeWitt Clinton"; a 1909, 2-8-0 Baldwin Locomotive; a 1923 Canadian Pacific snowplow; a 1925 Detroit, Toledo & Ironton caboose, and more.

Season and hours: Museum and Village: Daily, Jan. thru May and Sept. thru Nov., 10 a.m. to 5 p.m.; end of May thru Labor Day and Thanksgiving Fri., 9 a.m. to 5 p.m. Train: Daily, mid–April thru mid–Oct.; closed Thanksgiving and Christmas.

Cost: Museum and Village: Adults, $11.50; seniors, $10.50; children (5–12 yrs.), $5.75; under 5, free. Train: $2 for an all-day pass.

For further information write to the Henry Ford Museum & Greenfield Village, P.O. Box 1970, Dearborn, MI 48121, or call (313) 271-1620.

IRONWOOD DEPOT MUSEUM OLD DEPOT PARK

The Chicago Northwestern Railroad's Ironwood Depot was constructed in 1892 as both a passenger and freight train depot. It was most active during the iron mining boom days on the Gogebic Range, which ended in 1966. In the boom days ore trains transported ore from the Range to the ore docks in Ashland, Wisconsin. From there the ore was shipped to the steel mills in Illinois and Indiana.

MICHIGAN 69

Ironwood Depot—located in the Old Depot Park in downtown Ironwood, Michigan. The building is listed in the National Register of Historic Places. The Depot is being renovated into a museum that is open during the summer season. This picture was taken during the railroad's heyday in the early 1900s.

The depot is the last remaining depot on the Gogebic Range, and is currently being restored as an historical museum (although it is open to the public). Railway memorabilia is displayed along with mining and local historical displays. The building was placed on the National Register of Historic Places on January 13, 1985.

Season: Summers, starting Memorial Day. (Scheduled opening day, 1994.)

Hours: Noon–7 p.m., daily.

For further information write to the Old Depot Park, Ironwood Area Historical Society, P.O. Box 553, Ironwood, MI 49938, or call (906) 932-5576.

KALAMAZOO, LAKE SHORE & CHICAGO RAILWAY

This diesel-powered train takes passengers over a former Peré Marquette/Chesapeake & Ohio branch line through pastoral Michigan vineyard country. Passengers can choose between the "Scenic Train," a 12-mile, 1¼-hour round trip ride, and the "Wine Country Dinner Train," a two-hour lunch or three-hour dinner train. At the Paw Paw end of the line, passengers can visit two wineries which offer free tours and tastings.

The "Scenic Train" goes from Paw Paw to Bonamego Farm, where passengers may deboard to picnic or hike, and then return on a later train. The "Wine Country Dinner Train" features an elegantly served four-course lunch or dinner.

Season: Scenic Train: Daily, July thru Aug. and Oct.; weekends, April thru July and other times during the winter. Dinner Train: Year-round, Fri. & Sat. and occasional weekdays. Contact the Railway for schedule.

Cost: Scenic Train: Adults, $8; seniors, $7; children, $4. Dinner Train: Lunches, $35+; dinners, $49+.

For further information write to the Kalamazoo, Lake Shore & Chicago Railway, P.O. Box 178, Paw Paw, MI 49079, or call (616) 657-7037 or (616) 657-5963.

Leelanau Scenic Railroad

Diesel locomotives pull vintage coaches on this 140-mile round trip through Michigan's cherry country from Traverse City to Sutton's Bay, Michigan, and back. A two-hour layover at Sutton's Bay gives passengers a chance to watch the train being turned or go sight-seeing in the area. Passengers may choose a one-way trip or take advantage of special unscheduled train trips throughout the season. Be sure to contact the railroad for an accurate schedule.

Equipment used or owned by the railroad includes Diesel #148, an 1880s Barney & Smith coach, an elegant 1910 parlor car (including a sleeping compartment with mahogany interior and stained glass), three other 1910 coaches, and several 1880s boxcars and cabooses.

Season: Scheduled: mid-June thru Labor Day and last two weeks in Oct., Wed.-Sun.; mid-May thru mid-June & mid-Sept. thru mid-Oct., weekends.

Hours: Leaves Traverse City at 10 a.m. and Sutton's Bay at 2 p.m. for the return trip. Extra trains often leave Traverse City at 4 p.m.

Cost: Round-trip: Adults, $15; seniors, $14; children, $9. One-way: Adults, $12; seniors, $11; children, $6.

For further information write to the Leelanau Scenic Railroad, 10831 Carter Rd., P.O. Box 5317, Traverse City, MI 49685, or call (616) 947-6667.

"MICHIGAN STAR CLIPPER" DINNER TRAIN
COE RAIL

The COE Rail offers regular one-hour excursions and three-hour lunch or dinner excursions aboard the "Michigan Star Clipper." Plans call for special three-hour tours aboard vintage sleeping cars for family or group entertainment.

Standard gauge diesel locomotives used by the line include a 1945 Whitcomb

gas-drive engine, a 1947 ALCO S1 and a 1952 ALCO S1. Passenger cars used include 1917 coaches (former Erie Lackawanna), a 1947 tap car (former Milwaukee Road), 1920 baggage cars, 1945 bay-window cabooses, 1952 dining cars, a kitchen car and a power car.

Season: Year-round.

Hours: COE Rail: Mon.-Sat., 1 p.m. and 2:30 p.m. Star Clipper: Tues.-Thurs. & Sat., 7 p.m.; Fri., 7:30 p.m.; Sun., 5 p.m. A few special events are also offered at other times.

Cost: COE Rail: Adults, $6; seniors (65+), $5; children (2-10 yrs.), $5. Star Clipper: Adults, $52.50; special entertainment runs, $67.50.

For further information write to the COE Rail, 840 N. Pontiac Trail, Walled Lake, MI 48390, or call (810) 960-9440.

MICHIGAN TRANSIT MUSEUM TROLLEY TRAIN RIDES & RAILROAD DEPOT MUSEUM

The Michigan Transit Museum (MTM) was established in 1973 as a museum for all types of transportation systems and equipment. Railroading history and equipment seem to be the biggest part of their emphasis, however, with the Museum itself being located in an 1859 depot which was built for the Chicago, Detroit & Canada Grand Trunk Junction Railway.

It was at this historic depot that a young Thomas Edison saved the life of the station agent's small child who was on the track in the path of a runaway box car. In gratitude, the station agent taught Tom telegraphy, on which he based many of his earliest inventions.

The depot was in use until 1980, when the city of Mount Clemens bought it and leased it to the Michigan Transit Museum for use as its headquarters and museum. The museum has restored the depot to its 1900 appearance and exhibits displays and memorabilia from that era. A gift shop is also on the premises. The train depot/museum is NOT the depot for the Trolley-Train ride, however. It departs from the caboose station on North Gratiot Avenue nearby and offers visitors a 45-minute ride through a variety of sceneries—both urban and rural.

The equipment roster includes Locomotive No. 1807, built in 1941 by the American Locomotive Company as a yard switcher. It was later sold to the US Army and worked at Ft. Bragg, North Carolina, until sold to the M.T.M. "El" cars #4442 and #4450, now at the museum, were built in 1924 by the Cincinnati Car Company for the Chicago Transit Authority where they were used until 1974. They were acquired by the M.T.M. in 1976. Caboose No. 77058 was built near the turn of the century for the Grand Trunk Railroad and saw service over most of that system.

Today, the diesel locomotive functions as a 600-volt generator, eastbound. Traction motors are shut down and electrical power is transmitted

to the "El" cars by cable, giving the motorman control of the train. At the east end of the trip, however, the diesel locomotive takes over, running the train in the normal fashion, and the engineer has control of the train.

Season: Sundays only, last Sun. of May thru last Sun. of Sept.

Hours: Train leaves the caboose ticket office at 1 p.m., 2 p.m., 3 p.m. and 4 p.m.

Cost: Museum admission is free (donations appreciated). Train ride only: Adults, $5; children (4-12 yrs.), $2.50; under 4, free. (If passengers choose to stop at the nearby Air Museum, adults must add $.50 to the cost of their tickets, children add $.25.)

For further information write to the Michigan Transit Museum, P.O. Box 12, Fraser, MI 48026, or call (819) 307-5035.

THE OLD ROAD DINNER TRAIN & EXCURSION TRAIN
ADRIAN & BLISSFIELD RAIL ROAD

The Adrian & Blissfield Rail Road travels on a segment of the Erie & Kalamazoo Railroad which began operations in 1836 as the first railroad west of the Allegheny Mountains. Regular excursions take passengers on a 1½- to 2-hour round trip through the rich farmland of Southeastern Michigan, while the dinner trains offer a more leisurely 2- to 2½-hour ride. The Murder Mystery Dinner Train ride lasts approximately 3 hours and includes a four-course meal along with the murder mystery. Reservations are required for all Dinner Trains.

Season: Year-round.

Hours: Hours vary greatly according to excursion chosen. Dinner trains usually board at 6 p.m., departing at 7 p.m. on weekends. Regular excursions generally depart at 2 p.m. Tues., Thurs., Sat., and Sun.

Cost: Regular excursions: Adults, $7.50; seniors (60+), $6.50; children (3-12 yrs.), $4.50. Dinner Trains range in price from $45.95 to $57.95. Special events fares vary.

For further information write to the Old Road Dinner Train, Adrian & Blissfield Rail Road, P.O. Box 95, Blissfield, MI 49228, or call (517) 486-2141 (for reservations) or (517) 486-5979.

SOUTHERN MICHIGAN RAILROAD SOCIETY

The Society operates an indoor museum during the same hours that train rides are offered. The rides take passengers over two parts of the former Clinton Branch of the New York Central Railroad on a two-hour, 4½-mile round trip from Clinton to Tecumseh. Fall Color Tours are two-hour, six-mile round

trips between Tecumseh and Raisin Center. All rides cross over a number of trestle bridges, which offer panoramic views, especially beautiful in the Fall.

Equipment used by the Society includes a Plymouth diesel, a former South Shore commuter car, a gondola and cabooses.

Season: June thru Sept., plus weekends in Oct.

Hours: Summer: Daily, 11 a.m., 1 p.m. and 3 p.m. Fall Color Tours (weekends in Oct.): 11 a.m., 1:30 p.m. and 4 p.m. Different trains depart from Clinton or Tecumseh, and hours vary according to excursion chosen. Be sure to contact the Society well in advance.

Cost: Summer & Clinton Fall Festival: Adults, $6; seniors (65+), $5; children (2-12 yrs.), $4. Fall Color Tours: Adults, $9; seniors, $8; children, $6.

For further information write to the Southern Michigan Railroad Society, P.O. Box K, Clinton, MI 49236-0009, or call (517) 423-7230 or (517) 456-7677.

TOONERVILLE TROLLEY & RIVERBOAT TRIP

This historic wilderness tour began operation in 1927 when the owners took visitors over a 5½-mile section of track (left over from logging days) to a picturesque part of the Tahquamenon River. The original track was a standard size, and a Model T truck was fitted with train wheels to transport visitors to a riverboat for a 21-mile cruise to an area near the Tahquamenon Falls. Around 1930, the riverboat "Betty B," along with a barge named the "Hiawatha Floating Cafeteria," joined the team, improving the facilities by adding a nicer cafeteria and dance facilities.

Also around 1930, the railroad track was converted to narrow gauge and a train engine was purchased from a copper mine to pull the open cars. Further improvements have been made and now the completed tour takes approximately 6½ hours.

Three engines are currently on the equipment roster—two Plymouth 5-ton w/cat D311 Diesel engines and one gas-powered engine (built in the late 50s). Open cars are still used, but cars are enclosed after Labor Day. A depot, coffee and gift shop are also on the premises.

Season: Mid-June thru early Oct.

Hours: Trolley leaves Soo Junction at 10:30 a.m. daily and returns at 5 p.m.

Cost: (includes round-trip trolley & boat rides): Adults, $15; children (6-15 yrs.), $7; under 6, free.

For further information write to the Toonerville Trolley & Riverboat Trip, Tahquamenon Boat Service, Inc., R.R. 2, Box 938, Newberry, MI 49868.

MINNESOTA

THE BUDD CAR/ NORTH SHORE SCENIC RAILROAD

The Budd Cars, unusual self-propelled coaches built by the Budd Co. and used for passenger transportation along the Lakefront Line in the 1950s, are today being used for passenger excursions. In addition to historic tours that follow the same route as the Lake Superior and Mississippi Railroad, the Budd Cars offer trips to Two Harbors for a view of the ore docks and railyard there, and to the harbor and fishing village at Knife River.

The Duluth-Lakefront tour is a one-hour round trip excursion. The Duluth-Two Harbors tour is a five-hour round trip excursion which offers a two-hour layover option in Two Harbors to eat, shop and visit historic sites. The Two Harbors-Knife River tour is a one-hour round trip excursion.

Season and hours: Duluth-Lakefront tour runs Mon.-Thurs., leaving at 9:30 a.m., 11 a.m., 12:30 p.m., 2 p.m. and 3:30 p.m. Duluth-Two Harbors tours run Fri. only, leaving at 10 a.m. The Two Harbors-Knife River tour runs on Sat. and Sun., leaving at 10 a.m., 11:30 a.m., 1 p.m., 2:30 p.m. and 4 p.m.

Cost: Duluth-Lakefront tour and Two Harbors-Knife River tour. Adults, $6; seniors, $5 children (0–12 yrs), $4. Duluth-Two Harbors tour: Adults, $12; seniors, $11; children (0–12 yrs.), $8.

For further information write to the North Shore Scenic Railroad, 506 W. Michigan St., Duluth, MN 55802, or call (218) 722-1273.

DULUTH-LAKEFRONT TOUR

A Great Northern diesel engine built in 1966 and known as the "Hustle Muscle" takes passengers on a scenic one-mile, 1½-hour trip along the Lake Superior shore and around east Duluth aboard vintage passenger cars. Trains operate from the Lake Superior Museum of Transportation depot and use the Lakefront Line, built in 1886. A steam locomotive is being restored for future use on the tours. The museum also offers trolley rides and historic railroad exhibits. Special excursions are offered throughout the year.

Season: Summer.

Hours: Sat. at 10 a.m., noon, 2 p.m. and 4 p.m.; Sun. at noon, 2 p.m. and 4 p.m. thru Aug.

Cost: Adults, $6; seniors, $5; children 12 & under, $4.

For further information write to the Lake Superior Transportation Museum, 506 W. Michigan St., Duluth, MN 55802, or call (218) 727-0687.

LAKE SUPERIOR & MISSISSIPPI RAILROAD

The Lake Superior & Mississippi Railroad offers passengers a 12-mile, 1½-hour round trip over trackage first laid in 1870 by the Lake Superior &

Mississippi Railroad, which later became part of the Northern Pacific and the Burlington Northern. The trip is sponsored by the Lake Superior Museum of Transportation.

Equipment used on the railroad includes Locomotive #46 (a 1946 GE 45-ton diesel), two heavyweight coaches from the Duluth, Missabe & Iron Range, an open observation car, and a caboose.

Season: Early July thru early Sept.

Hours: Weekends, 11 a.m. and 2 p.m.

Cost: Adults, $5; seniors (60+), $4; children (under 13), $3.

For further information write to the Lake Superior & Mississippi Railroad, c/o Lake Superior Museum of Transportation, 506 West Michigan St., Duluth, MN 55802, or call (218) 727-8025 or (Seasonal) (218) 624-7547 or (218) 727-0687.

LAKE SUPERIOR MUSEUM OF TRANSPORTATION
DULUTH UNION DEPOT

The Lake Superior Museum of Transportation is housed in the former Duluth Union Depot and is part of the St. Louis County Heritage & Arts Center. The North Shore Scenic Railroad station is adjacent to the Center.

A great number of pieces of rolling stock are uniquely displayed along with numerous pieces of railroading artifacts and memorabilia. Some of the pieces of equipment at the museum include: Great Northern's famous "William Crooks" locomotive; Great Northern's #400 engine, the first production-model SD-45 diesel; Northern Pacific's first engine, the "Minnetonka"; the Duluth, Missabe & Iron Range 2-8-8-4, #227, displayed with revolving drive wheels and recorded sound; several cars from the 1860s era; an 1887 steam rotary snowplow; a Railway Post Office Car; and much more.

The museum sponsors several excursions throughout the year with different railroads. Be sure to contact them before visiting for an accurate list of excursions scheduled.

Season: Year-round, daily.

Hours: Mid-May thru mid-Oct., 10 a.m. to 5 p.m.; mid-Oct. thru mid-May, Mon.-Sat., 10 a.m. to 5 p.m.; Sun. 1 p.m. to 5 p.m.

Cost: Adults, $5; children (3-12 yrs.), $3; under 3, free; family rate, $15. (Cost includes admission to Heritage & Arts Center.)

For further information write to the Lake Superior Museum of Transportation, 506 W. Michigan St., Duluth, MN 55802, or call (218) 727-0687 or (218) 727-8025.

MAHONING VALLEY RAILROAD HERITAGE ASSOCIATION

Founded in 1985, this association aims to preserve the railroading history of the Mahoning Valley, including greater Youngstown and Warren, Ohio.

Railroads having once served or now serving this area include the Baltimore & Ohio, the Erie, the New York Central and the Pennsylvania Railroads.

Equipment on the roster includes Locomotive #301, a 1915 Baldwin 0-6-0, former Youngstown Sheet & Tube Co.; two troop sleepers (now converted to camp cars); a motor car; a cabin car from PRR; a caboose and several other units once used in the steel industry in the area.

Season and hours: By appointment only, except for #301 which can be seen anytime.

Cost: No charge except during fair days (early Sept.) or other special events.

For further information write to the Mahoning Valley Railroad Heritage Association, P.O. Box 3055, Youngstown, OH 44511, or call (216) 568-0328.

MINNESOTA TRANSPORTATION MUSEUM MINNESOTA ZEPHYR LIMITED THE STILLWATER DEPOT & EXCURSIONS

Excursion passengers visiting the Stillwater Depot, an historic logging and railroad museum, can choose a variety of railroading options. Visitors can choose to eat on the train as it remains stationary in the depot, take a casual three-hour luncheon journey along the river, streams and woodland bluffs of the area, or simply take a 1½-hour round trip excursion.

All passengers who choose to ride will travel over seven miles of track (one-way) originally laid by the Stillwater and St. Paul Railroad over 120 years ago and later acquired by the Northern Pacific Railroad. Those who choose the classic blue and silver Minnesota Zephyr will enjoy a leisurely three-hour meal while the train travels over the branch until stopping at Duluth Junction where it prepares for its journey back to Stillwater (the birthplace of Minnesota).

The Minnesota Zephyr is powered by two 1951 diesel electric locomotives, one at each end of the train—No. 788, a 1,750 hp FP9 unit, and No. 787, a 1500 hp F7 unit. Also on the train, passengers can ride the Grand Dome car, the St. Croix Dome Club Car, and the Northern Winds car. The Grand Dome was built in 1938 by the Southern Pacific Railroad, who also refurbished it in 1954. It is a one-of-a-kind, 80 ft. glass domed car which seats 48 passengers. The St. Croix, at the opposite end of the train, seats 24 passengers. The Northern Winds car was built in 1949 and is one of five restored dining cars used by the Zephyr. Locomotive No. 328, a 1907 steam engine originally used on the branch line and later restored by the museum, is stoked up for special occasions.

Passengers on the 1½-hour excursion ride in coaches from the '20s and '40s which are pulled by diesel engines acquired from Burlington Northern.

Season: Summers, thru Oct. (and some holidays).

Hours: Times vary according to trip chosen, with earliest excursion

MINNESOTA 77

starting at 10 a.m. and latest one at 4 p.m. Zephyr luncheon train boards at 11:30 a.m., departing at noon. Send for Train Schedule for details.
 Cost: Excursion: (Round trip) Adults, $6; children, $4; seniors, $4. Minnesota Zephyr: $47.50.
 For further information on excursions contact the Minnesota Transportation Museum, P.O. Box 1796, Pioneer Station, St. Paul, MN 55101, or call (612) 228-0263. For the Minnesota Zephyr write to 601 N. Main St., P.O. Box 573, Stillwater, MN 55082, or call 1-800-992-6100 or (612) 430-3000 for reservations.

NORTH STAR RAIL, INC.

The North Star Rail operates day-long standard gauge steam-powered excursion rides over various railways. All trips are aboard air-conditioned coaches, most of which are first-class cars of various makes and descriptions.
 The locomotive used by the railway is #261, a 1944 ALCO 4-8-4, former Milwaukee Road, leased from the National Railroad Museum in Green Bay, Wisconsin.
 Season, hours and cost: Vary according to excursion chosen. Be sure to check with the railway well in advance of your visit.
 For further information write to North Star Rail, Inc., Firststar Financial Center, Suite 800, 1550 East 79th St., Bloomington, MN 55425, or call (612) 858-8859.

OSCEOLA & ST. CROIX VALLEY RAILWAY
(see "OSCEOLA & ST. CROIX VALLEY RAILWAY" in Wisconsin)

RAMSEY & DAKOTA COUNTY HISTORICAL TOURS

The Ramsey and Dakota County Historical Societies jointly sponsor a number of historic railfan tours, all departing from Minneapolis-St. Paul. Included are the Circus & Wisconsin Dells tour, the River and Rail to Galena tour, and the St. Croix River Valley tour.
 In July, a 14-mile St. Croix River Valley tour takes passengers on a vintage train ride through the St. Croix countryside, stopping for lunch at the Dock restaurant in Stillwater, a tour of the Fillebrown House (1879) at White Bear Lake, and a tour of original Swedish immigrant homes at Scandia.
 In August and September the societies offer the River and Rail to Galena tour—a combination paddlewheel boat-Amtrak overnight tour which allows several stops for historic sightseeing.

In September, the Circus & Wisconsin Dells tour leaves on Saturday by bus, and returns on Sunday by Amtrak. Highlights include a circus performance, the Ringling Bros. Museum at Baraboo, Wisconsin (trains on exhibit), a double-decker boat tour of the Upper Dells, a steam train ride in the Baraboo River Valley and visits to an antique railway museum and the Norman Rockwell Museum of Art.

For further information about any of these tours (or others) write to Ramsey County Historical Society, 323 Landmark Center, 75 W. 5th St., St. Paul, MN 55102, or call (612) 426-3238 (between 9 a.m. and 1 p.m.).

MISSISSIPPI

CASEY JONES RAILROAD MUSEUM STATE PARK

The world's most famous railroad engineer is remembered at this museum operated by the Division of Parks and Recreation, Mississippi Dept. of Wildlife, Fisheries and Parks. An old railroad depot moved here from Pickens, Mississippi, now houses the museum, which is located less than a mile from the scene of the famous wreck. The museum contains several exhibits showing the importance of railroading in the history of Mississippi, along with Casey Jones memorabilia.

Parked on a specially built siding adjacent to the museum and the mainline of the Illinois Central Gulf Railroad is steam locomotive No. 841, built in 1923 by the American Locomotive Works. This locomotive sits as a monument both to railroading in general and especially to the engine that transported Johnathan Luther "Casey" Jones into immortality on April 30, 1900.

Season: Year round.
Cost: A small admission fee is charged.
For further information write to the Division of Parks and Recreation, Mississippi Dept. of Wildlife, Fisheries and Parks, P.O. Box 451, Jackson, MS 39205-0451.

CORINTH, MISSISSIPPI, TRAIN DEPOT

The railroads actually determined the location of Corinth, originally known as Cross City, because it was there that the longest railroads in the nation intersected and crossed in the 1860s. The railroads were the Memphis & Charleston Railway and the Mobile & Ohio Railroad. That intersection and the battlesite of the Civil War's "Battle of Shiloh" can be seen from the main waiting room of the depot. The Battle, of course, was fought because of the town's location at this important railroad junction.

The original depot was destroyed, but this building was built in 1919, and exists today very much as it stood then. In 1991, the MidSouth Railroad Corporation gave over ownership of the Corinth Depot, one of Corinth's most historic landmarks. Plans call for further renovations and improvements as funds become available. Tours are available by appointment only.
For further information call (601) 287-5269.

MISSOURI

BRANSON SCENIC RAILWAY
BRANSON DEPOT

The Branson Scenic Railway offers a choice of two different trips. Both trips board at the historic 1906 Branson Depot and take approximately 1½ hours to cover more than 40 miles of beautiful Ozark Mountain countryside. The trackage is owned by the Missouri & North Arkansas Railroad (former Missouri Pacific). The Northbound train passes through a tunnel, crosses the James River, travels through the countryside, then returns. The Southbound train crosses Lake Taneycomo, two high trestles, goes through two tunnels and through part of the Arkansas Ozarks.

Passengers can regularly ride on one of several coaches—the "Silver Solarium" (dome/observation/lounge), the "Silver Palace" (dome/lounge), the "Silver Garden" (dome/lounge/buffet/coach), the "Plaza Santa Fe" (dome/lounge) or a lounge car. Several special events (including all-day excursions) are scheduled throughout the season. Be sure to contact the Railway before visiting.

Since Branson is considered to be the live-entertainment capital of the nation, the Branson Scenic Railway can become part of a wonderful vacation in the area.

Season: March thru Oct. and some runs in Nov. and Dec.
Hours: March & April, Thurs.–Mon., 8:30 a.m., 11 a.m. & 2 p.m.; May thru Oct., Wed.–Mon., 8:30 a.m., 11 a.m., 2 p.m. and 4:30 p.m.
Cost: Adults, $17.50; seniors, $16.50; children, (3–11 yrs.), $9.75. Special events fares vary.
For further information write to the Branson Scenic Railway, 206 East Main St., Branson, MO 65616, or call 1-800-2-TRAIN-2 or (414) 334-6110.

NATIONAL MUSEUM OF TRANSPORT

The National Museum of Transport was founded in 1944 with the acquisition of the 1880 mule-drawn streetcar, the "Bellefontaine." Among other acquisitions,

the museum acquired the historic Barretts tunnels constructed in 1951-53 by the Pacific Railroad, along with 39 acres of land upon which the museum located permanently. Under the St. Louis County Parks and Recreations Dept., the museum has continued acquisition of land and equipment, and even offers educational and preservations programs.

Sixty-five locomotives highlight the more than 150 years of rail transportation history depicted in the museum's exhibits. The equipment roster includes the entire "Purdue" Collection with its "Eddy Clock," and a B&O "Davis Ten Wheeler" engine.

Season: Year round (closed Thanksgiving, Christmas and New Year's days).

Hours: Daily, 9 a.m. to 5 p.m.

Cost: Adults, $4; seniors (65+), $2; children (5-12 yrs.), $2.

For further information write to the National Museum of Transport, St. Louis County Dept. of Parks and Recreation, 3015 Barrett Station Road, St. Louis, MO 63122-3398, or call (314) 965-7998.

SMOKY HILL RAILWAY

The Railway's standard-gauge diesel engine pulls a passenger train over the original 1871 route of the Kansas City, Osceola & Southern railroad, approximately five miles south of the Santa Fe Trail. The trackage was formerly the Frisco line, which acquired the property in 1921. The eight-mile, one-hour round trip takes passengers from downtown Belton, through scenic Missouri farmland, along the western Missouri high ridge, and back.

The engine used by the Railway is a 1952 Baldwin SW-12 diesel, former Rock Island E-6 #630. Passengers can ride in a 1920 open-window coach (former Erie-Lackawanna), the 1920 parlor car "City of Peru" (former Wabash Cannonball), or a 1969 former Santa Fe caboose.

Other pieces of equipment on display include Locomotive #5 (a 1923 ALCO 2-8-0, former Okmulgee Northern); a 1918 Baldwin "Russian" Decapod 2-10-0; a former Rock Island "Rocket"; a 1952 Baldwin SW-12 (former Army switcher); No. 3 business car "Oklahoma" (former Frisco); a 1920 open-window coach; an observation-instruction car from the Santa Fe line; a 1940 tavern-lounge-observation car (#55, "Hospitality"); the "Southern Belle" (former Kansas City Southern); other cabooses, tank cars, wood refrigerator cars, and much more.

Besides the regularly scheduled excursions on the season's weekends, several special events are scheduled, including the beautiful "Fall Foliage Specials." Be sure to check on reservations before visiting.

Season: April thru Oct.

Hours: Weekends only. Hours vary, so be sure to contact the railway before visiting.

Cost: Adults, $6; seniors (55+), $4.50; children (under 12), $4. Special events fares vary.

For further information write to the Smoky Hill Railway, 502 South Walnut, Belton, MO 64012, or call (816) 331-0630.

ST. LOUIS IRON MOUNTAIN & SOUTHERN RAILWAY CO.

The only steam-powered tourist train in the state of Missouri, the St. Louis Iron Mountain & Southern Railway Co. offers visitors a choice of sightseeing or dinner trips. Most sightseeing trips last 1½ hours while the dinner trips run for two hours. A variety of special sightseeing excursions are offered throughout the year, including Indian attacks, train robberies, Murder Mysteries (five hour trip) and much more.

The track used is a spur off the Belmont Branch of the actual St. Louis Iron Mountain & Southern Railway (formed over 135 years ago and later known as the Missouri Pacific) that connected St. Louis, Missouri, to Little Rock, Arkansas. The IM&SR also carried Union troops to Pilot Knob for the battle of Fort Davidson.

At the train site is a newly remodeled depot that now houses the ticket office, gift shop, Whistle Stop Soda Shoppe and railroad memorabilia displays.

On the Saturday evening dinner excursion, passengers ride aboard several 1920s passenger cars which are pulled by steam engine No. 5, an H.K. Porter built in 1946 in Pittsburgh, Pennsylvania. It is a coal-fired, steam-powered engine, with 2-4-2 wheel alignment (one of the last to compete with the newer diesels at that time). The coach cars were built for Illinois Central's Commuter Service in Chicago. The tender used on the longer trips was built in 1910 and is the oldest part of the train. Also on the equipment roster are two cabooses and a diesel engine. One caboose, a 1929 cupalo Caboose, was donated by the Missouri Pacific Railroad, and the other is a 1971 Chessie System bay window caboose. (Both can be rented for parties.) Although most excursions are pulled by the steam-powered locomotive, a diesel locomotive (a 1951 Baldwin-Lima-Hamilton-Whitcomb) is used in the winter months when the old steam locomotive undergoes routine maintenance.

Season: Weekends, April thru Oct., plus special charters and special trips. Nov. thru March, Sat. 12:30 p.m.

Hours: Sat. 11 a.m., 2 p.m. and 6 p.m. Dinner train: Sun. 1 p.m. and 3 p.m.; Wed. 1 p.m. Write for information about other special excursions.

Cost: Sightseeing tours: Adults, $8; children (3–12 yrs.), $4. Dinner train: Adults, $22, children, $16. Excursion to Dutchtown: Adults, $12; children, $6. Murder Mystery: Adults, $34.50; children $29.50; children under 2 are free, but it is suggested they not participate in the Murder Mystery excursion.

For further information write to the St. Louis Iron Mountain & Southern Railway Co., (Highway 61 N.), P.O. Box 244, Jackson, MO 63755, or call 1-800-455-RAIL or (314) 243-1688.

St. Louis Iron Mountain & Southern Railway Co.

MONTANA

THE LAST CHANCE TOUR TRAIN

The Last Chance Tour Train does not run on a track. The tour train leaves the Montana Historical Society building at 6th and Roberts in the Capitol Complex every day to tour historic sites in Helena, Montana.

Although not an official rolling stock train, we have included the Last Chance in this book in order to include the RAILROAD FAIR that is held in Helena in mid-April. Call (406) 443-0287 for more details.

Season: May 15 thru Labor Day.
Hours: Daily and hourly from 9 a.m. to 6 p.m.
Cost: Adults, $4.50; children (2-12 yrs.), $3.50; seniors (65+), $4.
For further information about the Last Chance Tour Train write to the Last Chance Tour Train, Helena, MT, or call (406) 442-1023.

Neversweat & Washoe train one mile west of Butte, MT.

NEVERSWEAT & WASHOE RAILROAD ROCKER DEPOT & YARD

The Neversweat and Washoe Railroad began operations in 1986 using an old inspection car (M-10) as a 24-passenger tour coach, and running over two miles of track. When Blue Range Engineering took over in 1992, they rebuilt former smelter cars and a locomotive and began operating from the former Rocker yard, three miles west of Butte, to the Kelley mine on the edge of the Berkely open-pit copper mine. The 1-hour, 15-minute ride includes stops for sight-seeing at the World Museum of Mining, the Montana Tech Mineral Museum, and the Anselmo Mine Industrial Park. Spectacular views of Butte and the Continental Divide can also be seen.

In 1993, the Federal Railroad Administration said that the equipment originally built for smelter use was not standard railroad rolling stock, and shut down the railroad. In June of 1994, however, waivers were finally obtained for using the unique locomotive and cars, and the railroad now runs on five miles of the Missoula Gulch Branch of the former Butte, Anaconda and Pacific track in Butte, Montana. (The BA&P was a standard-gauge line that operated from 1893 until 1981, hauling ore and supplies for the mines in Butte and the smelter in Anaconda. It was the first major electrified railroad in the United States.)

1928 Porter 0-6-OT in Rocker, being pulled by Whitcomb #25 before painting.

Equipment on the roster now includes a 1950 Whitcomb 20-ton diesel-electric locomotive, the M-10 inspection car, four open-top smelter cars and a 1928 Porter 0-6-OT steam locomotive. The M-10 was built in the 1920s by the BA&P to inspect and maintain the trolley wire along the line and is used in bad weather. The four open-top smelter cars are used in nice weather. The Porter locomotive (last used in 1985) was donated by Western Sugar in Billings, Montana.

Other improvements are slated to be made, and funds have been secured to renovate the Rocker depot and yard for the 1995 season. (In 1994 the railroad operated as a "research project" to determine the best operating strategy to be used. The following information is what they expect to do in 1995.)

Season: Memorial Day into September (as weather and demand permit). Passengers may board at the Mining Museum or in Rocker.

Hours: Late morning to early evening.

For further information write to the Neversweat and Washoe Railroad, c/o Blue Range Engineering Co., Inc., 56 E. Mercury St., Butte, MT 58701, or call (406) 782-9354 or Fax (406) 782-9354.

NEBRASKA

FREMONT ELKHORN VALLEY RAILROAD
THE FREMONT DINNER TRAIN

The Fremont Elkhorn Valley Railroad began as the Fremont Elkhorn and Missouri Valley Railroad. Its trains were the first to reach into the Black Hills where a westward extension of the line terminated near Yellowstone Park in western Wyoming. (The Line nearly became a transcontinental routing following a merger with the Chicago and Northwestern Railway in 1903). On a typical excursion today, passengers cross an historic Indian road, the route of Maj. Stephen Long's 1820s western military expedition and the 1840s Mormon Trail.

Besides visiting the old Fremont depot (where a museum and souvenir shop are located), visitors can tour Hooper's 1890s Main Street, which is listed as an historic district on the National Register of Historic Places.

Along with their various regular excursions, the FEVRR also offers the well-known Fremont Dinner Train which operates from Fremont to Hooper, Nebraska—a 30-mile round trip excursion through the beautiful Elkhorn Valley—on weekends and holidays.

Listed on the FEVRR equipment roster are several rail cars dating from the 1920s which are used for regular excursions. The 40s era Dinner Train operates two dining cars—the Elkhorn River Car and the Maple Creek. The Elkhorn River Car was built in 1947 by Pullman Standard Co. for the Illinois Central Railroad, who later sold it to the Rock Island Railroad where it was converted into a diner. It has been kept as historically accurate as possible. The Maple Creek car is a 1942 product of Canadian National Railways, later used by the VIA Rail (Canada's national intercity passenger train service). It has been remodeled into a bar/dining car, but its Canadian heritage has been retained.

Season and hours: Vary according to excursion chosen. Basically, weekends April thru October. Reservations are recommended.

Cost: Vary according to excursion chosen, with prices ranging from $6.75 for children up to $12.75 for adults. Dinner train: $37.95 per person (plus tax and gratuity).

For further information about any of the excursions write to Fremont & Elkhorn Valley Railroad, 1835 N. Somers Ave., Fremont, NE 68025, or call 1-800-942-RAIL (7245) or (402) 727-0615.

NEVADA

THE GHOST TRAIN OF OLD ELY
NEVADA NORTHERN RAILWAY MUSEUM
"The Last Bonanza Railroad"

By 1902 extensive copper deposits had been found around Ely, Nevada. Mark Requa, owner of the Eureka & Palisade Railroad (a narrow gauge connecting the mining area of Eureka with the Central Pacific Railway at Palisade) soon organized the White Pine Copper Company and saw a need for extending his track. After several consolidations and mergers, construction of the Nevada Northern Railway began in September of 1905. The railroad continued to grow and ran successfully until the 1920s when Pullman passenger service was discontinued. Regular passenger and freight services continued until 1948 when dieselization of ore trains began. More services were discontinued throughout the years until the last NNR freight train shut down in June of 1983.

As soon as the train service shut down, the White Pine Chamber of Commerce began working to save some of the historic Nevada Northern Railway properties. Eventually the White Pine Historical Railroad Foundation, Inc., was organized to oversee donations of the East Ely Depot and General Office Building, the old NNR Freight Warehouse, Dispatcher's Office, yard tracks and locomotive #40 and her train. Once her foundation was formed, further donations were received, including over 32 miles of former Nevada Northern Railway trackage, the complete East Ely complex of machine shops, roundhouse, yards and rolling stock, the McGill Depot and all historic buildings on the mainline between Ely and Cobre, including the quaint Cherry Creek Depot. The majority of donations were made by the Kennecott Corporation to the White Pines Historical Railroad Foundation for operation of a working railroad museum.

In September of 1986, Engine #40 was steamed up for the first time since 1964 and was found to be in perfect mechanical condition. The newly dubbed "Ghost Train of Old Ely" thus began operations in 1987 on the donated railway. Several different excursions are now being offered. All buildings on exhibit at the site appear just as they did when the facility originally opened in 1907.

The Nevada Northern Railway Museum offers guided, 45-minute walk thru tours of the railroad facility and its historical artifacts. These tours include the buildings mentioned above, as well as more than 90 pieces of historic rolling stock of steam, diesel and electric locomotives and turn-of-the-century passenger and freight cars and memorabilia.

Steam locomotives on the roster include #40, a 4-6-0 1910 Baldwin (in operation): #81, a 2-8-0 1917 Baldwin (being restored); and #93, a 1-8-0 1909 Alco/Schen. (in operation). Diesel locomotives listed include #105, a 1948

RS-2 ALCO; #109, a 1952 RS-3 ALCO (in service); #310, a 1950 0-4-0 GE (industrial switcher, in service); #801, a 1943 VO Baldwin (ex-B&G #301); #802, a 1952 S-12 BHL (ex-NYC #9313). Both #801 and #802 are stored, but are serviceable. Two electric locomotives are on the roster: #80, a 1937 B-B GE (stored); and #81, a 1948 BB GE (stored). Passenger Cars include the A-2, a 1908 St. Louis coach; #05 and #6, 1886 Pullmans; #5, an 1897 Pullman (formerly named "Silesia"); #20, a 1907 rpo-bag ACF; and #1030, a 1942 ACF dining car (formerly U.S. Army #8733 troop kitchen). Other equipment includes a steam hoist and rotary snow plow from 1907, several cabooses and over 70 freight cars built from 1900 to 1917.

Season: Mid-May thru mid-Sept.

Hours: Museum Tours begin 9 a.m., 11 a.m., 1:30 p.m. and 3:30 p.m. Train schedules vary according to excursion chosen.

Cost: Museum Admission & Tour: $2.50 per person; under 10, free. Train ride costs vary according to excursion chosen.

For further information write to Nevada Northern Railway Museum, (Avenue A at 11th St. East), P.O. Box 150040, East Ely, NV 89315-0040, or call (702) 289-2085.

NEVADA STATE RAILROAD MUSEUM

The Nevada State Railroad Museum offers steam train excursions and motor car rides, along with hand car races, lectures, an annual railroad history symposium, changing exhibits and a variety of special events. Over 50 pieces of railroad equipment are in use or on display, including five steam locomotives and several restored coaches and freight cars. Most of the equipment was originally owned by the Virginia & Truckee Railroad, "America's richest and most famous short line."

Steam locomotive No. 8 is the primary 4-4-0 locomotive used in operations by the Museum. Originally built in 1888 by the Cooke Locomotive & Machine Co. for the Denver Texas & Fort Worth Railroad (then No. 9). It has been in several major movies including the 1939 classic *Jesse James* and the more recent *Gambler* with Kenny Rogers. Other locomotives at the museum include the Virginia & Truckee No. 25 (built in 1905 by the Baldwin Locomotive Works), the Virginia & Truckee Locomotive No. 22 (built in 1875 by the Baldwin Locomotive Works, this is currently the oldest presently operating steam locomotive in North America). No. 22 has also been in several movies.

Virginia & Truckee coaches #9 and #10, built by the Kimball Manufacturing Co. of San Francisco in 1873, worked in caboose and third class passenger service for years, and have been in a few movies. Coach #8, originally built as #1 for the then Virginia City & Truckee Railroad, was built in 1869 by the V&T shops in Virginia City. The museum's third caboose, the Nevada Copper Belt Caboose No. 3, was probably built in 1906-07. Several Flat Cars are also on the roster, mostly from the V&T line, along with one Motor Car No. 401 (Washoe Zephyr No. 50).

Season: Museum: Year-round, Wed.–Sun. Excursions & rides: Weekends, Memorial Day weekend thru Labor Day weekend, with special Oct. and Dec. events.
Hours: Museum: 8:30 a.m. to 4:30 p.m. Rides: Vary (send for an Operating Schedule).
Cost: Museum: $2 per person; under 18, free. Motor Car: Adults, $1; children (6–11 yrs.), $.50; 5 and under, free. Trains: Adults, $2.50; children (6–11 yrs.), $1; 5 and under, free.
For further information write to the Nevada State Railroad Museum, 2180 S. Carson St., Carson City, NV 89701, or call (702) 687-6953.

VIRGINIA & TRUCKEE RAILROAD COMPANY

This steam operated, standard gauge railroad offers passengers a five-mile round trip from Virginia City to Gold Hill, traveling through the historic Comstock mining region of Nevada. This narrated trip acquaints passengers with the area and the 124-year-old railroad.

Locomotives used by the railroad include #29, a 1916 Baldwin 2-8-0, former Longview, Portland & Northern and #8, a 1907 Baldwin 2-6-2, former Hobart Southern. Passengers ride in either an open car or two semi-enclosed passenger cars. On display (or used by the railroad) are an 1888 Northwestern Pacific combine and coach, a former Northern Pacific caboose, and #30, a 1919 0-6-0, former Southern Pacific locomotive.

Besides the regularly scheduled excursions, special events are held occasionally throughout the year and party trains are available for rental.
Season: End of May thru first of Oct., Daily; Oct., weekends only.
Hours: 10:30 a.m.–5:45 p.m.
Cost: Adults, $4; children (5–12 yrs.), $2; under 4, free. All day passes, $8.
For further information write to the Virginia & Truckee Railroad Co., P.O. Box 467, Virginia City, NV 89440, or call (702) 847-0380.

NEW HAMPSHIRE

CONWAY SCENIC RAILROAD

The Conway Scenic Railroad takes passengers on an 11-mile scenic tour through Mt. Washington Valley in New Hampshire aboard old fashioned open-air cars or enclosed coaches. A restored 1898 Victorian Pullman Parlor-Observation Car, the "Gertrude-Emma," and the Dining Car "Chocorua" offer passengers first class old-time luxury. Both coach and first class services are available on all trains, and Dining Car service is available from early May thru late December.

The Railroad also owns the historic 1874 North Conway Depot, listed in the National Register of Historic Places. The Depot Museum contains early railroading memorabilia, along with a gift shop and snack bar. Visitors can also stroll through the railroad yard to see other pieces of rolling stock and an historic turntable.

Season: End of April thru end of Oct. with special excursions available during holiday times.

Hours: Vary according to excursion chosen.

Cost: Coach: Adults, $7.50; children (4–12 yrs.), $5; under age 4, free. First class: Adults, $9.50; children (4–12 yrs.), $7; under age 4, $3.50. Dining costs vary, as passengers can order from the menu.

For further information write to the Conway Scenic Railroad, P.O. Box 1947, North Conway, NH 03860, or call 1-800-232-5251 or (603) 356-5251 (NH).

HOBO RAILROAD

The Hobo Railroad takes passengers on a 1¼-hour round trip aboard open-platform coaches or dining cars. The train runs on former Boston & Maine track which follows the Pemigewasset River. Passengers may choose to eat the special "Hobo Picnic Lunch" aboard the train, or lunch at the Jack O'Lantern Resort. The "Hobo Picnic Lunch" is served on a free hobo souvenir bindle stick. The evening Dinner Train offers a five-course meal, elegantly served aboard the "Cafe Lafayette," a restored 1924 Pullman dining car. Several special events are offered throughout the year, in early Spring and Fall. Some of these are not regularly scheduled or advertised, so it is a good idea to contact the railroad before visiting.

The roster of equipment includes three diesel locomotives (earliest one built in 1943), four modified former Erie & Lackawanna motor cars, a modified New York Central Pullman day coach, two U.S. Army kitchen cars, several Budd cars, and more.

Season: Mid–March thru New Year's Eve, daily.

Hours: Regular excursions: 11 a.m., 1 p.m., 3 p.m., 5 p.m. and 7 p.m. Extra trains run as the need arises. Dinner trains: Wed.–Sun., 7 p.m.

Cost: Regular excursions: Adults, $7; children, $4.50; under 4, free. Dinner trains: $34.95. Reservations suggested.

For further information write to the Hobo Railroad, P.O. Box 9, Lincoln, NH 03251, or call (603) 745-2135 or (603) 745-3500 (dinner train).

THE MT. WASHINGTON COG RAILWAY
THE COG RAILWAY CO., INC.

Open for business in 1869, the Cog Railway was an engineering marvel, using a new technology of toothed cog gears, rack rails and tilted boilers. It was the

world's first mountain-climbing cog railway and is the only one built on three miles of wooden trestles. The average grade is 25 percent, while the steepest grade is 36.41 percent. The cog train runs at a speed of four miles per hour. The coaches hold 56 passengers on the trip. The bumper, by which the engine pushes the car up the mountain, is made of rubber rather than steel and wood.

The Railway has recently completed a new building at the base which houses the Ticket Office, Museum, Gift Shop, Restaurant and Office. On the summit is the mile-high state park featuring the Sherman Adams Observation Center. Round trip tours generally take three hours.

Today, the Cog Railway possesses two aluminum and steel passenger cars (the first began running in 1958), as well as other coaches and engines which now run on the 4' 8" gauge track. A number of the rolling stock coaches were built at the old Laconia Car Company in Laconia, New Hampshire. Coaches No. 3 and No. 4 were built around 1875, and No. 1 was built around 1866. It is believed to be the oldest operating coach in the world. Although improvements to the mechanics of the coaches have been made, care has been taken to preserve the original appearance of each coach.

There are eight locomotives listed on the Locomotive Roster: Locomotive #1 (1st #1, nicknamed "Peppersass"), built in 1866 by Campbell and Whittier, Cambridgeport, Massachusetts, with a vertical boiler and two $8'' \times 12''$ cylinders (purchased by the Cog Railway in 1929, it operated one day, was wrecked, and is now on display at Marshfield Station); #1 (2nd #1, nicknamed "Mt. Washington") was built in 1883 by Manchester Locomotive Works, Manchester, New Hampshire, as the first #7 "Falcon"; #2 ("Ammonusuc"), built in 1875 by Manchester Locomotive Works as the 2nd #4 ("Atlas"); #3 ("Base Station"), built in 1883 by the Manchester Locomotive Works #2 for the Green Mountain Cog Railway in Maine; #4 ("Summit"), built in 1883 by the Manchester Locomotive Works as the #1 ("Mt. Desert") for the Green Mountain Cog Railway; #6 ("Great Gulf") was built in 1878 by Manchester Locomotive Works as #6 ("Tip-Top") then rebuilt about 1950; #8 ("Tip-Top"), built in 1892 by Manchester Locomotive Works as the "Pilgrim" (with a diamond-shaped smoke stack); #9 ("Waumbek"), built in 1908 by Alco-Manchester Locomotive Works, with the cab on the same plane as the boiler; #10 ("Col. Arthur S. Teague"), built at the Base Shops of the Mt. Washington Cog Railway—completed in 1972. In 1895 there was a disastrous fire at the Base Shops, causing extensive damage to much of the rolling stock. Several engines were lost or badly damaged, causing the owners to renumber them as they were placed back on line or for other reasons. All of the locomotives on the roster (except for "Peppersass") either have or had horizontal boilers.

Season: Early May thru early Nov.

Hours: Hourly departures from early morning to late afternoon in the summer. Spring and fall schedules may vary.

For further information (including ticket prices) write to the Mt. Washington Cog Railway, Route 302, Bretton Woods, Mt. Washington, NH 03589, or call 1-800-922-8825 Ext. 6 or (603) 846-5404 Ext. 6 (NH).

Black River & Western Railroad, Ringoes, NJ

WHITE MOUNTAIN CENTRAL RAILROAD

Departing from an 1890s-style depot, the White Mountain Central Railroad takes passengers on a two-mile, 30-minute roundtrip through the scenic White Mountains. Before boarding the train, passengers can visit the other tourist attractions available at Clark's Trading Post, including trained bears, subject museums, a 1920s garage, an illusion building and more.

Passengers can ride in open excursion cars or a caboose pulled by an authentic steam engine – #6, Climax, former Beebe River Railroad. Two other steam engines are available, also. These are a 1927 Heisler, #4, former International Shoe Co., and #3, a former East Branch & Lincoln locomotive.

Season: June thru Sept.

Hours: Daily, July & Aug. & Oct. 15; weekends, June & Sept. Six trains run each day.

Cost: Adults, $7; children (6–11 yrs.), $6; children (3–5 yrs.), $1; under 3, free.

For further information write to the White Mountain Central Railroad, c/o Clark's Trading Post, Box 1, Lincoln, NH 03251, or call (603) 745-8913.

NEW JERSEY

BLACK RIVER & WESTERN RAILROAD

Located midway between Philadelphia and New York, the BR&WRR operates steam locomotive excursions out of the Flemington Depot and the

Ringoes Station. Within walking distance of the Flemington Depot is a shopping area called Turntable Junction, Liberty Village and Cut Glass, Pottery and Fur Factories. At Ringoes (the home of the BR&WRR), visitors can see the restored 1854 Station, snack bar, souvenir shop, picnic grounds and several pieces of equipment used on the restored steam railroad as well as in modern freight hauling.

The BR&WRR's Roster of Equipment includes Steam Engine #60 (built 1937 by ALCO, for Great Western Railway), Diesel Engine #57 (built 1948 by ALCO, RS-1, former Washington Terminal Railway), Diesel Engine #752 (built 1956 by EMD, GP-9, former Burlington Northern); Diesel Engine #42 (built 1978 by EMD, CF-7 former AT&SF), and coaches #301-305 (Pullmans formerly at DL&W), #320-322 (built by Bethlehem Ship Building, former Central Railroad of New Jersey), and #491-494 (former Canadian National).

Many special events are held throughout the year, including a "Mixed Freight Train" run, Easter Bunny Express, Train Robbery, Railroad Days, Train Robbery, Pumpkin Festival, Santa Express and more.

Season: Between Ringoes and Flemington: April thru Dec., Sat. & Sun. only; July & Aug., daily. Between Ringoes and Lambertville: May thru Oct., Sun. only. Special Events are offered every month but Jan.

Hours: Vary according to route chosen. Earliest regular train leaves Ringoes at 10:45 a.m.

Cost: Vary according to trip chosen.

For further information write to the Black River & Western Railroad, P.O. Box 200, Ringoes, NJ 08551, or call (908) 782-9600. (We suggest you call to obtain ticket costs.)

OCEAN GATE MUSEUM

The small depot in Ocean Gate was built in 1909 and is currently the home of the Ocean Gate Historical headquarters and museum. Although the museum houses all sorts of Ocean Gate historical memorabilia, emphasis has been placed on keeping the railroading ambiance. Much railroading memorabilia is on display, including an original crossing sign and ticket counter.

Season: May thru Sept.

Hours: Sat., 10 a.m. to 12 p.m.; Wed. 6:30 p.m. to 8 p.m.

Cost: Donation.

For further information write to the Ocean Gate Museum, Cape May Avenue, P.O. Box 895, Ocean Gate, NJ 08740, or call (908) 269-3468.

THE PATERSON MUSEUM

The Paterson Museum was organized in 1925 by the City of Paterson Board of Library Trustees and began operating in the assembly room of the Danforth Public Library. In 1927 the museum's collections were moved to the carriage house of former Paterson mayor and philanthropist, Nathan Barnert,

next to the library. Finally, in 1982, due to the increasing growth of the exhibits, and because the Thomas Rogers Locomotive Erecting Shop had recently been restored, the Museum was moved there. The Thomas Rogers Building, with the museum, is now the focal point of the 119-acre Great Falls Historic District.

The focus of the museum is to relate the history of Paterson, exhibiting its evolution as a machinery and textile center, the "Silk City," locomotive manufacturing, Colt arms and the unique Holland submarine.

Season and hours: Year-round, Tues.-Fri., 10 a.m. to 4 p.m.; Sat. & Sun., 12:30 p.m. to 4:30 p.m. (Closed Mon. and Holidays).

Cost: Suggested donation: Adults, $1; children, free.

For further information write to the Paterson Museum, Thomas Rogers Building, 2 Market Street, Paterson, NJ 07501, or call (201) 881-3874.

PINE CREEK RAILROAD
THE NEW JERSEY MUSEUM OF TRANSPORTATION, INC.

The New Jersey Museum of Transportation/Pine Creek Railroad is located in Historic Allaire State Park. All funds are raised by train fares, souvenir sales, membership dues and donations. Visitors to Allaire State Park can ride authentic 3' gauge antique railroad cars pulled by coal burning steam or vintage diesel locomotives, as well as visit the restored iron manufacturing village of James P. Allaire.

The Pine Creek Railroad was organized as a club in 1952 and was the first operating steam train exhibit in New Jersey. In 1963 the club reorganized, moved to Allaire State Park and incorporated as the New Jersey Museum of Transportation, Inc. The mainline of the railroad is a ¾ mile long loop using locomotives and cars once used in regular train service by railroads in various parts of the Americas, including Newfoundland, Canada and Hawaii. One special train (one locomotive and three cars) originally ran in Ireland. All museum buildings (except repair shop and tool shed) were once used on New Jersey railroad lines.

The Railroad operates a huge roster of rolling stock, including steam engines, diesel units, passenger cars and freight cars. Many different pieces are used on different occasions, and many pieces are still awaiting restoration. Some of the regularly operating units are as follows: Steam Engines #3 ("Lady Edith," 4-4-OT, built in 1887 by Stephenson & Co., Newcastle-on-Tyne, England, and run in Ireland); #6 (Type B32-2 Shay, built at Lima Locomotive Works in 1927 and operated from 1927 to 1955 by the Ely-Thomas Lumber Co.); #26 (2-6-2, built in 1920 by Baldwin Locomotive Works and run from 1920 to 1960 on the Surrey, Sussex & Southampton Railway in Virginia); Diesel Locomotives #1 (0-4-0 Plymouth, built in 1942 by Plymouth Loco Works, Ohio and run for Haws Refractories, Pennsylvania, from 1942 to 1965); #5 (0-4-0 Plymouth, built in 1932 and run for Marcus Wright Sand Co.

in New Jersey from 1932 to 1959); #39 (a 50-ton General Electric built in 1950 and run at US/Kobe Steel, Ohio, from 1940 to 1993); #45 (a 50-ton GE, with same credentials as #39); #7751 (25-ton GE Diesel Electric built in 1942 and used by the US Army in Oahu, Hawaii, from 1942 to 1966); #502 coach, built in 1902 and run on the Newfoundland Railway; Caboose #91155, built in 1874 as a box car but converted to a caboose in 1902 (ran on the Central Railroad of New Jersey); and Flat Car #331787, which ran for the US Navy in Hawaii until converted to an open excursion car.

All trains leave and return to Allaire Station, taking passengers on a 1½-mile, 8–10 minute trip around the museum grounds.

Season and hours: May thru Oct., Sat., Sun. & Holidays using steam locomotive; trains leave every 30 minutes from noon to 4 p.m. July and Aug., Mon–Fri., using diesel locomotive; trains leave every 30 minutes from noon to 4 p.m. Special excursions are offered throughout the year, including a Great Locomotive Chase, Railroaders Day and Christmas Express.

Cost: Regular Service: $2 per person; under 3 free. Special excursions are generally $2.50 per person. A park entrance fee is charged from Memorial Day thru Labor Day: $3 per car weekdays; $2 per car weekends.

For further information write to the Pine Creek Railroad, c/o The New Jersey Museum of Transportation, Inc., P.O. Box 622, Farmingdale, NJ 07727, or call (908) 938-5524.

NEW MEXICO

COLUMBUS HISTORICAL SOCIETY

The Village of Columbus in New Mexico was established in 1891 near the Mexican border, just north of Palomas. When the El Paso & Southwestern Railroad built their depot in 1902, the town moved three miles north and grew to support two hotels and a number of merchants.

The town of Columbus is designated as a National Historic Site as it was the site of a March 9, 1916, raid by General Francisco (Pancho) Villa. General (Black Jack) Pershing commanded the unsuccessful U.S. Punitive Expeditionary force from Camp Furlong, pursuing General Villa deep into Mexican territory. The expeditionary forces' efforts were not totally in vain, however, as this was the first time in American history that motorized vehicles and aircraft were used in warfare, making American history.

The old Southern Pacific Railroad Depot is now the home of the Columbus Historical Museum. The main thrust of the museum is to preserve Columbus history and, since railroading had a big influence on the town, several pieces of railroading memorabilia can be seen there.

Season: Daily, except Christmas, New Year's, Thanksgiving and Easter.

For further information write to the Columbus Historical Society, P.O. Box 562, Columbus, NM 88029, or call (505) 531-2708 or 531-2733 or 531-2543.

CUMBRES & TOLTEC SCENIC RAILROAD
(Chama, New Mexico—*see* listing in Colorado)

SANTA FE SOUTHERN

The Sante Fe Southern runs on tracks originally laid in 1879 by the Atchison, Topeka and Santa Fe Railway to its namesake city. After 112 years, passenger service to Santa Fe was terminated in 1960, and by 1992 the line was threatened with abandonment until the Santa Fe Southern was formed to preserve this historic piece of railroad. Today, the Santa Fe Southern delivers freight to Santa Fe and has instituted passenger services via leisurely excursions through beautiful New Mexico territories.

Diesel Engine #92, the ex–Santa Fe #2075, generally pulls the "mixed train" (freight and passenger services combined), whose passengers travel on a newly-acquired, refurbished 70-passenger coach or an old caboose. Two air-conditioned stainless steel Vista Dome cars are also on line—one for dining and the other as a lounge car with full service bar.

Besides the regular runs, private tours can be arranged beginning at a cost of $600. The "Sunset Train" is also running on Friday evenings all summer. Passengers must call the railway for exact details.

Season: Year-round.

Hours: Departs Santa Fe Depot, Tues., Thurs., and Sat., at 10:30 a.m.; returns 4 p.m.

Cost: Adults, $21; seniors (60+), $16; students (7–13 yrs.), $16; children (3–6 yrs.), $5; 2 and under, free.

For further information write to the Sante Fe Southern, c/o Santa Fe Southern Railway, Inc., P.O. Box 6184, Santa Fe, NM 87502, or call (505) 989-8600 or Fax (505) 983-7620.

NEW YORK

ARCADE & ATTICA STEAM RAILROAD

The Arcade & Attica is an old common carrier shortline railroad in Western New York state that has hauled freight year-round since 1881. During the spring and fall, mixed-trains (freight and passenger cars) run the seven-mile length of track.

Passengers on this 90-minute excursion ride in coaches built around 1915, behind one of three locomotives: #14, a 1917 4-6-0 Baldwin; #18; a 2-8-0 American; or a vintage Diesel. (The diesel is used when operating conditions warrant. Be sure to check ahead of time if you want to ride behind a steam engine.)

The route of the railway travels through rolling meadows and woodlands

to the Curriers Depot at its mid-way stop. This 1880s vintage station houses a small museum, giftshop, snack bar and restrooms. The Arcade Depot houses the ticket office and several pieces of rolling stock, including the NYO & WRR's "Warwick Car." The Warwick is said to have been used by President Grover Cleveland on his honeymoon. (Open 11 a.m. to 3 p.m.)

Season: Decoration Day thru Oct.

Hours: Decoration Day weekend, 12:30 p.m. and 3 p.m.; June, Sat. & Sun., 12:30 p.m. and 3 p.m.; July & Aug., Fri., 1 p.m., Sat., Sun. & Wed., 12:30 & 3 p.m.; Sept. & Oct., same as June. Special excursions run at different times, including a Fall Foliage Excursion.

Cost: Round trip fares: Adults, $8; children (3–11 yrs.), $5; seniors (discounted).

For further information write to the Arcade & Attica Steam Railroad, P.O. Box 246, 278 Main St., Route 39, Arcade, NY 14009, or call 1-800-841-2418.

CATSKILL MOUNTAIN RAILROAD

This standard gauge, diesel train operates over former Ulster & Delaware Railroad trackage (later the Catskill Mountain Branch of the New York Central). This six-mile, one-hour round trip takes passengers from Mt. Pleasant to Phoenicia, New York, traveling along the Esopus Creek and through the heart of the scenic Catskill Mountains. Passengers may disembark at Phoenicia, enjoy the water sports available there, and then take a later train back, if desired.

Equipment used by the Catskill Mountain Railroad includes two locomotives—#1, "The Duck," a 1942 Davenport 38-ton diesel (former U.S. Air Force) and #2, "The Goat," an H.K. Porter 50-ton diesel-electric (former U.S. Navy). Three coaches and a modified flat-car are also used. An 1894 wooden baggage car from the Delaware & Hudson and a 1937 caboose from the Lehigh Valley (No. 94071) are also on display.

Besides the regularly scheduled excursions, a few special events are scheduled throughout the year, including the beautiful "Fall Foliage Trains." Be sure to schedule your trip well ahead of time if you want to ride on one of the Fall Foliage Trains.

Season: Memorial Day weekend thru mid-Oct.

Hours: Weekends and holidays only; running regularly from 11 a.m. to 5 p.m.

Cost: Round trip: Adults, $5; children (4–11 yrs.), $1; under 4, free. One way: Adults, $4; children, $1; under 4, free.

For further information write to the Catskill Mountain Railroad, P.O. Box 497, Phoenicia, NY 12464, or call (914) 688-7400.

THE CHAMPAGNE TRAIL EXCURSION TRAIN
COHOCTON VALLEY FARM MUSEUM

For further information write to the Champagne Trail Excursion Train, 55 Maple Street, Cohocton, NY 14826, or call (715) 384-9187.

DELAWARE ULSTER RAIL RIDE

The historic 10-mile, 50-minute round trip route of the Delaware Ulster Rail Ride begins at the well-maintained original 1920s depot in Arkville. Passengers ride in vintage open-air or closed coaches. There are several different types of excursions from which to choose, including train robberies, ghost trains, and dinner trains, as well as regular excursions.

Equipment used on the line includes Locomotive #5106, a 1953 ALCO S-4, formerly from the Chesapeake & Ohio; No. 1012, a 1954 ALCO S-4 formerly Ford Motor Co., and more. For a complete equipment roster, write to the railroad.

Season: Weekends and holidays, end of May thru end of Oct.; Wed.-Sun., July thru Labor Day; special excursions and charters also available.

Hours: Depot/Museum opens at 10 a.m. on operating days. Trains run at 11 a.m., 1 p.m. and 3 p.m.

Cost: Adults, $7; seniors, $5.50; children (5–11 yrs.), $4; under 5, free.

For further information write to the Delaware & Ulster Rail Ride, Arkville Depot, P.O. Box 310, Stamford, NY 12167, or call 1-800-225-4132 or (914) 586-DURR.

THE GRAND ADIRONDACK LINE OF THE ADIRONDACK SCENIC RAILROAD

The Grand Adirondack Line, operated by the Utica & Mohawk Valley Chapter of the National Railroad Historical Society, offers passengers an eight-mile, one-hour round trip ride over a section of the former Adirondack Division of the New York Central Railroad. Locomotive No. 8223 (a standard gauge diesel, the first ALCO RS3 on the NYC) pulls six former Canadian National open-window coaches over the same track that used to carry the rich and famous to beautiful resort hotels in the most scenic areas of the Adirondacks. A former Pullman 12-I sleeper is currently being converted to an open-air car to be used on the line.

Inside the century-old Thendara Station, in the former Ladies Waiting Room and the former Baggage Room, is a small museum focusing primarily on the Adirondack Division, with information about the New York Central and railroading in general.

Season: May: weekends and Memorial Day; June: Sat.–Thurs.; July 1

thru Oct. 1, daily. Nov.: weekends only. Many special events are held throughout the year, including Santa trains, Train Robbery, Railroad Appreciation Week and more.
Hours: Weekends in Nov.: 11:30 a.m. and 2:30 p.m. Other days: 10 a.m., 11:30 a.m., 1 p.m., 2:30 p.m. and 4 p.m.
Cost: Adults, $5; children (2-11 yrs.), $3.
For further information write to the Adirondack Scenic Railroad, P.O. Box 84, Thendara, NY 13472-0084, or call (315) 369-6290.

NEW YORK & LAKE ERIE RAILROAD

The first through train from Piermont-on-Hudson to Dunkirk, New York, ran on May 14, 1851, as the New York, Lake Erie & Western Railroad over a six-foot gauge track. Several consolidations and name changes have occurred since that time, including the merger of the Erie Railroad and its rival, the Lackawanna Railroad, which formed the Erie Lackawanna Railroad. The EL merged with several other bankrupt railroads in 1976 to form the Consolidated Rail Corp. (Conrail). Conrail operated parts of what is now the New York & Lake Erie Railroad for about two years.

Today, the NY&LE RR provides rail service to several feed mills and runs a variety of passenger excursion trains. The NY&LE RR has been used in the filming of two major motion pictures — *The Natural* starring Robert Redford, and *Planes, Trains and Automobiles* starring Steve Martin and John Candy.

Among other equipment owned by the NY&LE RR are Locomotive #1013, an ALCO C-425 Diesel built in 1965 for the Norfolk & Western Railway; Cars 1, 2 and 3, built in the 1930s and used by Baltimore & Ohio Railroad; Car #4, a former Amtrak coach; and Cars 5, 6, and 7, former Delaware, Lackawanna & Western Railroad electric transit cars built in the late 1920s.

Season: Regular trips are offered year-round, June thru Oct. "The South Dayton Flyer" makes one roundtrip excursion between Gowanda and South Dayton on weekend days. From mid-May thru mid-Dec., "The Blue Diamond" dinner train makes one roundtrip from Gowanda to Cherry Creek on Sat. evenings and Sun. afternoons.

Hours: Be sure to send for a Train Schedule, as times vary according to ride or excursion chosen.

Cost: Regular round-trip fares: Adult, $8; seniors, $7.50; children (3-11 yrs.), $4; under 3 (in lap), free. Prices vary for Dinner Train rides, Murder Mystery Dinner Train rides and other special excursions.

For further information write to the New York & Lake Erie Railroad, 50 Commercial St., P.O. Box 309, Gowanda, NY 14070, or call (716) 532-5716.

NEW YORK MUSEUM OF TRANSPORTATION

The Museum features a collection of railroading equipment, artifacts and memorabilia, including a 1914 interurban from Rochester & Eastern; a wooden

caboose (#8) former Delaware, Lackawanna & Western; a Plymouth gasoline locomotive; an H.K. Porter 0-4-0 steam locomotive; several trolleys and more. Visitors can view a rare color film about the Rochester subway. Many other transportation exhibits are also on display.

On the museum grounds, visitors can take a track-car ride on a short trip around the grounds, or deboard at the neighboring Rochester & Genesee Valley Railroad Museum to see the exhibits there.

Season: Year-round.

Hours: 11 a.m. to 5 p.m., Sundays only.

Cost: Adults, $4; seniors, $3; students (5–15 yrs.), $2; family fares, $15. Admission cost includes both museums and track-car ride. Lower prices available from Nov. thru mid–May include entry to this museum only.

For further information write to the New York Museum of Transportation, P.O. Box 136, West Henrietta, NY 14586, or call (716) 533-1113.

NEW YORK, SUSQUEHANNA & WESTERN RAILWAY CORP.

This corporation runs several excursions throughout the year, including a regular 13-mile, 75-minute round trip between Hawthorne and Franklin Lakes, New Jersey; diesel service from 11 a.m. to 6 p.m. to points of interest in Syracuse, New York; steam train rides on most weekends; Fall Foliage trips and much more. Since the excursions offered are so varied, we strongly suggest you contact the Railway for exact and specific information.

A variety of equipment is used on these excursions, including nine coaches from the New York Central railroad, commuter coaches, and different locomotives. For a more accurate roster of equipment, contact the railroad.

Season: Diesels generally run daily, Steam Trains usually run on weekends.

Hours: Diesels run 11 a.m. to 6 p.m.; Steam Trains generally run at 10 a.m., 12 p.m. and 2 p.m., but this varies occasionally on different excursions.

Cost: Regular excursions generally cost $9 for adults and $5 for children, but special events and steam excursion prices vary.

For further information write to the New York, Susquehanna & Western Railway Corp., 215 Walton St., Suite 201, Syracuse, NY 13202, or call 1-800-367-8724 (OnTrain services) or (315) 424-1212.

ONTARIO-MIDLAND RAIL EXCURSIONS

The Rochester Chapter of the National Railway Historical Society offers Fall Foliage Excursions and a few other special events throughout the year using engines owned by the Ontario-Midland Railroad. The Society owns five former New York Central stainless steel Budd cars once used on the "Empire State Express," which are now pulled by the Ontario-Midland standard-gauge diesel engines.

Season: Sept. & Oct.
Hours: Vary according to excursion chosen.
Cost: Regular excursions: Adults, $9.50; children (3–15 yrs.), $6; under 3, free. Special events fares vary.
For further information write to the Ontario-Midland Rail Excursions, P.O. Box 1161, Webster, NY 14580, or call (716) 224-0581.

RAILROAD MUSEUM OF LONG ISLAND

This museum is chartered by the state of New York as a non-profit museum and is affiliated with the Steam Locomotive 39 Restoration Project of Riverhead. Located in Greenport, the historic seaport on the North Fork of eastern Long Island, it occupies the 100-year-old Long Island Railroad brick railway freight station and sits adjacent to the locomotive turntable there. Regular LIRR trains can be boarded from this area, while ferry boat or bus trips can also become part of a passenger's itinerary.
Season: Year-round.
Hours: Museum: Sat., Sun., & holidays, or other times by special arrangement.
Cost: No admissions charge. Contributions appreciated.
For further information write to the Railroad Museum of Long Island, Box 726, Greenport, NY 11944, or call (516) 477-0439. For train information call LIRR at (516) 822-LIRR.

ROCHESTER & GENESEE VALLEY RAILROAD MUSEUM

This museum features railroading artifacts from various railroads in the area. The museum is housed in a restored 1900s Erie Railroad station. On the grounds outside are a number of locomotives and other pieces of rolling stock, including a track-car ride which takes passengers to the neighboring New York Museum of Transportation and back. Passengers can disembark at the New York Museum of Transportation, then board a later train to return.

On the roster of equipment are five diesel or electric locomotives, a 1909 70-ton hopper car, baggage car #633 (former Baltimore & Ohio), several cabooses, baggage cars, coaches, a milk car, ice refrigerator car, speeder, section car and more. Many pieces of maintenance-of-way equipment are also on display.
Season: Mid-May thru late Oct., Sundays only.
Hours: 11 a.m. to 5 p.m.
Cost: Adults, $4; seniors, $3; students (5–15 yrs.), $2; family fares, $15. Admission cost includes both museums and track-car ride.
For further information write to the Rochester & Genesee Valley Railroad Museum, P.O. Box 664, Rochester, NY 14603, or call (716) 533-1431 or fax (716) 425-8587.

TIOGA SCENIC RAILROAD

The Tioga Scenic Railroad was originally built in 1869 as the Southern Central Railroad and was a link between the Southern Tier of New York and the Great Lakes. The station sites at Owego, Flemingville and Newark Valley are original depots from that time. As with most railroads, ownership and names changed many times, until 1992, when the lease went to the newly formed Owego and Harford Railway, which owns and operates the Tioga Scenic Railroad.

The Tioga Scenic Railroad travels through 22 miles of scenic countryside between historic Owego and Newark Valley, with passengers riding aboard vintage 1900s railroad cars or late 1800s open air cars. Stops are made along the way to visit the historic Owego and Newark Valley Depots and Museums. Several special excursions, including a 1940s-style dinner train and a comedy, murder, mystery train are offered throughout the year. Passengers must call ahead for reservations.

The Tioga Scenic Railroad Freight House at the Owego Depot houses a museum which features railroading displays and a large HO scale train layout, as well as a gift shop.

Season: Memorial Day thru Oct. 30th.

Hours: Local excursions from Owego Depot: Sat., and Sun. at 11 p.m., 1 p.m. and 3 p.m. Holiday and special excursions run at various times.

Cost: Local excursions: Adults, $6; seniors, $5.50; children (4–12 yrs.), $4. Meal excursion prices vary. Comedy, murder, mystery excursion: $44.95 per person.

For further information write to the Tioga Scenic Railroad, 25 Delphine Street, Owego, NY 13827 or call 1-800-42-TIOGA.

NORTH CAROLINA

FLOYD McEACHERN HISTORICAL TRAIN MUSEUM

This on-going museum basically features the collection of one man, Floyd McEachern, who has been collecting and refurbishing railroading memorabilia for thirty years. Other rail fans have contributed or loaned pieces as well, making a total of well over 3,000 items on display, covering every aspect of steam railroading history.

Besides the actual railroading equipment displays, the museum also features a huge model train layout, with 1800 feet of track, running an "O" gauge train.

Season: April through December.

Hours: Daily, 8:00 a.m. to 4 p.m. and 5 p.m. to 7:30 p.m.

Cost: Adults, $3; children, $2.

For further information write to the Floyd McEachern Historical Train Museum, 1 Front Street, P.O. Box 180, Dillsboro, NC 28725 or call (704) 586-4085 or Fax (704) 586-8806.

GREAT SMOKY MOUNTAINS RAILWAY

The Great Smoky Mountains Railway began in late summer of 1988, and offered a full schedule of passenger excursions by April of 1989. The excursion trains run on a section of track that was completed in 1891.

The original Western North Carolina Railroad line dates back to the 1840s. In 1894, the WNCR was purchased by the Southern Railway who ran it until 1982, when the Southern Railway merged with the Norfolk Western to become the Norfolk Southern. As with other railroads of the time, changing transportation interests led the Norfolk Southern to file for abandonment of the 67 miles of track between Dillsboro and Murphy. This track was then purchased in 1988 by the North Carolina Department of Transportation, which signed a long-term lease agreement with a new company called the Great Smoky Mountains Railway, Inc. This agreement assured that freight service would continue on the line and that passenger service could be reinstituted in the form of scenic excursions.

On the scenic excursions, the Railway operates five locomotives: four diesel-electric locomotives acquired from the Union Pacific, Norfolk Southern, and Chicago & Northwestern railways, and one steam locomotive, No. 1702. No. 1702 played a prominent role in the Paramount movie, *This Property Is Condemned* starring Robert Redford, Natalie Wood, and Charles Bronson.

The engines on the line pull comfortable reconditioned coaches, including several cars from the Canadian Pacific Railroad. Rail fans can also see specially designed open cars and reconditioned and refurbished cabooses.

Passengers riding on the Great Smoky Mountains Railway can also view the magnificent Great Smoky Mountains National Park, parts of the Appalachian Trail and the Cherokee Indian Reservation, and a number of cascading waterfalls. Several excursions (from regular passenger trips to Raft & Rail excursions) are offered, boarding from different stations.

Season: April through October.

Hours: Vary according to excursion chosen.

Cost: Vary according to excursion and options chosen.

For further information write to the Great Smoky Mountains Railway, 1 Front Street, P.O. Box 397, Dillsboro, NC 28725 or call 1-800-872-4681 Ext. V or (704) 586-8811.

NATIONAL RAILROAD MUSEUM

Officially opened in 1976, the National Railroad Museum is located in the old Seaboard Air Line Railway's depot and hotel at the crossing of SAL Railway

National Railroad Museum, Hamlet, N.C.

predecessors. The Seaboard Air Line Railroad (SAL) and the Atlantic Coast Line Railroad merged in 1967 to form the Seaboard Coast Line Railroad, which later became the Seaboard System Railroad and is now CSX Transportation.

The depot was built in 1900 as the home of the North Carolina Division of SAL and currently features photographs, maps, displays, a model railroad layout, four pieces of rolling stock and a gift shop. The atmosphere is reminiscent of that by-gone era when wood and coal burning steam-driven locomotives were in vogue.

The rolling stock on display at the museum includes an SAL-114 (an SDP-35 diesel locomotive built by EMD in 1964 for SAL — Seaboard Air Line Railroad), an SAL-5241, and a caboose built by Magor Car Corp. in 1924.

The Museum's HO gauge model train layout represents an early Seaboard Air Line Railway trackage and includes such premier trains as the "Orange Blossom Special" and the "Silver Meteor." A gift shop is also on the premises.

Season: Year-round, Sat. and Sun. only.
Hours: Sat., 10 a.m. and 5 p.m.; Sun., 1 p.m. to 5 p.m.
Cost: Admission is free. Donations are appreciated.
For further information write to the National Railroad Museum, 2 West Main Street, Hamlet, NC 29345.

NORTH CAROLINA TRANSPORTATION MUSEUM

Touted as "the South's largest transportation museum," the North Carolina Transportation Museum is located at the Historic Spencer Shops on the site of what was once Southern Railway Company's largest steam locomotive servicing facility. Begun in 1896, the facility sat roughly halfway between Washington and Atlanta. Both the town of Spencer and the Spencer Shops were named for Samuel Spencer, the first President of Southern Railway.

During the railway's heyday, the shops employed over 2,500 people. The need for repair facilities such as these waned in the '40s and the shops were finally closed in 1960. Southern closed down all work at the shops in the late 1970s, at which time preservationists and local legislators began efforts to preserve the historic buildings as a transportation museum. Finally, in September of 1977, Southern's President, L. Stanley Crane, presented a deed to Governor Hunt for nearly four acres on the site. Then, in 1979, Southern donated another 53 acres along with several historic structures. Administered by the Historic Sites Section of the North Carolina Department of Cultural Resources, historic Spencer Shops' first exhibit area opened in 1983, with ongoing restoration of the site being planned. Well over $2 million worth of rare transportation artifacts have been acquired, restored and placed on exhibit.

A 50-minute tour around the site is provided by the museum's former Buffalo Creek & Gauley Railroad steam locomotive No. 4, which pulls several restored coaches. Diesel locomotives are used on weekdays and during the off-season. Other restored equipment at the museum includes a Model T Ford depot hack, RFD mail wagon, the luxurious "rolling palace" rail cars "Doris" and "Loretta," Southern's steam engine #604, and more.

Season: Trains: April 1 thru Labor Day; Sept. thru mid-Dec. trains run only if 20 or more people buy tickets. Museum: Year-round, but closed Mondays Nov. 1 through March 31. Also closed Thanksgiving, Christmas Eve, Christmas Day and New Year's Day.

Hours: Season: Steam engines run Sat. at 11 a.m., 1 p.m., 2 p.m. and 3 p.m.; Sun. they run 1:30 p.m., 2:30 p.m. and 3:30 p.m. Diesels run Mon.-Fri. at 11 a.m., 1 p.m., 2 p.m., and 3 p.m. Off-season trains run the same hours, if they run. Museum (in season): 9 a.m. to 4 p.m. Mon.-Sat., 1 p.m. to 5 p.m. on Sunday; (off season): 10 a.m. to 4 p.m., Tues.-Sat., 1 p.m. to 4 p.m., Sun.

Cost: Steam: Adults, $4; seniors, $3; children (3-12 yrs.), $3. Diesel prices are $.50 less.

For further information write to the North Carolina Transportation Museum, P.O. Box 44, Spencer, NC 28159 or call (704) 636-2889. For group reservations write to P.O. Box 165, Spencer, NC 28159 or call (704) 636-2889.

WILMINGTON RAILROAD MUSEUM

Incorporated in the port city of Wilmington in 1834, the Wilmington and Weldon Railroad was completed in 1840. With its 161 miles of track, it became the longest rail line in the world, linking north to south.

As with other railroads of the time, inevitable name changes and mergers eventually led to the name Atlantic Coast Line Railroad.

Visitors to the museum can recapture part of the essence of the by-gone railroading days by boarding a steam locomotive or bright red caboose, or by exploring extensive displays of photographs and artifacts, ranging from a 150-ton locomotive (#250) to a conductor's 4-oz timepiece.

Season: Year-round, but closed Jan. 1 thru Jan. 7.
Hours: Tues.–Sat., 10 a.m. to 5 p.m.; Sun., 1 p.m. to 5 p.m.
For further information write to the Wilmington Railroad Museum Foundation, 501 Nutt Street, Wilmington, NC 28401 or call (910) 763-2634.

NORTH DAKOTA

BONANZAVILLE, U.S.A.

One of North Dakota's major tourist attractions, Bonanzaville is a reconstructed village representing 25 towns in the Cass County area. Located within the 15-acre facility are approximately 42 historic buildings housing various types of museums and historic displays, including a number of railroading displays.

At Bonanzaville, visitors can see the original Embden, North Dakota Northern Pacific Railroad depot and Locomotive No. 684, the only surviving engine of the original NPRR. Built in 1883, No. 684 was one of 11 locomotives purchased when the Northern Pacific first started operations. With that locomotive are displayed a caboose, a 1930s eighty-passenger coach, a snow plow and an old switch locomotive.

Also on the grounds is the Kathryn, North Dakota Depot, which houses the Spud Valley Railroad Club and model train complex.

Season: Memorial Day weekend to late Oct.
Hours: Daily, hours vary.
For further information write to Bonanzaville, U.S.A., P.O. Box 719, West Fargo, ND 58078 or call (701) 282-2822 or fax (701) 282-6706.

DICKEY COUNTY HISTORICAL PARK

This park offers visitors displays of local and regional history, including memorabilia and displays of trains of the area in the transportation collections. A Soo Line caboose is displayed on a rail in the park.

Season: Mid–March to mid–Oct. and by appointment.
Hours: By appointment.
Cost: Free.
For further information write to the Dickey County Historical Park, c/o Dickey County Historical Society, R.R. 3, Box 178, Oakes, ND 58474 or call (701) 783-4408 or (701) 742-2637.

FRONTIER VILLAGE

Frontier Village is home to what remains of the Midland Continental (or Midland and Northern Pacific) Railroad, chartered in North Dakota. Started after the turn of the century, Midland was soon bought out by a bigger company. What is left of the rolling stock, including the original caboose, can be seen at the Frontier Village in Jamestown, east of Bismark on Interstate 94.

For further information call (701) 252-6307.

HERITAGE VILLAGE

This village, run by Walsh County and the Walsh County Historical Society, is a reproduction of an early North Dakota settlement, including a two-story log cabin, church, schoolhouse, and railroad depot. An early carousel is also available for visitors to ride.

Season: Summer months.
Hours: Sunday afternoons only.
Cost: Free admission.
For further information write to the Heritage Village, Hwy 17 West, Grafton, ND 58237 or call (701) 352-3280.

LOCOMOTIVE #451
FORT BERTHOLD INDIAN RESERVATION

A Sioux Line #451, 2-8-0 steam locomotive dominates the eastern edge of the community on the Fort Berthold Indian Reservation. This steam engine, a rarity for its time at this location, was needed to haul grain in the area.

For further information write to the Ft. Berthold Reservation Public Library, Main Street, New Town, ND 58763.

MCHENRY RAILROAD LOOP

This unique site was once the "turn around" point for railroads bringing materials and supplies in during the construction of the Garrison Dam. The dam was the largest earth filled dam in the United States at the time of its construction, and is now listed on the National Register of Historic Places. The depot and museum located in McHenry are highly recommended by rail fans.

For further information call (701) 785-2333.

MANDAN DEPOT

This historic depot, built by the Burlington Northern Railroad, now houses a museum of Native American culture and art. The works of more than 200

North Dakota artists are available for purchase here year-round, and special programs are offered during the summer.
Season: Daily, summer months only.
Hours: 10 a.m. to 7 p.m.
For further information write to the Mandan Depot, 401 W. Main, Mandan, ND 58554 or call (701) 663-4663.

NORTH DAKOTA HERITAGE CENTER

Located on the grounds of the Capitol Building, the North Dakota Heritage Center is the largest museum in the state. The museum houses a large and diverse transportation collection, including a small number of pieces of railroading equipment.

At the end of Main Street sits historic Camp Hancock, built on the Missouri River to guard the ground survey crews for the Trans-Continental Railroad. A 1909 Baldwin #2164 is located at the site.

Two original depots are also located in Bismarck, both of which are now prominent restaurants—the Fiesta Villa and Captain Meriwethers. Diners can still watch trains traveling on the tracks behind Fiesta Villa.

For further information write to the North Dakota Heritage Center, c/o State Historical Society, 612 E. Blvd., Bismarck, ND 58505 or call (701) 328-2666 or (701) 328-3567.

NORTH DAKOTA RAILROAD MUSEUM

The museum sits on four acres of land donated by Kenneth and Darlene Porsborg, and includes a yard office donated by Burlington Northern, Inc. On the grounds outside the museum are located two cabooses—a 1913 wooden "Soo" caboose (nearing complete restoration) and a 1954 metal Burlington Northern, equipped for present-day operations. Several other pieces of rolling stock are also on display.

Inside the museum are numerous pieces of memorabilia and several collections. One unique collection includes over 200 "hopper car" models representing the elevator companies that purchased them, and several other equipment models, as well as an operating model train. Another collection includes "Time Tables" from every railroad in the United States.

The museum offers free mini-train rides on the grounds on Sundays and holidays.

Season: Memorial Day thru Labor Day.
Hours: Museum: 1 p.m. to 5 p.m., daily; mini-train rides: 2 p.m., 3 p.m. and 4 p.m., Sundays and holidays only. (The museum has been open on Thursday evenings from 7 to 9 p.m. Be sure to contact the museum before visiting, however.)
Cost: Admission and rides are free.
For further information write to the North Dakota Railroad Museum,

c/o Railroad Museum Historical Society, P.O. Box 1001, Mandan, ND 58554-7001 or call (701) 663-9322.

NORTHERN PACIFIC DEPOT

An original Northern Pacific depot, this building is now used as a City Parks Administration building, and is not open to the public. Outside, visitors can see a three-car train (two passenger cars and a caboose).

For further information write to City Parks Administration, 701 Main Ave., Fargo, ND 58103 or call (701) 241-1350.

OTHER RAILFAN NEWS

On Labor Day weekend the town of Rollag, Minnesota, holds its annual West Minnesota Steam Threshers Reunion. Over 250 acres are filled with work horses, steam-powered farm equipment and authentically reproduced buildings to recreate a turn-of-the century village. A special feature of interest to all rail fans is Locomotive No. 353, the last steam engine to operate in the Twin Cities, which runs on a two-mile track built by festival volunteers and which carriers up to 500 passengers at a time.

Dates: Aug. 31 to Sept. 3.
Hours: 5 a.m. to dusk each day.
Cost: Adults, $5; children under 15, free.
For further information write to W.M.S.T.R. Secretary, 2610 1st Ave. N., Fargo, ND 58102.

PIONEER HERITAGE CENTER

Located outside of Cavalier on Highway 5, the Pioneer Heritage Center is housed in a Great Northern Depot built in the 1890s. Icelandic State Park sits adjacent to the Center, but visitors need not enter the park to gain access to the Depot.

Season: Memorial Day thru Labor Day.
Hours: 9 a.m. to 5 p.m.
Cost: Free admission.
For further information write to the Pioneer Heritage Center, c/o Icelandic State Park, HCR 3, Box 64A, Cavalier, ND 58220 or call (701) 265-4561.

PIONEER VILLAGE & MUSEUM

The Pioneer Village in Rugby, North Dakota, houses the first railroad depot (built in 1886) of the Great Northern Railroad, and is now home to a wooden caboose which originated off that line. The Burlington Northern Railroad has been in operation since that date.

Also in Rugby is a 1906 depot, currently owned and operated by Amtrak. This depot is listed on the National Register of Historic Places. It is unique in that it was actually designed by an architect — an extravagance for those times.

The town of Rugby itself offers visitors another unique feature. It is the geographical Center of North America, as determined in 1931 by the U.S. Geological Survey.

Season: Village: May through Oct. 1st.
Cost: Adults, $3.50; students, $1; under 6, free.
For further information write to the Pioneer Village & Museum, R.R. 4, Box 12A, Rugby, ND 58368 or call (701) 776-6414.

SOO DEPOT TRANSPORTATION MUSEUM

Although this Soo line depot is now an American Legion Club Room, it has been nicely restored and is open to the public with permission. Besides a number of pieces of railroading memorabilia, the museum offers local and regional history and art displays.

Season: April through October.
Hours: 12 p.m. to 4 p.m., Mon.–Sat., and by appointment.
Cost: Free.
For further information write to the Soo Depot Transportation Museum, c/o Dennis & Meryl Lutz, 15 North Main St., Minot, ND 58701 or call (701) 852-2234.

SOO LINE LOCOMOTIVE #735 ROOSEVELT ZOO

The Roosevelt Zoo in Minot, North Dakota, is home to Soo Line Locomotive #735, a 4-6-2 coal burner steam locomotive.

Not too far away is Minot's Gavin Yard, a favorite contemporary train watching site for rail fans. The yard is the crossroads of the Soo Line and the Great Northern, called the Surrey cutoff. The state's highest and longest trestle bridge is also located nearby.

Season: Year-round.
For further information write to the Roosevelt Zoo, 1219 Burdick Expy. East, Minot, ND 58701 or P.O. Box 538, Minot, ND 58702 or call (701) 852-2751.

TOWNER COUNTY HISTORICAL MUSEUM

An old Soo Line Depot houses the Towner County Historical Museum in Egeland, North Dakota.

For further information call the Towner County Historical Museum at (701) 656-3698.

WILLISTON DEPOT

Presently an Amtrak depot, the Williston depot was built by the Great Northern Railroad. This unique depot resembles a pagoda in structure. Locomotive #3059, a 2-8-2 oil burner is on display outside. This engine was ordered in 1902 by the Soo Line, and is the only one of its class to remain in the states. The rest of these Baldwin engines were sent to Japan and became known as the "Mikado Class."

In the area, visitors can visit historic Fairview Lift Bridge and Snowden Tunnel (built into a butte, it is the only tunnel in the state).

For further information write to the Amtrak Depot, Williston, North Dakota.

OHIO

BUCKEYE CENTRAL SCENIC RAILROAD

Passengers board the Buckeye Central Scenic Railroad at the historic Newark, Ohio depot, built just after the end of the American Civil War. The depot now houses a large display of railroading memorabilia.

The train takes passengers on a 12-mile round trip over part of the former Shawnee branch of the Baltimore & Ohio Railroad, passing through Licking County, over two trestle bridges and a steel bridge which sits over the Licking River. Equipment used on the train includes Locomotive #8599, a 1948 Electro-Motive SW-1 (former Penn Central), two 1910 passenger cars, one 1956 passenger car, a 1941 gondola, and three cabooses.

Besides the regularly scheduled summer and fall excursions, several special events are offered each year, including "Halloween Nite Train," Santa Specials, train robberies and more. Be sure to contact the railroad for specific information.

Season: Memorial Day thru mid-Oct. (Charters available to end of Oct.)
Hours: Weekends only, 1 p.m. and 3 p.m.
Cost: Adults, $6; children (3–11 yrs.), $5; under 3, free.

For further information write to the Buckeye Central Scenic Railroad, P.O. Box 242, Newark, OH 43055 or call (614) 366-2029.

CUYAHOGA VALLEY SCENIC RAILROAD

The Cuyahoga Valley Scenic Railroad runs on track laid in 1880 by the Cleveland Terminal & Valley Railway. The CVSR now offers excursions of varying

lengths, with the longest going from Independence to Akron, Ohio. The route of the railroad runs through the Cuyahoga Valley National Recreation Area following the Ohio & Erie Canal and the Cuyahoga River.

One of five standard gauge diesel locomotives pulls the open-window or air-conditioned coaches.

For further information write to the Cuyahoga Valley Scenic Railroad, P.O. Box 158, Peninsula, OH 44141 or call 1-800-468-4070.

THE DENNISON RAILROAD DEPOT MUSEUM

The beautifully restored 1873 historic Pennsylvania Railroad station in Dennison, Ohio, now houses the Dennison Railroad Depot Museum. More than 3000 workers were once employed in the Pittsburgh, Cincinnati & St. Louis Railroad complex surrounding the depot in the mid-1860s. The building was used as a canteen during World War II, serving over one million GIs. Exhibits now include a canteen room, a large N-scale model railroad layout, the original men's and women's waiting rooms, the ticket booth, a cargo room, a Railway Express building and office, a 1950 former Norfolk & Western caboose, a 1946 "Thermos Bottle" engine, and railroading displays and memorabilia.

The museum also sponsors excursions through an arrangement with the Columbus & Ohio River Railroad in Coshocton. These excursions range from one-hour to all-day. (Be sure to contact the museum to get an accurate schedule for the time you plan to visit.) Equipment used on the train includes Steam Locomotive #1551, a 1912 Montreal Locomotive Works, former Canadian National, and several historic passenger coaches.

Season: Museum: Year-round. Trains: April to Dec. (dates vary from year to year).

Hours: Museum: Tues.-Sat., 10 a.m. to 5 p.m.; Sun., 11 a.m. to 5 p.m. Excursions: Vary according to excursion chosen.

Cost: Museum: Adults, $3; seniors, $2.50; students, $1.75; under 7, free. Excursions: Fares vary.

For further information write to the Dennison Railroad Depot Museum, P.O. Box 11, 400 Center St., Dennison, OH 44621 or call (614) 922-6776.

HOCKING VALLEY SCENIC RAILWAY
"A Piece of Yesterday ... Saved for Tomorrow"

Listed in the National Register of Historical Sites, the track of the Hocking Valley Scenic Railway runs over a century-old right-of-way, past brick kilns, a canal lock, and through the beautiful hills of southeastern Ohio. Passengers riding aboard the historic locomotives and passenger coaches may also visit Robbins Crossing, an 1860s settlers' village museum at Hocking College.

Season: Memorial Day through October.
Hours: Weekends only. Departs Haydenville (12-mile round trip) at noon. Departs Logan (25-mile round trip) at 2:30 p.m.
Cost: From Haydenville: Adults, $6.50; children (2-11 yrs.), $4. From Logan: Adults, $9.50; children (2-11 yrs.), $6.50.
For further information write to the Hocking Valley Scenic Railroad, P.O. Box 427, Nelsonville, OH 45764 or call (513) 335-0382 (weekdays) or (614) 753-9531 (weekends).

I&O SCENIC RAILWAY

Boarding either at Mason or Lebanon, Ohio, the I&O Scenic Railway follows an old stage coach route that was eventually turned into a train route. The original narrow gauge track was first laid in 1880. Today, the nine-mile trip lasts approximately 45 minutes each way.

The train used on the line also has historical significance. The diesel-electric locomotive was built in the 1950s for the Chicago, Burlington and Quincy Railroad and the four passenger coaches were built in 1930 for the Delaware, Lackawanna and Western Railroad. The I&O has restored them and added a 40-foot open gondola car for even more panoramic and picturesque views.

Season: May 1 to end of November.
Hours: Fri., from Mason Station, 2 p.m.; Sat. from Mason Station, 12 p.m. or 2:30 p.m. or from Lebanon Station at 1:15 p.m.; Sun., from Mason Station at 1 p.m. or 3:30 p.m.; from Lebanon Station at 2:15 p.m.
Cost: Round-trip fares: Adults, $9; seniors, $8; children (3-12 yrs.), $5.
For further information write to the I&O Scenic Railway, P.O. Box 414, Mason, OH 45040 or call 1-800-48-TRAIN or (513) 398-8584.

LINCOLN PARK RAILWAY EXHIBIT
THE ALLEN COUNTY HISTORICAL SOCIETY

The Allen County Historical Society and the Allen County Museum are two separate entities, even though the society is housed at the museum. All exhibits are owned by the society.

The Lincoln Park Railway Exhibit came about as a project to save recently retired Nickel Plate locomotive, No. 779 (the last steam locomotive built in Lima in 1949), a Nickel Plate official car (No. 5) and a Nickel Plate caboose (No. 1091), built in 1882. The car is Chauncy Depew's luxurious private car which was built by Pullman in 1883. An authentically equipped 1895 country station from the DT&I Railroad is also on exhibit, and a 1925 Shay, narrow gauge locomotive is located in a shelter adjacent to the museum.

For further information write to the Lincoln Park Railway Exhibit, c/o The Allen County Historical Society, 620 West Market Street, Lima, OH 45801 or call (419) 222-9426.

MAD RIVER & NKP RAILROAD MUSEUM

The Mad River & NKP Railroad Museum takes its name from the Mad River & Lake Erie Railroad and the Nickel Plate Railroad. The Mad River was the first chartered railroad in Ohio, traveling between Sandusky and Dayton, with Bellevue as one of its terminals. The first train arrived in Bellevue in 1938 and the first locomotive was the Sandusky. The Nickel Plate Railroad operated between Buffalo, Chicago, and St. Louis, and Bellevue was one of its major terminals.

In 1972, a society formed dedicated to preserving railroad history. In 1975, 24,500 sq. ft. of land was donated from the Norfolk & Western Railroad and 3630 sq. ft. was donated from the city of Bellevue, enabling a museum to open in June of 1976 for exhibition of a stone car, a caboose and two refrigerator cars. Additional land and rolling stock have been purchased, and numerous bits of memorabilia have been donated. Visitors are allowed to board the units equipped with steps and open doors.

Currently, approximately 30 pieces of rolling stock are on display: a 1946 Shaker Heights Pullman Trolley; CE&I Porter #7, "Fireless Cooker" built in 1943; Milwaukee Road Coach #618, built in Milwaukee in 1946; New Steel Caboose #516397; NKP Steel Box Car #25228, built in 1925; NKP Coach #105, built by Pullman in 1949; CB&Q "Silver Dome" #4714 (9401), the first dome car built in the U.S.; B&O Switch Engine built in 1904; WABASH F7A #571 Diesel, built in 1951; and more. Several buildings are also on display.

Season: Daily, Memorial Day through Labor Day; May, Sept. & Oct., weekends only.

Hours: 1 p.m. to 5 p.m.

Cost: Free admission, donations are welcome.

For further information write to the Mad River & NKP Railroad Society, Inc., 233 York St., Bellevue, OH 44811-1377 or call (419) 483-2222.

OHIO CENTRAL RAILROAD SUGARCREEK SERVICE

The Ohio Central Railroad is a 70-mile long working railroad. It operates the Sugarcreek Service which offers passengers steam or diesel-powered one-hour trips through the historic Amish country in Ohio known as "The Switzerland of Ohio." These trips run over former Wheeling & Lake Erie trackage.

Equipment used by the railroad includes Locomotive #1551, a 1912 Montreal 4-6-0 former Canadian National; Locomotive #13, a 1920 ALCO 2-8-0,

former Buffalo Creek & Gauley; a 1950 ALCO; and a 1942 ALCO 4-8-4, former Grand Trunk Western; and a couple of former Burlington, Grand Trunk & Lackawanna passenger coaches.

Season: First of May to end of October.

Hours: Mon.-Sat., 11 a.m., 12:30 p.m., 2 p.m. & 3:30 p.m. Extra trains sometimes run at 9:30 a.m. and 5:00 p.m. as the demand warrants.

Cost: Adults, $6.50; children (3-12 yrs), $4.50; under 3, free.

For further information write to the Sugarcreek Service, Ohio Central Railroad, P.O. Box 427, Sugarcreek, OH 44681 or call (216) 852-4676.

ORRVILLE RAILROAD HERITAGE SOCIETY
ORRVILLE DEPOT

The Orrville Depot was built in 1868 and served the Pittsburgh, Fort Wayne & Chicago, and the Cleveland, Akron & Columbus railroads, which both later became part of the Pennsylvania Railroad. Railroading artifacts and memorabilia are on display in this restored depot, along with other items of historical significance to the Orrville area. The interlocking tower that controlled the junction is on display, but not yet restored.

The Orrville Railroad Heritage Society sponsors periodic excursions from this depot. Most excursions are pulled by the former Nickel Plate 2-8-4 #765 locomotive and travel to various locations. Diesel engines are used occasionally, but steam power is used as often as possible. As these excursions are not regularly scheduled, we suggest you contact the society to get their most recent list.

Season: Depot: April to mid-Oct. (Not open when excursions are running.) Excursion: Contact the society for accurate information.

Hours: Depot: 10 a.m. to 4 p.m.

Cost: Depot: No admission charge. Trains: Fares vary according to excursion.

For further information write to the Orrville Railroad Heritage Society, P.O. Box 11, Orrville, OH 44667 or call (216) 683-2426.

QUAKER SQUARE RAILWAY CO.

The Quaker Square Railway Company's home office is located in Quaker Square's Depot Restaurant. The Restaurant is part of the complex which was built in what was formerly the mills, silos and railyards of the original Quaker Oats cereal factory and Akron's Railway Express Agency terminal. The Depot Restaurant also serves as a railroading museum, exhibiting a former Yard Master's Office (circa 1943) and a display from the "Railways of America" collection of "model rail baron" Mack Lowry.

OHIO 115

Quaker Square Railway Co.

Various pieces of railroading equipment and rolling stock are on display on the grounds of the Quaker State Railway Company. Burlington Railroad's switching locomotive No. 1548, a Pennsylvania Railroad solarium car, a circa 1900 baggage car, a caboose and a narrow gauge German-made Gotha steam engine are located near the entrance to the Depot Restaurant. At other locations visitors can see the "Skyline View" (a round-end observation-lounge car), "The Metropolitan View" (sister to the "Skyline View," not yet restored), and a Pullman car—one of the last six existing Altoona-built buffet/lounge/observation cars formerly assigned to the Trailblazer and the Jeffersonian trains.

The "Skyline View" was built by Pullman in 1938 as a rear end car on the New York to Chicago line of the Broadway Limited. Restoration was completed in 1982, and it is currently used as the office for the Quaker Square Management Company.

Several cars on the grounds are used as company cars, including Business Car No. 1 which was built in 1928 by the Pullman Co. as Pennsylvania's No. 1157, a coffeeshop/tavern car assigned to the New York to Washington run.

There is much here to be enjoyed by rail fans, but even non-fans might find the complex interesting. The Quaker Square Hilton is probably the most interesting "non-railroading" sight, as it is built in the former silos of the

Quaker Square Hilton

Quaker Oats Company. All-in-all, if you are looking for a unique minivacation, this is the place to take it!
Season: Year-round.
For further information about the trains, restaurant or hotel, write to the Quaker Square Management Co., 135 South Broadway, Akron, OH 44308 or call (216) 253-5970. For hotel reservations call 1-800-HILTONS.

TOLEDO, LAKE ERIE & WESTERN RAILWAY & MUSEUM

The Toledo, Lake Erie & Western Railway is an "operating museum," as equipment used is of historical significance. Currently, the train itself is powered by either #1 (a 1941 Whitcomb), #112 (a 1946 ALCO switcher), or #5109 (a 1948 ALCO switcher). Display cars are also used as needed. These include a 1916 New York Central, a 1924 NYC, a 1930 Lackawanna electric commuter car, Pullman Standard coaches, and a number of cabooses. Two other locomotives are on display: #15, a 1908 Porter 0-6-0 Brooklyn Eastern District Terminal (slated to run in 1995); and #202, a 1920 Baldwin 0-6-0 Detroit Edison. Other equipment also on display includes #406, a 1922 Wabash Coach; a 1924 Pullman from Pennsylvania; a 1943 Pullman Troop Sleeper; a C&O Woodside Caboose; two tank cars; three refrigerator box cars; two flat cars and one hopper car.

Trains may be boarded at either Waterville or Grand Rapids. The 20-mile trip takes passengers on a 60-minute ride past such historical sites as the 900

foot long bridge over the Maumee River, and the old Miami and Erie Canal. The "Grand Rapids Applebutter Special" is also offered one weekend each year. (Check with the Railway for specific date each year.)

Season and Hours: Second week in May through last weekend in Oct., Sat., Sun. & holidays, leaves Waterville at 1 p.m. or 4 p.m. or Grand Rapids at 2:30 p.m. or 5:30 p.m. June through Aug., Tues., & Thurs., leaves Waterville at 10:30 a.m. or 1:30 p.m. or leaves Grand Rapids at 11:45 a.m. or 2:45 p.m.

Cost: Round-trip: Adults, $8; seniors (65+), $7; children (3-15 yrs.), $4.50; 2 and under, free. One-way: Adults, $5.50; seniors, $5; children, $3.25; 2 and under, free.

For further information write to the Toledo, Lake Erie & Western Railway, P.O. Box 168, Waterville, OH 43566 or call the Waterville Depot at (419) 878-2177 or the Grand Rapids Depot at (419) 832-4671.

OKLAHOMA

HUGO HERITAGE RAILROAD
CHOCTAW COUNTY HISTORICAL SOCIETY

The Choctaw County Historical Society was formed in 1977 for the express purpose of saving the old 1914 Frisco (St. Louis-San Francisco) Depot from demolition and turning it into a museum. It is the largest depot left on Frisco's old southwest lines. The first floor consists of a waiting room with hand-rubbed ceiling beams, restrooms with original fixtures (Frisco Special), a train room with HO gauge model trains, and an original Harvey House Restaurant (one of the last left in the country that is still serving meals). The waitresses wear period costumes in the old railroading atmosphere. An original, well-preserved Fred Harvey Newsstand is also on the premises.

The depot's second floor was originally divided, with housing for the Harvey Girls on one side and Frisco offices on the other. The dividing wall has been partially removed to provide easy access through the museum.

A diesel engine owned by the Kiamichi Railroad pulls the Hugo Heritage Railroad's coaches over the route of the Frisco's old right-of-way north to Antlers, Oklahoma, or south to Paris, Texas, giving passengers a 45-mile, two-hour round trip excursion through the beautiful woods and rural countryside of southeastern Oklahoma. The route is determined by the Kiamichi Railroad, which routes the Heritage train around its freight traffic.

The two train coaches owned by the Hugo Heritage Railroad are the "Kiamichi Country," formerly the Norfolk & Western #1001, and "Circus City USA," formerly the N&W #1003; both were built in the 1940s. They were

eventually acquired by the Hugo Heritage Railroad and restored and reconditioned at the Kiamichi Railroad Shops in Hugo, Oklahoma.
 Season: First Sat. in April through November's fall foliage change.
 Hours: Every Sat. only, boarding at 1:45 p.m. and departing the Depot at 2 p.m.
 Cost: Adults, $15; children (under 12), $10; 2 and under, free.
 For further information write to the Hugo Heritage Railroad, Choctaw County Historical Society, P.O. Box 577, Hugo, OK 74743.

THE WATONGA CHIEF DINNER & EXCURSION TRAIN

The Watonga Chief is operated by the Central Oklahoma Rail Club along the AT&L Railroad line in Watonga. Equipment consists of a restored, vintage streamlined diesel-electric locomotive, coach, dining car and two cabooses. Passengers can choose from two excursions: an eight-mile, 45-minute "River Train" or a 20-mile, 2½-hour "Red Hill Train." An elegant dinner aboard the classic dining car is an additional option.
 The Rail Club also sponsors the Oklahoma City Train Show each December at the Oklahoma City Fairgrounds. Vendors of model railroad gear, railroad memorabilia and materials of every description attend this show from all over the nation.
 Season: Weekends in Spring and Fall.
 Hours: Trains generally depart at 1 p.m., 2 p.m. and 4 p.m.
 Cost: River Train: $5; Red Hill Train: $17.50; Dinner (on Red Hill Train only): $27.50.
 For further information write to the Watonga Chief, 2100 S.W. 61st Terrace, Oklahoma City, OK 73159 or call (405) 737-3518.

OREGON

MOUNT HOOD RAILROAD
MOUNT HOOD RAILROAD DEPOT

The Mount Hood Railroad offers passengers a 44-mile, four-hour round trip from Hood River to Parkdale, Oregon. During the trip, passengers can see breathtaking views of Mount Hood, Mount Adams, mountain forests and valleys while riding on Pullman coaches or the newly refurbished vintage caboose.
 Passengers board at the historic 1911 Mount Hood Railroad Depot, listed on the National Registry of Historic Places and recently restored.

Regular excursions are offered throughout the year along with a large number of special events. Be sure to contact the railroad for specific information.
Season: Year-round.
Hours: Jan. through March, third Saturdays at 10 a.m.; April through June & Oct., Wed.-Fri. at 10 a.m. and weekends at 10 a.m. and 3 p.m.; late June through end of Sept., Tue.-Sun., 10 a.m. & 3 p.m.; Thanksgiving weekend through designated dates in Dec., 10 a.m.
Cost: Adults, $19.95; seniors, (60+), $16.95; children (2-11 yrs.), $11.95; $1 discount on weekdays from Jan. to May and Oct. to Dec.
For further information write to the Mount Hood Railroad, 110 Railroad Avenue, Hood River, OR 97031 or call (503) 386-3556.

SUMPTER VALLEY RAILROAD RESTORATION

The Sumpter Valley Railroad Restoration members have successfully restored a Sumpter Valley Railroad Steam Locomotive, several SVR boxcars and stock cars, and more. The Steam Locomotive is now used to take passengers on a 10-mile trip through a wildlife area, past the rugged Elkhorn Mountains, through Sumpter Valley and on into Sumpter City and back. Regular excursions are scheduled throughout the season, while dinner rides are offered three times a year, and other special events are sometimes offered. Be sure to contact the railroad before visiting.

The newly opened Sumpter Valley Railroad museum is located in the historic Sumpter depot.
Season: Memorial Day weekend through end of September.
Hours: Weekends and holidays.
Cost: Round-trip: Adults, $8; children, $6; family fares, $20. One-way: Adults, $5; children, $4; family fares, $13.
For further information write to the Sumpter Valley Railroad Restoration, P.O. Box 389, Baker City, OR 97814 or call (503) 894-2268.

PENNSYLVANIA

ALLEGHENY PORTAGE RAILROAD NATIONAL HISTORIC SITE
(*see also* AMTRAK HISTORIC RAILTOUR)

The Allegheny Portage Railroad National Historic Site, a 1500-acre national park in west-central Pennsylvania, commemorates the first railroad to cross the Allegheny Mountains. At the park visitor center are exhibits on the railroad,

an introductory film, a book store and a park ranger who can answer any questions visitors might have about the area. On the premises are historic structures and remains of the railroad, as well as a new exhibit building built at the site of Engine House #6 (parts of the original building are sheltered there).

In 1826, state engineers established the Pennsylvania Main Line Canal, a route that eventually reached Pittsburgh (390 miles away). The supposedly uncrossable Allegheny Mountain barrier was breached when canal boats were placed on railroad-type flatcars and hauled over ten inclined planes between the Hollidaysburg canal basin in the east and the Johnstown canal basin in the west. The railroad, which reduced travel time from Philadelphia to Pittsburgh dramatically, was considered a technological wonder of its day and became a focal point for opening up trade to the interior. The remains of Inclined Plane #6 is at the end of the boardwalk outside the visitor center, along with a section of reconstructed track. A full-size model of one of the incline's stationary steam engines is located inside the new exhibit building.

(Original structures were mostly destroyed in the famous Johnstown flood.)

Season: Year-round; closed Christmas Day.

Hours: 9 a.m. to 6 p.m. daily, Memorial Day to Labor Day; 9 a.m. to 5 p.m., remainder of the year.

Cost: Free admission.

For further information write to the Allegheny Portage Railroad National Historic Site, Box 189, Cresson, PA 16630 or call (814) 886-6150.

AMTRAK HISTORIC RAILTOUR
(see also ALLEGHENY PORTAGE RAILROAD NATIONAL HISTORIC SITE)

Although most Amtrak trips are not recorded here, we felt this excursion was of great enough historic significance to interest most rail fans.

From early June through mid-October, National Park Service rangers narrate a train excursion through scenic and historic Allegheny Ridge, between Johnstown and Altoona, Pennsylvania. Passengers view sites of early transportation marvels, the Great Johnstown Flood of 1889, and other industrial innovations. Much of the track follows the route of the great flood.

Season: Early June through mid-October.

Hours and cost: Contact an AMTRAK agent in Johnstown (814) 535-3313 or in Altoona (814) 946-1100.

For further information about the tour contact the National Park Service at (814) 495-4643.

AVONDALE RAILROAD CENTER

A former Atlanta, Birmingham & Atlantic Baldwin steam locomotive and four former Pennsylvania Railroad passenger cars make up the Avondale

Bellefonte Historical Railroad's Rail Diesel Car. The railroad operates the RDC in scheduled excursion and charter service on former PRR trackage in central Pennsylvania.

Railroad Center which sits on trackage from the former Pennsylvania Railroad Octoraro Branch line. This line once extended from Chadds Ford to the Maryland state line. An antique shop (Iron Horse Antiques) is located inside the train, while the original Avondale (former Pennsylvania) passenger station and a former Pomeroy & Newark Railroad freight station are nearby. The freight station is the only surviving station from that line.

Season: Year-round.

Hours: 9 a.m. to 5 p.m., daily. (Antique Shop is open Wed. through Sun. only.)

Cost: No charge.

For further information write to the Avondale Railroad Center, State & Pomeroy Streets, P.O. Box 809, Avondale, PA 19311 or call (215) 268-2397.

BELLEFONTE HISTORICAL RAILROAD

The Bellefonte Historical Railroad departs from the restored Pennsylvania Railroad station in Bellefonte. The station houses the ticket office and a small "Centre County railroading" museum. The tracks were once owned by the Pennsylvania Railroad and are now used by freight trains of the Nittany & Bald Eagle Railroad and passenger trains of the Bellefonte Historical Railroad.

Passengers can choose a regularly scheduled trip, a chartered trip, a weekend trip, a dinner excursion, or special Fall or Christmas excursion, all of which travel over the more than 60 miles of track in Centre, Clinton and Blair counties in scenic central Pennsylvania. (Many excursions require reservations, so be sure to plan ahead.)

Equipment used by the Railway includes two air-conditioned Rail Diesel Cars (formerly with the Reading and the New Haven railroads).

Season: Summer & Fall: Weekends or special excursions only.

Hours: Vary according to excursion chosen.

Cost: Varies according to excursion chosen.

For further information write to the Bellefonte Historical Railroad, The Train Station, Bellefonte, PA 16823 or call for tickets and schedules (814) 355-0311 or charters (814) 355-2392.

THE BLUE MOUNTAIN & READING RAILROAD

The Blue Mountain & Reading Railroad offers scenic excursions along the Historic Schuykill Division of the Pennsylvania Railroad, between Temple and South Hamburg, Pennsylvania. A 1½-hour round-trip tour takes passengers over 26 miles of beautiful Pennsylvania Dutch countryside, including views of the Schuykill River and Canal, and a ½-hour layover at "the end of the line" (depending on where the train was boarded).

Locomotives used by the railroad might be either antique steam or a Reading Railroad diesel. The most often used steam locomotive is #2102, built in 1945 in Reading, Pennsylvania. Also run is #425, built by Baldwin. Special events are offered throughout the year during which passengers also ride vintage coaches.

Season: May through June, Sat., Sun., and Memorial Day; July through August, daily; September through October, Sat., Sun., and Labor Day.

Hours: From Temple Station: 1 p.m. or 3 p.m. From Hamburg: Noon, 2 p.m. or 4 p.m.

Cost: Adults, $7; seniors, $6; children (3-12 yrs.), $5. All Day Passes: $10; season passes (60 rides), $75.

For further information write to the Blue Mountain & Reading Railroad Co., P.O. Box 425, Hamburg, PA 19526 or call (610) 562-2102 or (610) 562-4083.

EAST BROAD TOP RAILROAD
adjacent to both the
SHADE GAP ELECTRIC RAILWAY & THE ARDEN TROLLEY MUSEUM

The EBT, listed as a national historic landmark, is the only narrow gauge railroad in the Eastern U.S. still operating at its original site. For 75 years, the

EBT's narrow gauge steam-powered locomotives pulled cars carrying coal and other raw materials for American industries. When the railroad closed in 1956, the trains, the 33-mile track, the yard and the shop were left intact, and are now available for rail fans to experience.

Visitors to the EBT Railroad can see all of the buildings, track and equipment previously owned and operated by the original EBT, as well as take a 50-minute, narrated train ride through the scenic Aughwick Valley. Beginning at the Orbisonia Station on the grounds, the train travels to Colgate Grove where it is turned around for the return trip.

The Shade Gap Electric Railway and Arden Trolley Museum are located adjacent to the East Broad Top Railroad. Trolleys run weekends and holidays from Memorial Day through October, every half-hour from 11:30 a.m. to 4:30 p.m.

Season: End of May through mid-October.

Hours: 11 a.m., 1 p.m., 3 p.m. Guided walking tours of the grounds: 10:15 a.m., 12:15 p.m., 2:15 p.m., 4:15 p.m.

For further information write to the East Broad Top Railroad, c/o Southwestern Pennsylvania Heritage Preservation Commission, 105 Zee Plaza, P.O. 565, Hollidaysburg, PA 16648-0565 or call (814) 447-3011.

"ENGINE #604 – THE EMPIRE CAR
THE GREENVILLE AREA RAILROAD MUSEUM

Built in 1936, Engine #604 was the largest switch engine ever built (322 tons). Nine were originally built for the Union Railroad at the Baldwin Works in Philadelphia, but #604 is the only one that remains. This two-seater cab has a unique 0-10-2 wheel arrangement. During its years of service for the Union line, the Greenville engine was called the 304, but took on #604 while working in Minnesota's iron ore industry.

Also on display with the engine are a coal tender which hauled 14 tons of coal, a hopper car built in 1952 at Greenville Steel Car Co. (used by the Bessemer & Lake Erie Railroad), and a caboose (crew car originally used in the Bessemer & Lake Erie Railroad's Shenango Yards in Greenville).

Season: Fri., Sat., and Sun., first weekend in May through first weekend in June (also Memorial Day), and September and October. Daily, beginning second week in June through Labor Day.

Hours: Noon to 5 p.m.

Cost: No admission charge; donations accepted.

For further information write to Friends of Engine 604, Shenango-Pymatuning Chapter No. 154, National Railway Historical Society, 314 Main Street, Greenville, PA or call (412) 588-4009 or write to the Greenville Area Chamber of Commerce, P.O. Box 350, Greenville, PA or call (412) 588-7150.

THE FRANKLIN INSTITUTE

Although no excursions are available, we felt that the transportation displays offered here are of such significant interest to rail fans that this site should be listed in this book. Locomotives on display include the "Rocket" (built in 1838 in England), a Reading Railroad 4-4-0 built in the mid-1800s, a 1926 Baldwin 4-10-2 (No. 60000), a three-cylinder compound engine with a water-tube firebox and more. Other pieces of railroad equipment are on display along with other transportation exhibits. Scientific and technological displays can also be seen in this large museum.

Season: Year-round.

Hours: Daily, 9:30 a.m. to 5 p.m.

Cost: Varies according to exhibits being offered.

For further information write to the Franklin Institute, 20th & The Parkway, Philadelphia, PA 19103 or call (215) 448-1200.

THE GETTYSBURG RAILROAD

The Gettysburg Railroad and Engine #1278 offer a choice of two excursions (rain or shine). Passengers may board at the Gettysburg Station and take the 16-mile, 1½-hour round trip to Biglerville and back, or board at Gettysburg and take a 50-mile, five-hour trip to Mt. Holly Springs and back. Reservations are suggested for the Mt. Holly Springs trip. Dinner trips are offered once a month from May to September on the Mt. Holly Springs train. Special events are also offered throughout the season.

The original Gettysburg Railroad began in 1864, finally opening for business in 1870. In 1872 the line was bought by the South Mountain Iron Company and eventually sold to the CVRR who, in turn, sold it back to the original owners (who had reorganized). After a few more name changes, it merged into the Conrail system, who abandoned it in 1975. In 1976, Mr. Sloan Cornell and family took over the branch from Gettysburg to Mt. Holly Springs and called it the Gettysburg Railroad. It now moves freight and operates an excursion line known as Gettysburg Railroad Passenger Service.

Steam Engines used on the Gettysburg Railroad are: No. 1278, a 4-6-2 Canadian Pacific (pictured on front cover), built in 1948; and No. 76, a 2-8-0 Baldwin, built in 1920. Diesel Engines used are No. 70, an RS3 & ALCO, and No. 39, an old Western Maryland EMD. The coaches used on the excursions were all built between 1920 and 1930, with the double decker open car being built in 1986 by Gettysburg for these excursions.

The Gettysburg Railroad Passenger Service station is the former Reading Station, built in 1881 and recently renovated. The original waiting room seats are in place (stamped with the letters G&H for Gettysburg & Harrisburg), along with the original stained glass windows.

Season: April through October, with Christmas Train offered in December.

Hours: Two trips each day from each station, generally boarding at

Horseshoe Curve National Historic Landmark

11 a.m. or 1 p.m. or 3 p.m. We suggest you send for the train schedule for exact boarding times.

Cost: Regular Fares (16-mile trip): Adults, $7.50; seniors (65+), $7; children (3-12 yrs.), $4. Regular Fares (50-mile trip): Adults, $16; seniors, $15; children, $9. Add dinner costs to price of 50-mile trip (order from menu).

For further information write to the Gettysburg Railroad, 106 North Washington St., Gettysburg, PA 17325 or call (717) 334-6932.

HORSESHOE CURVE NATIONAL HISTORIC LANDMARK
(*see also* RAILROADERS MEMORIAL MUSEUM)

In 1992, the Railroaders Memorial Museum opened a multi-million dollar interpretive facility at the Horseshoe Curve National Historic Landmark. Horseshoe Curve was a unique civil engineering solution to the steep mountain grade in the area, allowing for the first rail crossing of the Allegheny Mountains (1854), thus opening up rail transportation to the Western United States. Conrail still runs over 50 freight trains per day over the "Curve."

A ride to track elevation (an elevation increase of 100 feet over a distance of 270 feet) on the single-track Funicular provides passengers with a panoramic

view of the Horseshoe Curve. The Funicular cabins were built in the shops of the Durango & Silverton Narrow Gauge Railroad in Durango, Colorado. Visitors may also walk the newly-built steps to the area—all 194 of them!

Season & hours: Summer (April through October), 9:30 a.m. to 7 p.m., daily; Winter (November through March), 10 a.m. to 4:30 p.m., Tuesday through Sunday.

Cost: Free admission, but Funicular ride fares are $1.50. (Two "tokens" cost $1.50, and are used to purchase tickets for the Funicular, or can be saved as unique souvenirs.)

For further information write to the Visitors Center, Horseshoe Curve National Historic Landmark, 1300 Ninth Ave., Altoona, PA 16602 or call (814) 941-7960.

KNOX, KANE, KINZUA RAILROAD

The narrow gauge Pittsburgh, Bradford and Buffalo Railroad was completed from Knox, Pennsylvania, to Marienville in 1881, to Kane in 1882, and then to Jewett in 1883. In October of that year the line was taken over by the Pittsburgh and Western Railroad, who sold out to the Baltimore and Ohio Railroad in 1902. In 1911, standard gauge track was laid and Baltimore & Ohio began running passenger and/or freight services on that line. In 1982, the Knox and Kane Railroad purchased the track from Knox to Mt. Jewett and now runs excursion tours pulled by steam engines.

The Knox, Kane, Kinzua is the only train that runs over the historic Kinzua bridge on either its 96- or 32-mile journey through the peaks and valleys of the Allegheny National Forest. The Kinzua Bridge, built in 1882, was the highest railroad bridge in the world at that time, and is believed to be the second highest railroad viaduct in the U.S., and the fourth highest in the world, even today. It was placed on the National Register of Historic Places in 1977 and designated as a National Historic Civil Engineering Landmark in 1982.

Across the street from the Marienville station is the Marienville Area Railroad and Historical Museum which features the "Collection of Railroad Items and Artifacts." Caboose rentals (for riding and/or camping) are available from the Railroad.

Season: June: Fri., Sat., Sun.; July and August: Tues.-Sun.; September: Fri., Sat., Sun.; First two weeks in October: Wed.-Sun.; second two weeks: Sat., and Sun.

Hours: Leaves Marienville at 8:30 a.m.; leaves Kane at 10:45 a.m. Reservations are suggested.

Cost: Round-trip from Marienville to Bridge (96 miles): Adults, $20; children (3–12 yrs.), $13. Round-trip from Kane to Bridge (32 mi.): Adults, $14; children, $8.

For further information write to the Knox, Kane, Kinzua Railroad, P.O. Box 422, Marienville, PA 16239 or call (814) 927-6621.

PENNSYLVANIA

LAKE SHORE RAILWAY MUSEUM

The Lake Shore Railway Historical Society has operated this museum in the former New York Central passenger depot since 1970. Visitors can sit on old waiting room benches once used in the old Nickel Plate station in nearby Erie, and watch the more than 60 trains that pass by each day. Occasional special excursions are also offered by the museum, but passengers must check ahead to see when these are offered (usually in the fall).

Inside the museum, numerous artifacts are on display, including the Centralized Traffic Control board built in 1943, a large collection of signal lanterns, dining car dishes, a one-tenth scale model of a steam engine built by the Heisler Locomotive Works in Erie for their salesmen to use when visiting prospective customers, and much more.

Outside the museum, the old tracks hold more than a dozen pieces of rolling stock (normally on static display, but refurbished and running occasionally). Pieces include four electric or gasoline-driven locomotives; a 1918 Chicago, Burlington & Quincy #1530 steel baggage car; several Pullman lounge cars or combination cars (some dating back to the '20s); and more. The museum can provide rail fans with a well-done equipment roster.

Rail fans Ted and Sally Church also offer their personal collection for display at the museum during most summer weekends. This extensive collection is housed in their wooden caboose and three former World War II troop sleepers.

Season and hours: End of May through Labor Day: Wed.–Sun. (and holidays), 1 p.m. to 5 p.m.; September 10 through end of October: Sat. & Sun., 1 p.m. to 5 p.m. Special excursions offered at other times.

Cost: No admissions charge to the museum (donations appreciated). Excursion costs are generally: Adults, $30; children (under 16), $24. Reservations required.

For further information write to the Lake Shore Railway Museum, c/o the Lake Shore Railway Historical Society, P.O. Box 571, North East, PA 16428-0571 or call (814) 825-2724.

MIDDLETOWN & HUMMELSTOWN RAILROAD

The original Middletown & Hummelstown Railroad was incorporated in 1888 by local businessmen who began construction in 1889. The line was completed in 1890 and was operated as part of the Reading system until 1976, when it became an independent railroad by the same name.

Today, passengers board vintage 1920 coaches for a scenic 11-mile, 1¼-hour round trip narrated excursion along the Swatara Creek to Indian Echo Caverns, following the towpath of the historic Union Canal (1827 to 1884). Passengers can see sections of the Canal (including a canal lock), old limekilns, and Horse Thief Cave. A 45-minute tour of Indian Echo Caverns can be taken at one end of the line, if desired.

Currently, two GE diesel-electric centercab locomotives pull the vintage coaches. #1 was built in 1941 and #2 was built in 1955. Plans are to have a former Canadian National 2-6-0 steam locomotive (#91) operational soon. Other pieces of rolling stock on display at the "yard" include streetcars, a snowsweeper and a wooden boxcar with link and pin couplers.

Season: May through October with several special excursions offered at other times.

Hours: Vary according to season and excursion chosen.

Cost: Regular round-trip fares: Adults, $5.75; children (3-11 yrs.), $2.75. Combined train/cavern tickets: Adults, $12.75; children, $6.25. Special excursion prices vary.

For further information write to the Middletown & Hummelstown Railroad, 136 Brown Street, Middletown, PA 17057 or call (717) 944-4435.

NEW HOPE & IVYLAND RAILROAD

This standard gauge steam train adventure takes passengers on a nine-mile, 50-minute narrated round trip excursion between New Hope and Lahaska, Pennsylvania. Rolling stock used on these excursions include a Lancaster & Chester 2-8-0 #40 Baldwin built in 1925, an RSC-2 Seaboard Air Line #1102 built by ALCO in 1949, and an SW-1 Pennsylvania Railroad #9423 built by EMD in 1954, several ex-Reading Railroad passenger cars, two parlor cars and several dining cars. Also on display is Engine #1533 (a 4-6-0 ex-Canadian National), Locomotive #9 (a 0-6-0 ex-US Army unit), a Baldwin VO diesel and several passenger and freight units.

Aside from the scenic Pennsylvania countryside, passengers will see the famous "Perils of Pauline" Trestle used in the silent movie, and an underground railroad house used to harbor slaves. Several special excursions, including dinner trains, a Wine & Cheese Train, and several holiday excursions are offered by the New Hope & Ivy. Passengers may board either at the New Hope Station or at Lahaska Station. A gift shop is also available at the "Freight House."

Season: Year-round, schedules change seasonally.

Hours: Trains generally depart from New Hope Station hourly from 11 a.m. to 4 p.m.; from Lahaska Station hourly from 11:30 a.m. to 4:30 p.m. (Be sure to send for train schedule for exact times.)

Cost: Adults, $7.50; seniors (62+), $5.59; children (3-11), $3.95; under 3, $1. "Special Train" fares vary according to excursion chosen.

For further information write to the New Hope & Ivyland Rail Road, P.O. Box 634, New Hope, PA 19446 or call (215) 862-2332 or Fax (215) 862-2150.

OIL CREEK & TITUSVILLE RAILROAD

The history of the Oil Creek & Titusville Railroad dates back to the time of the world's first oil boom. The route runs "through the valley that changed the

world," where oil history began, and travels past sites of towns that sprang up over night when the oil boom started, then disappeared just as quickly when it was over.

Today, passengers can board the train at Rynd Farm, at the Perry St. Station in Titusville, or at the Drake Well Museum south of Titusville. The Perry Street Station is a restored 1892 freight house. Nearby sits a working replica of the historic first successful oil well, built by Edwin L. Drake. Rynd Farm is four miles north of Oil City, where Jonathan Watson became the world's first oil millionaire.

The only working railway Post Office car still in existence in the U.S. is on the OC&T railway. Passengers can write letters or send postcards and have them cancelled with the OC&T mark.

Passengers may choose to deboard at Petroleum Centre, a recreational park and visitors center.

The Roster of Equipment includes the following: Locomotive #75, an S-2 turbo-charged diesel-electric switch engine built in 1947 by the American Locomotive Co. for the Southern Buffalo Railroad; 7 OC&T passenger cars built in 1930 as electric multiple unit motor cars for the Delaware, Lackawanna & Western Railroad; a 1925 Pullman previously owned by the Keystone-Buckeye Railcar Corp.; Lakeshore #1399, built by Pullman in 1922 as a coach for the Wabash Cannonball; the Railway Post Office car, built in 1927 for the Chesapeake & Ohio Railroad; and a wood-sided open car, originally built as a flat car in 1944 for the Great Northern Railroad.

Season: Mid–June through late October.

Hours: June: Sat. & Sun.; July 1 through August 31: Wed., & Fri.–Sun.; September 1 through September 30: Sat. & Sun.; October 1 through October 23: Wed., & Fri.–Sun. Hours actually vary depending on where passengers board the train. Two trains run per day, rain or shine.

Cost: Round-trip: Adults, $9; seniors (60+), $8; children (3–12 yrs.), $5; Bicycles, $1; Canoes, $2.

For further information write to the Oil Creek & Titusville Railroad, P.O. Box 68, Oil City, PA 16301 or call (814) 676-1733.

PIONEER TUNNEL COAL MINE RAILROAD

The Pioneer Tunnel Coal Mine Railroad offers passengers a 1½-mile steam ride from Ashland along the Mahaney Mountain line to an abandoned anthracite strip mine, where passengers may disembark for a tour of the mine. Before boarding the open mine cars or vintage red caboose, passengers can view the "Henry Clay," a 1927 Vulcan steam locomotive on display.

Season: Daily, Memorial Day through Labor Day; weekends in September and October.

Hours: Daily, 10 a.m. to 6 p.m. Hours occasionally vary, so be sure to contact the railroad before visiting.

Cost: Train: Adults, $2.25; children (under 12), $1.25. Mine Tour: Adults, $5; children $2.75.

For further information write to the Pioneer Tunnel Coal Mine Railroad, 19th & Oak Streets, Ashland, PA 17921 or call (717) 875-3850 or (717) 875-3301.

RAIL TOURS, INC.

Passengers board vintage coaches at the Jim Thorpe Depot, a former Jersey Central Railroad station in downtown Jim Thorpe, Pennsylvania. The depot now contains the ticket office for Rail Tours and a museum featuring mining artifacts and other items of local history.

Three different steam excursions are offered by Rail Tours, all of which run over former Jersey Central Branch line trackage. A 45-minute round trip, a 1½-hour round trip and a 2½-hour round trip are available. Dining cars are available on some of the trips, and other features sometimes change by trip, so be sure to contact Rail Tours before visiting.

Equipment on the roster includes a 1913 4-6-0, former Canadian Pacific (#1098) locomotive; locomotive #56, an EMD F3A, former Central of New Jersey; several vintage coaches (formerly from Reading or Central of New Jersey); and a number of cabooses and freight cars.

Season: April through September plus fall foliage tours in October.

Hours: Vary according to excursion chosen. Send to Rail Tours for an accurate schedule.

Cost: Fares vary, but generally adult tickets range in price from $5 to $12; children (3-11 yrs.) tickets range in price from $3 to $6; under 6 is free.

For further information write to Rail Tours, Inc., P.O. Box 285, Jim Thorpe, PA 18229 or call (717) 325-4606.

RAILROAD MUSEUM OF PENNSYLVANIA

The Railroad Museum of Pennsylvania exhibits an extensive collection of locomotives, cars and railroad equipment (over 80 units all together), as well as offering special events that would be of interest to rail fans. At various locations throughout the museum's more than 100,000 square feet of space, visitors can explore pieces of railroading equipment, entering the cab of a steam locomotive, walking under Locomotive #1187, or viewing the state room of a private care or the interior of a Pullman sleeper.

At least once a year, the Museum sponsors an actual train ride in conjunction with the local Railroaders Historical Society.

Season: Year-round.

Hours: Mon.-Sat., 9 a.m. to 5 p.m.; Sun., noon to 5 p.m. (Closed Mondays, November through April and certain holidays.)

Cost: Adults, $6; seniors, $5; youth (6-17 yrs.), $4.

Railroad Museum of Pennsylvania

For further information write to the Railroad Museum of Pennsylvania, Box 15, Strasburg, PA 17579 or call (717) 687-8628.

RAILROADERS MEMORIAL MUSEUM
(see also HORSESHOE CURVE NATIONAL HISTORIC LANDMARK)

The Railroaders Memorial Museum in Altoona opened in 1980 with a 10,000 square foot facility. The unique aspect of this museum is that it is a socio-

GG1 #4913 in background of visitors to the Railroaders Memorial Museum.

cultural display, dedicated to the railroad *workers* and railroad *work,* not to the technology of the railroading industry. Indoors, interpretive exhibits use selected artifacts as "windows" to the stories of the men and women who designed, built, and operated the Pennsylvania Railroad. Outside, several pieces of rolling stock are not just on display, but open to public exploration.

Even though the emphasis is placed on the "people" of the railroad, an impressive equipment roster is available, including two steam locomotives — s/n #2826, built by Vulcan Iron Works at Wilkes-Barre, Pennsylvania, in 1918; and #1361, an ex–PRR K4 engine; a gasoline locomotive, built by Brookville Locomotive Co. in 1941; and a Standard Steel Diesel-Electric Locomotive, #6712, built in 1940 (only four of which are remaining at this time). Approximately 30 pieces of equipment on display include Cabin Car #19031 (one of the first all-steel designed cabooses); Tender #45304; Nicholas Firestone Sleeper/Lounge Car #7153 (one of eight built by Pull-Standard Company in 1949, and originally named "Colonial Doorway" #8416); the "Loretta" (the second private car by this name built for Charles M. Schwab of Carnegie Steel, U.S. Steel and Bethlehem Steel fame, built in 1917 by Pullman at a cost of $151,000. The first "Loretta" was built in 1901 with a wooden body and now resides at North Carolina Transportation Museum in Spencer); Dining Car #4468 (built in 1913, and one of the only two of its class); Penn Central Coach

#3931 (built in 1908); and much more. Other pieces of equipment owned by the museum are stored in other places, including a few pieces at Horseshoe Curve National Historic Landmark. Be sure to write to the museum for a professional roster.

There is much to see at the Altoona Museum, including a model train display and various special exhibits brought in throughout the year. A brand new $20 million expansion is currently in the works, to be completed in 1998, increasing the museum footage by 70,000 square feet.

Season and hours: Summer: May through October, 10 a.m. to 6 p.m., daily. Winter: November through April, 10 a.m. to 5 p.m., Tues.-Sun.

Cost: Small admission charge.

For further information write to the Railroaders Memorial Museum, 1300 Ninth Ave., Altoona, PA 16602 or call (814) 946-0834 or Fax (814) 946-9457.

READING COMPANY TECHNICAL & HISTORICAL SOCIETY, INC.

The Reading Company Technical and Historical Society was established in the early 1980s to preserve the rich history of the Reading Company Railroad. Originally established in 1833 as the 94-mile long Philadelphia & Reading Railroad (which was built to transport anthracite coal), this pioneering line eventually became a huge corporation serving Pennsylvania, Delaware and New Jersey. The corporation held a position of leadership in the train industry for more than a century, helping to fuel the Industrial Revolution with the diversity of its railway lines, and becoming the largest corporation in the world by the 1870s.

Numerous problems plagued the P&R through the next few decades until eventually, in 1971, the company declared bankruptcy. Its operations became part of the federally financed CONRAIL System on April 1, 1976.

The RCT&H Society soon formed to preserve the memory of this great railroad. A museum is open to the public, where visitors can see much railroading memorabilia and watch restoration activities in progress. On the grounds are locomotives, freight cars, cabooses, passenger cars, work equipment, signals, tower control panels and more.

The following equipment is on display there: first production GP-30, Reading #5513; last built Budd RDC, Reading #9512; Diesel Instruction Car, "LEMTU"; the last caboose built by the Reading Shops, #94074; an FP7-A Passenger Diesel, Reading #900; as well as various passenger and freight cars. Freight Diesel Locomotives on display include an ALCO C-630, Reading #5308 (the lone survivor of Reading's largest diesels); an ALCO C-424, Reading #5204; a GE U-30-C, Reading #6300; an EMD GP-35, Reading #3640; an EMD NW-2, Reading #103; and a Baldwin DS-1000, Reading #702.

Excursions are run at various times throughout the year. You must write to the Society for specific information.

Season: May through October.

Hours: Weekends, 12 p.m. to 5 p.m.
For further information write to the Reading Company Technical & Historical Society, P.O. Box 15143, Reading, PA 19612-5143.

THE SHOHOLA CABOOSE

Many changes have occurred in the train industry since its inception. One of the current trends is to sell off or donate railway cabooses to various organizations as a good public relations act for railways that now have more sophisticated technology. The Consolidated Railways Company made one such caboose—#21754—available to the Shohola Railroad and Historical Society. This caboose, formerly used on the Reading, Penn Central, and Conrail lines, was built in January 1949 as an N7 caboose. It is now used as a museum and tourist information center in Shohola.
Season: Year-round.
Hours: Regular business hours.
Cost: No admission charges.
For further information write to The Shohola Caboose, Museum & Tourist Information Center, Shohola, PA 18458.

STEAMTOWN NATIONAL HISTORIC SITE

Congress created the Steamtown National Historic Site in 1986 to interpret the story of main line steam railroading from 1850 to 1960. In 1850, American railroads operated just 9,021 miles of track; this mileage peaked in 1920 at 252,845 miles. The number of people employed by the railroading industry rose from 20,000 in 1850 to 3.6 million in 1950.

The museum now occupies the former Scranton Yards of the Delaware, Lackawanna & Western Railroad, and offers exhibits, tours and excursions. The DL&W was formed in 1853 as a merger between the Lackawanna & Western and the Delaware & Cobbs Gap Railroads. The DL&W then merged with the Erie to become the Erie Lackawanna (EL) in 1960. In 1976, the EL became part of the Conrail group, who abandoned it in 1979. The National Park Service then took over the site in 1988, planning extensive reconstruction. The old locomotive shop and the roundhouse are now operational, and plans call for a 1995 completion date for the three-stall 1902 roundhouse, north and south exhibit buildings, theater, and visitor center and oil house.

Visitors to Steamtown can enjoy a 2½-hour steam excursion from the loading platform next to the Visitor Center over the old Delaware, Lackawanna & Western Railroad's main line between Scranton and Moscow, Pennsylvania.

The Steamtown National Historic Site has an impressive equipment roster, with over 130 pieces listed. Twenty-nine steam locomotives, five diesels and one electric engine are on the list, including the Baldwin #26 0-6-0 switcher

built in 1929, the Canadian National #3254 2-8-2 Mikado built in 1917, and the Canadian Pacific #2317 4-6-2 Pacific built in 1923 (all operational). You can send for a complete "Alpha List of Stock Motive Power" from the park.

Season: Year-round except Thanksgiving, Christmas and New Year's Day. Excursions begin Memorial Day weekend and operate through the last full weekend of October on weekends only.

Hours: Museum: Daily, 9 a.m. to 5 p.m. Excursions: Generally run at 10 a.m., 1 p.m. or 2 p.m., depending on the day.

Cost: No charge for museum. Excursion fares: Adults, $7; seniors, $6; children (0–12 yrs.), $3. Be sure to contact the park for accurate information.

For further information write to the Steamtown National Historic Site, 150 South Washington Ave., Scranton, PA 18503 or call (717) 961-2033.

STEWARTSTOWN RAILROAD

Originally opened in 1885, the Stewartstown Railroad Company operated between Stewartstown and New Freedom, 7.2 miles away. Regardless of owner, the freight hauled by the railroad was usually farm crops and supplies, earning the company the nickname "the Farmer's Railroad."

In 1939, the company replaced their steam engines with gasoline powered locomotives, and today, the engine roster consists of #9 "Mighty Mo" (a gasoline-powered Plymouth), #10 (a General Electric diesel), and #11 (an EMD diesel).

While waiting to board, passengers can visit the original 1915 Depot, the Freight House (which houses historic memorabilia), the 1906 Engine House, an 1870 Iron Truss Bridge, the "Mighty Mo" engine (built in 1943), and several 50+ year-old coaches.

Regular excursions include the "Countryside Excursion," Fall Foliage Specials and "Autumn Rail Rambles." Several special events are also offered throughout the year, including holiday trains, a Breakfast Special, Veterans Day Weekend and more.

Season: May through September, Sun. and holidays. Fall Foliage Specials, Sat. & Sun.; Autumn Rail Rambles, third Sun. only.

Hours: Trains usually depart at 1 p.m. and 3 p.m.

Cost: Adults, $5 or $6 (depending on excursion); children, $3. Special events fares vary from $3 to $12.50.

For further information write to the Stewartstown Railroad, P.O. Box 155, Stewartstown, PA 17363 or call (717) 993-2936.

STOURBRIDGE RAIL EXCURSION

The Stourbridge Rail Excursion's boarding platform is located on the site of the Delaware & Hudson Canal Company's boat basin. Anthracite coal was brought to the basin by the D&H's gravity railroad from Carbondale and the Lackawanna Valley and shipped out mostly to New York City.

The site is the birthplace of the American railroad. On August 8, 1829, the D&H ran the first locomotive on rails in the western hemisphere from the basin, three miles to Seelyville, and then back. Passengers today board at the site in Honesdale and ride to Hawley and back. Several different excursions are run throughout the year along with regularly scheduled rides on Saturdays and Sundays in the summer. Many "Special Excursions" are part of a package tour including a stopover at one of the destinations, but on-board experiences include the Country Jamboree, Halloween train, Santa Express, Fall Foliage Fun, and Train Robbery. A dinner train is offered, but passengers deboard at Hawley for the dinner and theater production.

Season: March through December including the special excursions.

Hours: Vary according to excursion chosen.

Cost: Vary according to excursion chosen, ranging from $8 to $40. Reservations are usually required.

For further information write to Stourbridge Rail Excursions, c/o Wayne County Chamber of Commerce, 742 Main St., Honesdale, PA 18431 or call 1-800-433-9008 or (717) 253-1960 for reservations.

STRASBURG RAILROAD

America's oldest shortline railroad, the Strasburg steam train takes passengers on excursion through historic and wonderfully scenic parts of Pennsylvania's Lancaster County, including the unique Amish area.

Passengers board authentic wooden coaches, fully restored and preserved, at the century-old station in Strasburg. Regularly scheduled tours are offered along with luncheon trains, dinner trains and special trips aboard the Parlor Car "Marian." All-day fares are available for unlimited riding pleasure.

Season: Year-round, though the winter schedule is weekends only.

Hours: Vary according to season and tour chosen.

Cost: Regular fares (round-trips): Adults, $7; children (3–11 yrs.), $4; 2 and under, free. All-day fares: $14. Dinner trail and other special options are priced per ride.

For further information write to the Strasburg Rail Road, P.O. Box 96, Strasburg, PA 17579-0096 or call (717) 687-7522.

WK&S, THE HAWK MOUNTAIN LINE WANAMAKER, KEMPTON & SOUTHERN, INC.

The first steam locomotive arrived in the tiny town of Kempton in 1874. The local passenger train eventually became known as the "Berksy" and ran through the little villages that dot the Maiden Creek Valley, carrying both freight and passengers from the late 1800s until 1962. The Wanamaker, Kempton &

Southern runs over a restored portion of the Reading's Schuylkill and Lehigh branchline, and is pulled by historic steam locomotives from that era.

The steam train trip takes about 40 minutes and covers a total of 6 miles. At the half-way turn-around point, passengers can deboard to visit the last original Berks County Railroad Station still in operation. On Sundays, the station is open as an antique shop. The WK&S also operates the "Berksy Trolley" on Saturdays in September and October. She was constructed in 1971 from an old brakeman's jitney, seats 20 passengers, and makes a nine-mile, 35-minute trip four times a day.

Several special events are offered throughout the year, including a Mother's Day Special, Christmas in July, dinner train (in September), Santa Claus Special and more.

Season: May through October., Sun. only; June through August, Sat.; Memorial Day and Labor Day.

Hours: Every hour on the hour: Sun., 1 p.m. to 5 p.m.; Sat. & holidays, 1 p.m. to 4 p.m.

Cost: Adults, $4; children (2-11 yrs.), $2; under 2, free. Special events fares vary.

For further information write to the WK&S, The Hawk Mountain Line, P.O. Box 24, Kempton, PA 19529 or call (610) 756-6469.

WEST SHORE RAIL EXCURSIONS

Railroads, and the prosperity they brought, came to Union County in Pennsylvania in the late 1800s. Two main rail lines were built there: the Lewisburg Centre & Spruce Creek Railroad (1853) and the Shamokin, Sunbury and Lewisburg Railroad (1882-83). As with most railroads, several mergers and name changes took place. In 1879, the LC&SP reorganized as the Lewisburg & Tyrone Railroad Company, which merged into the Pennsylvania Railroad in 1914. The Pennsylvania Railroad became the Penn Central, then eventually part of the Conrail group. By 1981 Conrail had abandoned the line and it lay dormant until the spring of 1984 when the West Shore Railroad was founded, owning and operating 12½ miles of track on the east end of the Lewisburg & Tyrone line.

The Shamokin, Sunbury and Lewisburg Railroad (a major east-west trunk line connecting the Philadelphia, Reading and Vanderbilt lines) merged with the Reading Railroad in 1944. The West Shore Railroad bought this line in 1988 and is now running it as the Lewisburg & Buffalo Creek Railroad. With this acquisition, the West Shore Railroad now offers both freight and excursion services.

On its excursion rides, the railroad uses vintage locomotives, passenger cars, cabooses, and a dining car (special dinner excursions offered monthly from June through October). The locomotive used is an SW-1 Diesel Locomotive built in 1950 by the General Motors Corporation for the Pennsylvania Railroad. The caboose is an ex-Sante Fe caboose built in 1938. The passenger cars used were built in 1916 by the Pullman Standard Company for the Delaware & Lackawanna Railroad.

West Shore Rail Excursions dining car built in 1915 for Jersey Central Railroad.

Other rolling stock owned by the railroad includes a GP-30 Diesel Locomotive built in 1963 by General Motors; a luxury coach car with reclining seats built in 1926 for the Pennsylvania Railroad (used in the movie *Sophie's Choice* starring Meryl Streep); an Erie-Lackawanna caboose; a Reading Railroad caboose; and a Pennsylvania Railroad caboose.

Season: April through October, with special excursions offered at other times.

Hours: Times vary, but most excursions leave the Delta Place Station in Lewisburg at 11:30 a.m. or 2 p.m. Dinner trains leave at 6 p.m. or 6:30 p.m.

Cost: Regular excursion fares vary according to which train is taken— L&BC or West Shore. L&BC: Adults, $6; seniors, $5.50; children (3–11 yrs.), $3.50. West Shore: Adults, $8; seniors, $7.50; children, $4.50. Dinner trains: $25 to $30, depending on season and excursion chosen.

For further information write to West Shore Rail Excursions, Inc., c/o Delta Place Station, R.R. 3, Box 154, (Rt. 15 North), Lewisburg, PA 17837 or call (717) 524-4337.

WHITE DEER & READING STATION AND MUSEUM

The White Deer, Pennsylvania, station was built in 1872 as part of the Catawissa, Danville & Milton Railway, which was taken over in 1882 by the Reading Company. In 1911, the original station burned, but it was rebuilt in 1912 as it stands today.

The station was the eastern terminus for the White Deer Valley Railroad, a narrow gauge line built in 1900 by John F. Duncan of Lewisburg to haul logs from the mountains of Clinton and Union Counties. Freight and passenger services began in 1906, but the area's lumber industry rather quickly shut down, causing the railroad's owners to stop all services in 1916. The station was eventually purchased from the Reading Company (in 1978) and opened as a museum in 1984. It is owned and operated by the Central Pennsylvania Chapter of the National Railway Historical Society.

The museum features a gift shop along with several pieces of rolling stock including a PRR caboose, Plymouth locomotive, baggage car, boxcar, Pullman cars, GE Locomotive, and ACF tank car.

Season: May through October.

Hours: Sun. only, 1 to 4 p.m.

Cost: Free admission (donations accepted).

For further information write to the White Deer Station, P.O. Box 145, White Deer, PA 17887 or call (717) 966-3252.

RHODE ISLAND

NEWPORT STAR CLIPPER DINNER TRAIN

The Newport Star Clipper runs on track dating back to 1864. The original track was laid by the Old Colony and Newport Railroad, later absorbed by the New Haven Penn Central-Conrail Lines, and finally purchased by the State of Rhode Island (1978). In 1988, the Newport Star Clipper began operating excursion rides using center cab diesels and four cars which are former Pennsylvania, Seaboard, and ACL coaches. Electric power is now provided to these cars by a former Amtrak head-power cab built as a U.S. Army kitchen car in 1953.

The dinner train runs several times each month, offering passengers a choice of regular dinner excursion or "entertainment" excursion. The entertainment offered includes an oldies singer/banjo player, vocalist, jazz trio, or murder mystery. Be sure to send for the entertainment schedule for exact dates. Charters and other choices of entertainment are also available. New excursions are added to the schedule occasionally.

Season: Year-round.

Hours: Lunch, 1 p.m.; dinner, 7 p.m. (Check-in 30 min. prior to departure.)

Cost: Regular excursion prices not available at time of publication. Entertainment is in addition to regular fares: Murder Mystery, $15; Jazz Trio, $10; Vocalists, $7.50. Dinner attire is suggested.

For further information write to the Newport Star Clipper Dinner Train, 102 Connell Hwy., Newport, RI 02840 or call 1-800-834-1556 (RI) or 1-800-462-7452.

OLD COLONY & NEWPORT SCENIC RAILWAY
NATIONAL RAILROAD FOUNDATION & MUSEUM

The Old Colony & Newport, the "Line with the Million Dollar View," runs on a 130-year-old right-of-way along Narragansett Bay in Rhode Island. Boarding at the tiny vintage Old Colony Depot, passengers can choose to ride in a 1912 open platform coach or an 1895 parlor car (one of the oldest operating parlor cars in existence). A vintage diesel pulls the trains.

Both regular excursions and charters are available. Passengers can choose between a three-hour, 21-mile roundtrip (which includes a one hour stop at Green Animals Topiary Gardens) or a one-hour, 10-mile round-trip ride. The different excursions are offered on different days. Be sure to contact the museum before visiting.

Season: First of May to mid-June, Sun. & holidays; mid-June to mid-September, Sat., Sun. & holidays; mid-Sept. to end of Nov., Sun. only.

Hours: Three-hour trip, 12:30 p.m.; one-hour trip, 12:30 p.m. and 2:15 p.m.

Cost: Three-hour trip: Adults, $6; seniors, $5; children (14 or younger), $4; family fare, $15; parlor car, $9. One-hour trip: Adults, $5; seniors, $4; children, $3; parlor car, $7.

For further information write to the Old Colony & Newport Scenic Railway, P.O. Box 343, Newport, RI 02840 or call (401) 624-6951.

SOUTH CAROLINA

SOUTH CAROLINA RAILROAD MUSEUM

This continually growing museum, founded in 1973, features exhibits in various pieces of rolling stock. Excursions are also offered from the museum in Rockton to the end of the track and back. Currently this means a 2½-mile, 40-minute round trip, but as more track is restored, the "end of the track" will be extended.

The extensive roster of equipment includes a 1927 Baldwin 4-6-0 (#44), former Hampton & Branchville locomotive; a 1949 Porter diesel; a 1946 GE Locomotive, former Pennsylvania Railroad; a 1910 office car, the "Norfolk," former Seaboard Air Lines; a 1926 Pullman, "Bizet"; a 1927 RPO car; two baggage cars; a number of boxcars; a 1946 refrigerator car; tank cars; flatcars; dumpcars; cabooses, and much more.

Season: April through October, third Sat. of each month. Season may be extended if volunteers are found so be sure to check before you visit.

Hours: 1 p.m. to 5 p.m.

Cost: Adults, $2; children (3-13 yrs.), $1; under 3, free.
For further information write to the South Carolina Railroad Museum, P.O. Box 7246, Columbia, SC 29202-7246 or call (803) 776-8856 or (803) 783-3537 or (704) 393-0335.

SOUTH DAKOTA

THE BLACK HILLS CENTRAL RAILROAD
"The 1880 Train"

The new Black Hills Central follows the original route of the CB&Q Railroad laid down in the 1880s for use by the mines and mills in the area around Hill City and Keystone. The 20-mile round-trip steam excursion winds through Black Hills National Forest and climbs over some of the steepest grades in North America, affording passengers spectacular vistas including a view of Harney Peak (the highest point between the Swiss Alps and the Rocky Mountains).

All locomotives on the Black Hills Central burn oil as fuel to reduce pollution and the risk of forest fires. Locomotive #7, a Baldwin 2-6-2 prairie type steam engine, was built in 1919 for the Prescott and Northwestern Railroad Co. of Arkansas. It has appeared in CBS' *Gunsmoke, Orphan Train,* and Walt Disney's *Scandalous John*. Engine #104, a Baldwin product built originally for a timber company in Oregon, also pulls coaches over the line. Diesels are also used occasionally. Passengers may board at the Keystone, South Dakota, station or at Hill City. Mt. Rushmore is only 15 minutes from Hill City.

Season: Mid-May through mid-October, daily. Be sure to check steam schedule ahead of time if you want to ride behind one of the steam engines.

Hours: From Hill City: Boards 8 a.m., 10:15 a.m., 1:30 p.m., and 3:45 p.m. From Keystone Junction: Boards 9 a.m., 11:15 a.m., 2:30 p.m. and 4:45 p.m. No 8 a.m. or 9 a.m. runs on Sat. or Sun.; evening trips scheduled during July and August; limited schedules during late Spring and early Fall.

For further information write to the Black Hills Central Railroad, Box 1880, Hill City, SD 57745 or call (605) 574-2222 or Fax (605) 574-4915.

KADOKA DEPOT MUSEUM

Listed on the National Registry of Historic Places, this historic depot now serves as a museum featuring railroading memorabilia from the area.

Season: Memorial Day to Labor Day.
Hours: 4 p.m. to 8 p.m.

Cost: No admission charge (donations accepted).

For further information write to the Kadoka Depot Museum, c/o the Kadoka Community Betterment Assoc., P.O. Box 529V, Kadoka, SD 57543 or call 1-800-467-9217.

PRAIRIE VILLAGE

A collection of turn-of-the-century buildings from around the area have been brought together to make up Prairie Village outside of Madison, South Dakota. Rail fans will also be pleased to find a huge collection of railroading equipment on display. Visitors can board the train that runs over part of the original Milwaukee line from Pipestone, Minnesota, to Wessington Springs, South Dakota, for a two-mile ride around the grounds. A 24" gauge train also takes passengers on a ⅓-mile trip around the old Wentworth, South Dakota, depot in the village.

Season: Village: Daily, Memorial Day to Labor Day. Train: Runs first and third weekends in June, July and August, and during the Fall Jamboree in late August.

Cost: Village: $4. Train: 2-miles, $2.50; ⅓-mile, $1; Fall Jamboree, $5.

For further information write to the Prairie Village, P.O. Box 256, Madison, SD 57042-0256 or call (605) 256-3644. For specific train information write to P.O. Box 302, Madison, SD 57042-0302 or call (605) 256-6177.

WHETSTONE VALLEY EXPRESS

The annual Whetstone Valley Express offers passengers a choice of two different excursions: a 21-mile, 2½-hour round-trip from Milbank to Corona, South Dakota, over a former branch of the Milwaukee Road; or a 10-mile trip through Whetstone Valley. Dinner is available on the Corona trip.

The Express is operated by the Sisseton Milbank Railroad in conjunction with the Milbank Chamber of Commerce. Equipment used for these rides includes Engine #627, a 1954 EMD SW-1200, former Milwaukee (the last Milwaukee Road engine to leave Tacoma, Washington) and several heavyweight coaches, built from 1911 to 1934. The National Guard Armory is also home to a railroading museum, which features model railroading layouts and genuine railroading collections and memorabilia.

The United States Post Office issues a special cancellation for mail canceled aboard the train during the Whetstone Valley Express train rides.

Season: Mid-August only.

Hours: Corona trip: 11:30 a.m. & 7 p.m. Valley trip: 10 a.m., 2:30 p.m., 4 p.m., and 5:30 p.m. As this is a very limited excursion, we suggest you contact the Chamber of Commerce well in advance of any planned visit to get up-to-date information.

Cost: Corona trip: Adults, $8; children, $5. Valley trip: Adults, $5; children, $3. Armory museum, $1.

For further information write to the Milbank Chamber of Commerce, 203 S. Main, Milbank, SD 57252 or call 1-800-675-6656.

TENNESSEE

THE BIG SOUTH FORK SCENIC RAILWAY
(*see* THE BIG SOUTH FORK SCENIC RAILWAY in Kentucky)

THE BROADWAY DINNER TRAIN

The Riverfront Depot in downtown Nashville is home to the Broadway Dinner Train which runs on Thursdays, Fridays and Saturdays by reservation only.

The train's route takes passengers from downtown Nashville to Old Hickory, covering about 35 miles of Tennessee countryside. The original route, completed in 1904, was once part of the Tennessee Central Railway.

The locomotive (#5764) is a model E8A, built in 1952, and previously owned by the Pennsylvania Railroad. Visitors to the station can take pictures of the locomotive even if they choose not to board the dinner train. Other equipment in use by the dinner train includes Diesel engine #514 (an ex-Rock Island RPO, built in 1954 by Budd); #504 Dome Lounge (ex-Sante Fe, built 1950 by Pullman-Standard); #245 Diner-Table Car (built 1947 by Pullman-Standard); #1494 Diner (ex-Sante Fe, with original kitchen complete, built in 1942 by Budd); #1493 Diner (ex-Sante Fe with original kitchen complete, built 1942 by Budd); #6507 Diner-Table Car (ex-Seaboard coach built in 1939 by Budd); and a Bay Biscayne Tavern Observation car (ex-Florida East Coast built in 1939 by Budd).

The Dinner Train's 2½-hour, 35-mile excursion also includes a four-course dinner, with choice of entrees, and musical entertainment in the famous "Dome Lounge" car.

Season: Year-round.
Hours: Boarding at 6:30 p.m. with departures at 7 p.m.
Cost: $42.95 per person.
For further information or reservations write to the Broadway Dinner Train, Riverfront Depot, 108 First Ave. South, Nashville, TN 37201 or call 1-800-274-8010 or (615) 254-8000.

CASEY JONES VILLAGE

At the Village, visitors can see the Casey Jones Home & Railroad Museum, the Casey Jones Station Inn, Casey's Steak House and the Old Country Store on the Square.

Casey Jones near the time of his death on April 30, 1900, at age 37.

At the Casey Jones Home & Railroad Museum, tours include a 16-minute video on the life and death of Casey, a scale model of the wreck itself, a replica of the "Ole 382" engine with attached coal car that Casey drove on his last run, the horse-drawn hearse which carried Casey to his grave in 1900, a detailed model train exhibit set up in an 1890s baggage car and, of course, Casey's actual home, decorated in period furniture, with lots of memorabilia on display.

Season and hours: Summer: Daily, 8 a.m. to 9 p.m. Rest of year: 9 a.m. to 5 p.m.

Cost: Adults, $3; seniors, $2.50; children (6–12 yrs.), $2.

Chattanooga Choo Choo Holiday Inn

For further information about the home and museum write to the Casey Jones Home & Railroad Museum, c/o Casey Jones Village, Jackson, TN 38305 or call 1-800-748-9588 or (901) 668-1222 or Fax (901) 664-TOUR (8687).

CHATTANOOGA CHOO CHOO HOLIDAY INN

Opened in 1909 as Terminal Station, the train depot, along with the famous "Chattanooga Choo Choo" was, and is, one of the South's most famous landmarks. It is listed on the National Registry of Historic Places.

Today, the depot is part of a 30-acre Holiday Inn resort complex featuring Parlorcar rooms, trolley rides, a miniature train display, shopping and eating opportunities, and more. (We suggest you call ahead for reservations if you want to sleep in one of the renovated parlorcars.)

Season: Year-round.

Hours: Regular hotel/motel hours apply.

Cost: Costs vary according to room chosen.

For further information contact your travel agent or write to the Chattanooga Choo Choo Holiday Inn, 1400 Market St., Chattanooga, TN 37402 or call 1-800-HOLIDAY or (615) 266-5000.

COLLIERVILLE HERITAGE RAILROAD DISPLAY

The pre-Civil War town of Collierville, Tennessee, was built on the Memphis-Charleston Railroad line (now Southern) and has continued its partnership

with railroading to this day. The historic town square looks much as it did in 1870, with commercial buildings on three sides and the depot and railroad on the fourth side. A train display sits on two spur tracks outside the depot, featuring Locomotive #1351 (a 1912 ALCO 2-8-0), "The Savannah" rail car, and a 1920s caboose. The Savannah was used by Seaboard executives and has mahogany paneling, an observation room, a valet's room, two suites, a dining room and a stainless steel kitchen with crew's quarter.

Visitors are also offered a choice of restaurants, antique shops, gift shops and other historic sites to see in the area, due to the railroad's historical district location.

Season: Year-round.

Cost: No charge (donations welcomed).

For further information about the railroad and other historic sites write to the Collierville Heritage Railroad Display, P.O. Box 53, Collierville, TN 38027-0053 or call (901) 853-1666.

COOKEVILLE DEPOT MUSEUM

This depot, built in 1909 as the Cookeville Central Railroad Station, is listed on the National Register of Historic Places. Once called "The Jewel of the Tennessee Central," it has been completely renovated on the inside for use as the Cookeville Depot Museum. The museum houses a collection of Tennessee Central artifacts and memorabilia along with photographs of the railroad in Putnam County and the surrounding communities.

The building itself has a few unique features. It is one of the very few Tennessee Central depots left standing on its original site; the brick exterior is unusual for its time, and the depot features a unique pagoda roof line.

Two pieces of equipment are currently on display at the museum—an L&N caboose and an original Tennessee Central caboose built before 1920.

Season: Year-round.

Hours: Mon., Wed., Fri., 11 a.m. to 2 p.m.; Sat., 1 p.m. to 4 p.m.

Cost: Admission is free.

For further information write to the Cookeville Depot Museum, c/o Dept. of Leisure Services, P.O. Box 998, Cookeville, TN 38503-0998 or call (615) 526-4897 or Fax (615) 526-4897.

COWAN RAILROAD MUSEUM

Located in the valley of the Cumberland Mountains, the Railroad Museum features a restored depot, a steam locomotive, a caboose and several other relics of railroading history. The famous Cumberland Mountain Tunnel of the Cowan Pusher District (built 1849-1852) is nearby.

The Depot houses the museum, which also exhibits a telegraph operator's set-up, a model steam locomotive built in 1910, an HO Gauge Model Railroad (showing the Cowan Pusher District), and a rare Columbia-type locomotive built by Porter Locomotive Works in 1920.

Both the depot and the tunnel are listed on the National Register of Historic Places.
Season: May through October.
Hours: Thurs.-Sat., 10 a.m. to 4 p.m.; Sun., 1 p.m. to 4 p.m.
For further information write to the Cowan Railroad Museum, P.O. Box 53, Cowan, TN 37318.

HOHENWALD TRAIN DEPOT

The historic Hohenwald Train Depot was built in the 1880s and is now listed on the National Registry of Historic Places. Originally built to serve the mining and logging industries in the area, it later became an all-purpose train depot, and is currently the home of the Lewis County Chamber of Commerce.

Railroading memorabilia is located inside the building, with a caboose and 1880s box car located outside.
Season: Year-round.
Hours: Mon.-Wed., 8 a.m. to 4 p.m. Visitors must call ahead to board the box car and caboose.
For further information write to the Hohenwald Train Depot, Lewis County Chamber of Commerce, East Main Street, Hohenwald, TN 38462 or call (615) 796-4084.

L&N DEPOT & RAILROAD MUSEUM

The 1906 Louisville and Nashville Railroad Station and Depot, located in Etowah, Tennessee, was once the home of the L&N Atlanta Division Headquarters, and is now owned by the City of Etowah. The 15-room Victorian-style building was the first permanent structure built in this planned township, and it is listed on the National Register of Historic Places.

On the main floor of this large Depot is the "Growing Up with the L&N: Life and Times in a Railroad Town" Museum, which shows how the L&N working class was affected by the early boom years and other historic changes, such as the 1922 national shopman's strike, the Great Depression and two world wars. Besides the museum, the building now houses an art gallery and visitor center. Many special events are held here throughout the year.

A vintage caboose sits outside on the grounds. The museum also sponsors an annual railroad excursion, "The Bald Mountain Rail Loop Excursion" (canceled in 1994, but planned to resume in 1995).
Season: Museum: Year-round, closed Mondays and major holidays.
Hours: Tues.-Sat., 9 a.m. to 4:30 p.m.; Sun., 1 p.m. to 4 p.m.
Cost: Donations accepted.
For further information write to the L&N Depot & Railroad Museum, P.O. Box 390, Etowah, TN 37331 or call Depot Manager at (615) 263-7840 or Etowah Area Chamber of Commerce (615) 263-2228.

LOOKOUT MOUNTAIN INCLINE RAILWAY
"America's Most Amazing Mile"

Trolley-style railcars carry passengers to the top of Lookout Mountain on the world's steepest passenger railway. The Incline has been designated both as a National Historic Site and National Historic Mechanical Engineering Landmark (featuring a grade of 72.7 percent near the top).

At the top of the track is the upper station which features a free observation deck, and gift and refreshment stands, while offering visitors the highest overlook on Lookout Mountain. Visitors should also visit the Incline's machine room which helps to operate the Incline.

The Lower station, at the base of Lookout Mountain, is built in the style of an early 1895 train station. It also offers refreshments and souvenirs.

Season: Year-round, except Christmas Day.

Hours: Memorial Day weekend through Labor Day, 8:30 a.m. to 10 p.m.; Labor Day through Memorial Day weekend, 9 a.m. to 6 p.m.

Cost: Round-trip fares: Adults, $6; children (3–12 yrs.), $3; 2 and under, free. One-way trips are only slightly less.

For further information write to Lookout Mountain Incline Railway, 827 East Brow Road, Lookout Mountain, TN 37350 or call (615) 821-4224 or Fax (615) 821-9444.

ROGERSVILLE DEPOT MUSEUM

The 1890 Rogersville Depot has been restored into its present use as a museum and Chamber of Commerce. A stationary caboose is on display on the premises.

For further information write to the Rogersville Depot Museum, c/o Rogersville-Hawkins County Chamber of Commerce, Inc., 415 South Depot Street, Rogersville, TN 37857-3331.

TENNESSEE VALLEY RAILROAD

The Tennessee Valley Railroad was founded in 1961 by a group of Chattanooga rail fans determined to preserve *operating* steam passenger engines. It has become the largest *operating* historic railroad in the south. Much of the present route follows the original right-of-way of the East Tennessee & Georgia Railroad, which played a vital role in the war between the states.

Besides the rides offered, visitors to the main entrance at Grand Junction can view an audio-visual show and several exhibits, tour the repair shop, and visit the dining room and gift shop. The station at Grand Junction is a copy of the 1888 depot at Tuscumbia, Alabama, from which the original Tennessee Valley Railroad operated. In East Chattanooga, at the other end, sits a modest

Tennessee Valley Railroad

wood frame structure reminiscent of a typical 1890 small town depot. At this site, visitors can see many displays as well as visit "the backshop" where heavy maintenance and restoration is always underway. A turntable is demonstrated there, also. Guided tours through railcars on display are offered at both ends of the line (included in ticket price).

Equipment used includes a 1930-era steam passenger train #4501, and vintage passenger cars. Passengers may board at either the Grand Junction or East Chattanooga station.

Season: April through October, daily; November, weekends only.

Hours: Depots open 30 minutes before first train, which usually departs at 10 a.m. Be sure to send for "Passenger Timetable" for accurate information. Average visit time is two hours or longer.

Cost: Adults, $8; children (3-12 yrs.), $4; "Downtown Arrow", $13 (coach), or $17, (First Class).

For further information write to the Tennessee Valley Railroad, 4119 Cromwell Road, Chattanooga, TN 37421-2119 or call (615) 894-8028.

UNION STATON

The Union Station in Nashville, located at 1001 Broadway, was built from 1898 to 1900. It was "the" passenger train station until 1975. It has now been turned into a hotel, and much of the natural ambiance has been retained.

For further information write to the Union Station Hotel, 1001 Broadway, Nashville, TN 37201 or call (615) 726-1001.

TEXAS

AGE OF STEAM RAILROAD MUSEUM

Operated by the Southwest Railroad Historical Society, this museum features a vast collection of steam locomotives and equipment from steam railroading days. Just a few of the many pieces on display at the museum include: "Big Boy," No. 4018, a 1942 ALCO 4-8-8-4; "Centennial," #6913, an EMD DDA4OX former Union Pacific; a 1918 ALCO 2-10-0, former Eagle Pitcher Mining Co.; a 1942 Baldwin 4-8-4, former Frisco; a 1923 Baldwin 0-6-0; and more. More than 10 locomotives and trolleys are located at the Museum all together. Also on the roster of equipment are the dining car "Goliad," the business car "Texland," and several restored parlor-club cars, Pullman cars, freight cars, and cabooses.

Dallas's oldest train station also sits on the grounds of the museum, and many items of railroading memorabilia are displayed there. The "Doodlebug" diesel-electric locomotive (former Santa Fe) and a former Western Railroad VO-1000 No. 1107 operate periodically on tracks located on the museum grounds.

Season: Year-round.
Hours: Thurs. & Fri., 10 a.m. to 3 p.m.; Sat. & Sun., 11 a.m. to 5 p.m.
Cost: Adults, $3; children (under 13), $1.50.
For further information write to the Age of Steam Railroad Museum, P.O. Box 153259, Dallas, TX 75315-3259 or call (214) 428-0101.

GALVESTON SIGHTSEEING TRAIN

The Galveston Sightseeing Train takes passengers on a 1½-hour, 17-mile narrated tour around the island city of Galveston on one of two trains. The tour includes sites in both Old and New Galveston.

Season and hours: Fall & Winter: September 1 to May 1, 11 a.m. and 1:30 p.m. Summer: May, first train boards at 9 a.m., last train boards at 4:40 p.m.; June–Aug.: First train boards at 9 a.m., last train boards at 6:40 p.m. Be sure to send for schedule for more accurate information.

For further information write to the Galveston Sightseeing Train, 1214 25th, Galveston, TX 77550 or call (409) 765-9564 or (409) 763-1703.

HILL COUNTRY FLYER
Austin & Northwestern Railroad

A vintage steam engine takes passengers on a scenic 33-mile cruise through Central Texas, past ranches, towns, canyons and creeks. The train departs from Cedar Park at 10 a.m. and returns at 5:30 p.m., with a three-hour layover in historic Burnet.

Originally built as the narrow gauge Austin & Northwestern Railroad, the route and railroad passed through the hands of various owners until finally reaching the City of Austin in 1986. The line was originally part of a system which reached northwest through the rock-quarrying country to Marble Falls, Llano and Lampasas. All of the famous pink granite used in constructing Texas's magnificent Capitol building was carried to Austin over this line.

Steam Locomotive #786, currently used to pull the Hill Country Flyer, was built in 1916 by the American Locomotive Company. It was used for freight and passenger service on the SP's Texas Lines until 1956. The Flyer's red coaches were built in the 1920s by the Pennsylvania Railroad, and the first-class and air-conditioned cars were built in the 1950s for the Missouri Pacific Railroad.

Besides the regular excursions, the Austin Steam Train Association offered an occasional Saturday night run called "The Twilight Flyer," which included a "complimentary" basket of fruit and cheese, along with a glass of wine, beer or soft drink.

Season: Year-round, Sat. and Sun. only.

Hours: Departs Cedar Park at 10 a.m., returns at 5:30 p.m. with a 3-hour layover in Burnet.

Cost: Coach: Adults, $24; seniors, $21.60; children (13 & under), $10. First class: All fares, $38. "The Twilight Flyer!": Coach, $20; first class, $26. Reservations are required.

For further information write to the Austin Steam Train Association, P.O. Box 1632, Austin, TX 78767-1632 or call (512) 477-8468.

THE RAILROAD MUSEUM
(also called The Center for Transportation & Commerce)

The Railroad Museum in Galveston has the largest restored railroad collection in the Southwest and is listed among the five largest of its kind in the U.S. The Collection contains more than 46 rail cars and locomotives plus nearly 20,000 other railroading items. Visitors can actually board several rail passenger cars, three steam engines and two diesel locomotives, even though none currently carry passengers over track. (Plans are to renovate a fourth steam engine which will be used to carry passengers.) Three baggage cars and a coach have also been remodeled for use as shelters for protected exhibits.

In the depot, which is housed on the first floor of Shearn Moody Plaza, visitors can "eavesdrop" on ghostly conversations of 35 life-size sculptures talking about railroading and other topics of interest to Galvestonians in the 1930s. This depot often hosts social events.

Other features of the museum include: hand car races; the Renfert Collection, believed to be the largest collection of railroad china, silver, and glassware in the U.S.; Port Exhibit, a working HO-scale model of the Port of Galveston; and the Texas Limited, a passenger excursion train running between Houston and the museum (*see* The Texas Limited) in the 10-story white art deco office tower.

The Roster of Equipment at the Railroad Museum includes five steam locomotives: Southern Pacific's 4-6-0 #314, built in 1892 by Cooke; Waco, Beaumont, Trinity & Sabine's 2-6-2 #1, built in 1920 by Baldwin; Center for Transportation & Commerce's 2-8-0 #555, built in 1922 by ALCO; Center for Transportation & Commerce's Shay #112, built in 1923 by Lima. The two diesel-electric locomotives on display are a Southern Pacific NW-2E Switcher #1303 built in 1949 by GM-EMD and Union Pacific's H20-44 Switcher No. 410 built in 1954 by Fairbanks-Morse. Quite a number of Passenger Cars, Diner-Lounges, Baggage Cars, Freight Cars, and Maintenance-of-Way Cars are also on exhibit. Rail fans can write to the museum for a complete roster.

Season: Year-round, daily, except Thanksgiving Day, Christmas Eve and Christmas Day, and Mardi Gras Weekend.

Hours: 10 a.m. to 5 p.m.

For further information write to the Railroad Museum, c/o the Center for Transportation and Commerce, 123 Rosenberg, Galveston Island, TX 77550 or call (409) 765-5700 or Fax (409) 765-8635.

RAILROAD & PIONEER MUSEUM

This museum focuses on early Santa Fe and Missouri-Kansas-Texas equipment, furniture and memorabilia and features a working telegraph, men's and women's waiting rooms, railroading artifacts and memorabilia, as well as other historical items from the area.

Equipment on the roster includes steel caboose #1556, former Gulf, Colorado & Sante Fe; steel caboose #140, former M-K-T; three section cars; a handcar; a wooden caboose and boxcar from Missouri Pacific; and a World War II Pullman troop sleeper. A 1937 ALCO (the oldest surviving Santa Fe diesel), #2301, and a 1921 Baldwin 4-6-2 former Santa Fe steam locomotive, #3423, are also located at the museum.

The museum is currently working on restoring the former M-K-T Temple depot, the last mission-style M-K-T depot in Texas, and plans to use it as a railroad research center.

Season: Year-round.

Hours: Tues.–Fri., 1 p.m. to 4 p.m.; Sat., 10 a.m. to 4 p.m.

Cost: Adults, $2; seniors, $1; children, $1; under 5, free.

For further information write to the Railroad & Pioneer Museum, P.O. Box 5126, Temple, TX 76505 or call (817) 778-6873.

SOUTHERN ORIENT EXPRESS
DRC RAIL TOURS

DRC Rail Tours launched its new Southern Orient Express excursion on October 6, 1994. The train will leave the Fort Worth Stockyards on its maiden voyage to Big Bend National Park and Mexico's Copper Canyon as part of the

festivities celebrating the 50th anniversary of Big Bend's status as a National Park.

The train will make bus tour stops at Fort Concho, Fort Davis, the McDonald Observatory and Big Bend. In Presidio, the last Texas stop, passengers can choose to take a rafting trip down the Rio Grande, a hike through Big Bend Park or a driving tour of the area. Passengers can then choose an alternative method of transportation for their return trip (cost not included in the tour), or stay aboard the train for a six-day trip through Mexico's Copper Canyon region. (The Copper Canyon run, from Chihuahua to Los Mochis, began in February of 1994, and is an additional fare to the Southern Orient Express run.)

Current plans call for four Grand Tours per year (two from Ft. Worth to Chihuahua, and two from Chihuahua to Ft. Worth). The Grand Tours do include the various side-trips, but do not include return fares. (The regular Copper Canyon runs from Chihuahua to Los Mochis will be offered weekly from October through December and then again from mid-February to April. DRC Rail Tours is the only American Railroad that operates in Mexico.)

Equipment used on the Southern Orient Express includes stainless steel cars built in the 1940s and 1950s and refurbished with a turn-of-the-century flair. Gourmet dining is offered on these luxury tours, along with first-class accommodations and service.

Season: Southern Orient Express's Grand Tour: Mid-February and first of October, from Ft. Worth to Chihuahua; end of April and end of December, from Chihuahua to Ft. Worth. Texas Park Tour: January — the train does not go into Mexico, but does stop for the historic bus tours at Fort Concho, Fort Davis, the McDonald Observatory and Big Bend.

For further information about exact dates, costs, and travel times write to the DRC Rail Tours, 16800 Greenspoint Park Dr., Suite 245 North, Houston, TX 77060-2308 or call 1-800-659-7602 or (713) 659-7602.

TARANTULA TRAIN

The Tarantula runs between the Historic Ft. Worth Stockyards and Downtown Ft. Worth. The train can be boarded at one of two depots — 2318 S. Eight Avenue or 140 E. Exchange Avenue. Trains are often pulled by vintage steam engines, but the schedule is varied. Be sure to call ahead if you want to be pulled by steam power. Parties and groups can also be booked.

Visitors to the Historic Stockyards can see rodeos, Billy Bob's Texas "The World's Largest Honky-Tonk," the Stockyards Station market with shops and restaurants, the White Elephant Saloon with live entertainment; and much more.

Season: Year-round.

Hours: Mon. & Tues. leaves 8th Ave. at 12:15 p.m.; leaves Stockyards at 1:15 p.m. Wed.-Sun., leaves 8th Ave. at 12:15 p.m., 2 p.m. and 4:15 p.m.; leaves Stockyards at 1:15 p.m., 3:30 p.m. and 5:45 p.m. Special summer evening runs are also available.

Cost: Round-trip: Adults, $10; seniors, $8; children (3–12 yrs.), $5.50. One-way: adults, $6; seniors, $5; children (3–12 yrs.), $3.
For further information write to the Tarantula Train, 140 E. Exchange Ave., Ft. Worth, TX 76106 or call 1-800-952-5717 or (817) 625-RAIL (7245).

TEXAS LIMITED
(see also THE RAILROAD MUSEUM)

The Texas Limited is a luxurious excursion taking passengers to and from Houston, League City and Galveston. The track used is 55 miles of the Union Pacific's Galveston, Houston & Henderson Railroad, the oldest in Texas. Passengers board at the Eureka Depot (in the historic Heights area), then the train runs through the White Oak Bayou to Allen's Landing in downtown Houston, has a short layover in League City, then runs on to Galveston Island in the Strand district, which is also the home of the Railroad Museum.

Passengers may choose a 2¼-hour ride from Houston or the shorter one-hour run from League City. Many special events are held throughout the year as well, including Murder Mysteries, Casino Night, Santa on the Train, New Year's Eve and more.

The railway's equipment consists of two diesel electric locomotives, seven restored vintage cars, and a baggage car. The seven passenger cars each have a unique history. "The Rock Island" was built in 1941 by the Budd Co. for the Chicago, Rock Island & Pacific Railroad's Rocket streamliner train. "The Chimayo" is the oldest of the seven cars, having been built by Pullman Standard in 1938 for the Santa Fe Railway's famous Chicago-to-Los Angeles streamliner, the Super Chief. "The Magnolia" was built in 1946 by the Budd Co. and was one of the first cars built after World War II. It has a body of solid stainless steel. "The Silver Stirrup" (originally numbered 4722), one of the nation's early Vista-Dome cars, was built in 1948 by the Budd Co. for the Burlington section of the famous California Zephyr. "The Silver Knight" (originally numbered 365) is the youngest of the seven cars, and was one of six cars built in 1944 by the Edward G. Budd Manufacturing Co. of Philadelphia for the Minneapolis & St. Louis Railroad (delivered to them in 1948). "The Silver Queen" was built in 1957 by the Budd Co. as a standard car for the Minneapolis & St. Louis Railroad. It was unique at that time as it was equipped for oil-fired heat instead of the conventional steam heat. The "New York Central 61" was built shortly after World War II as a parlor-lounge-observation car for the New York Central System. It has "brought up the rear" of such famous NYC trains as the "Pacemaker," the "James Whitecomb Riley" and the "Twilight Limited." (The Silver Stirrup, Silver Queen, Silver Knight, Magnolia and NYC 61 are on lease from Houston businessman Randy Parten.)

Season: End of April through Labor Day, Wed.–Sun. (plus "special events" excursions throughout the year).
Hours: Trains generally depart four times a day from Houston, with the

first run at 9:30 a.m. (8 a.m. on Sat.). Evening runs are offered on Sat. only. Be sure to send for a schedule for exact departure times.

Cost: Excursion class from Houston: Adults, $30; children, $16. From League City: Adults, $20; children $10. First class from Houston: Adults, $40; children, $26. From League City: Adults, $28; children, $18. All fares include admission to the Railroad Museum in Galveston.

For further information write to the Texas Limited, 3131 W. Alabama, #309, Houston, TX 77098 or call 1-800-374-7475 (outside Houston) or 713-522-9090 (in Houston).

TEXAS STATE RAILROAD
State Historical Park

The State Historical Park operates three vintage steam locomotives to pull its scarlet, gold, and black coaches over the 25-mile long track between Rusk and Palestine, Texas. The excursion is a round-trip (50 miles) experience, with trains leaving simultaneously from each of the two stations, and crossing 30 bridges in between. These depots are not the original structures, but have been built to reflect the aura of the 20th Century railroad depot. The Rusk station has a small theater in which the railroad's history and other films are shown. The depots, park and steam engines have been used in movies and TV commercials.

Before each train departs, passengers are invited to tour the locomotive cab to see the mechanics of steam power. Special events allow passengers other railroading adventures throughout the year.

The first excursion of the season generally runs in conjunction with the first weekend of the Dogwood Festival in Palestine, and the last run usually runs on the last Sunday in October—insuring that the trains are out of the woods before the fall deer-hunting season begins.

Season: Spring: March 12 through May 29, Sat. & Sun. only; Summer: May 30 through July 31, Thur.-Mon.; Fall Aug. 6 through Oct. 30, plus Labor Day, Sat. & Sun. only.

Hours: 11 a.m., 12:30 p.m., 1:30 p.m. and 3:00 p.m.

Cost: One Way: Adults, $10; children (3-12 yrs.), $6. Round-trip: Adults, $15; children, $9. Reservations are recommended.

For further information write to the Texas State Railroad State Historical Park, P.O. Box 39, Rusk, TX 75785 or call 1-800-442-8951 (Texas only) or (903) 683-2561.

TEXAS TRANSPORTATION MUSEUM

Located in a Southern Pacific station originally from Converse, Texas, this museum features a number of railroad displays and pictures, as well as a G-gauge "garden railroad," a 5000 square foot display building with 100 foot

model railroad, and other displays of antique vehicles, fire trucks, transportation toys, and more.

A main feature of the Museum is the one-third-mile caboose ride (soon to be extended) on the "Longhorn & Western Rairoad," pulled by a Baldwin 0-4-OT steam engine or a 44-ton diesel locomotive. Be sure to contact the museum before you visit if you want to ride behind the steam engine which generally runs only on the first Sunday of each month. Passengers may also ride on Fairmont motor cars during regular museum hours, or view other locomotives and passenger cars on display on the grounds.

Season and hours: Museum: Thurs.–Sun., 9 a.m. to 4 p.m. Trains: Sun., every 20 min. from 1 p.m. to 3:30 p.m. Steam engines run on first Sunday of each month.

Cost: Free admission and rides. Suggested donations: Adults, $3; children, $1.

For further information write to the Texas Transportation Museum, 11731 Wetmore Road, San Antonio, TX 78247-3606 or call (210) 490-3554.

UTAH

GOLDEN SPIKE NATIONAL HISTORIC SITE

The famous Golden Spike ceremony was held on May 10, 1869, near Promontory, Utah, signaling the completion of the nation's first transcontinental railroad. Today, replicas of the original locomotives used at that ceremony run out to the Last Spike site every morning of the season, and return each evening. Park rangers are on hand to offer historical dialogues about the event.

Season: Year-round; closed Thanksgiving, Christmas and New Year's Day.

Hours: Memorial Day through Labor Day, 8 a.m. to 6 p.m.; 8 a.m. to 4:30 p.m. rest of year.

Cost: Adults, $2; seniors (62 +), free; cars, $4.

For further information write to the Golden Spike Historic Site, P.O. Box 897, Brigham City, UT 84302 or call (801) 471-2209.

HEBER VALLEY RAILROAD

This historic railroad is now operated by the Heber Valley Historic Railroad Authority, which is operated jointly by Heber City, Wasatch County and the state of Utah. Two locomotives, several coaches, a mountain observation car, cabooses from the Union Pacific railroad, a number of freight cars, and several pieces of maintenance-of-way equipment are on display or in use by the railroad.

A new shop, depot and yard complex have been recently opened to help restore the railroad which had been closed for a couple of years.

The railroad offers passengers a 32-mile, 3½-hour round-trip through Heber Valley and into the deep canyon of the Provo River to Vivan Park and back. The railroad has both steam and diesel engines, but you must contact them to assure passage behind the steam locomotive (a 1907 Baldwin 2-8-0).

Season: Memorial Day through Labor Day.

Hours: Daily through the main season, weekends in early May and September through mid-October.

Cost: Adults, $12.50; seniors, $10.50; children (10 & under), $8.50; "babes in arms," free.

For further information write to the Heber Valley Railroad, P.O. Box 641, Heber City, UT 84032 or call 1-800-982-3257.

UNION STATION MUSEUM

This station has now been turned into a railroading museum which helps play host to the Golden Spike festival held every Spring in Ogden.

For further information write to the Union Station Museum, 25th and Wall Ave., Ogden, UT 84401 or call The Western Group, (801) 621-5311 or Fax (801) 393-7740.

VERMONT

GREEN MOUNTAIN FLYER

The "Green Mountain Flyer," owned and operated by the Green Mountain Railroad, is named after a passenger train which ran in Vermont from the 1930s through the 1950s. Today the 26-mile excursion takes passengers from Bellows Falls station, over the first man-made canal built in the U.S., along the banks of the Connecticut and Williams Rivers, past the Brockways Mills Gorge (90 ft. below), past two covered bridges, and on to the Chester Depot. At the Chester Depot, passengers can sightsee or picnic while waiting the 35 minutes that it takes the train to prepare for the trip back. (Lunch is available on the lunch coach on the Texas Limited.)

The Chester Depot was built in 1872 and has been restored to its original state. Also on display at the depot is a 1941 Bay-window caboose, originally built for the Bessemer & Lake Erie Railroad.

Vintage cars used on the railroad itself include #260 and #551. The #260 is possibly the oldest passenger car still in active revenue service in New England. It was constructed in 1891 by the Wagner Car Company as car #700. The #551 was constructed in 1913 for Rutland by Osgood-Bradley's (later part of the Pullman Co.) Worcester, Massachusetts, car shops as a "smoker car."

Green Mountain Flyer

Season: Summer & Fall: June, weekends; July and August, daily (except Mon.); September, through Labor Day, then last two weeks; October, first two weeks.

Hours: Departs Bellows Falls 11 a.m., Chester Depot, 12:10 p.m.; Bellows Falls, 2 p.m.

Cost: Round-trip: Adults, $10; children (3–12 yrs.), $6. One way: Adults, $6; children (3–12 yrs.,), $4. Special excursions are offered at varying prices. $3 charge added for riding coaches #551 or #260.

For further information write to the Green Mountain Flyer, c/o Green Mountain Railroad Corporation, Passenger Services, P.O. Box 498, Bellows Falls, VT 05101 or call (802) 463-3069.

LAMOILLE VALLEY RAILROAD

Open window coaches from the Delaware, Lackawanna & Western Railroad pulled by one of two 1952 standard gauge ALCO RS-3S's (#7801 or #7805), former Delaware & Hudson locomotives, take passengers on a choice of excursions through scenic northern Vermont. The working common-carrier railroad operates a 98-mile route, offering a two-hour round-trip from Morrisville to East Hardwick and back or a one-hour round trip from Morrisville to Johnson and back. The route parallels the Lamoille River. The East Hardwick train passes through Fisher Bridge, one of the nation's last covered railroad bridges.

Season: July through mid-October, with some Sunday specials offered off-season.

Cost: Two-hour trip: Adults, $15; children, $7. One-hour trip: Adults, $10; children, $5.

For further information write to the Lamoille Valley Railroad, Stafford Ave., RD 1, Box 790, Morrisville, VT 05661 or call (802) 888-7183.

SHELBURNE MUSEUM

This famous 45-acre museum features 37 historic buildings, each housing a unique collection of Americana from toys and tools to the 220-foot sidewheel steamer, the "S.S. Ticonderoga," which was moved overland from Lake Champlain. Rail fans will especially enjoy the restored 1890 Shelburne depot which was a Central Vermont steam locomotive and the private car "Grand Isle" situated outside. A wooden replica of Baldwin's "Old Ironsides," the former Woodstock Railroad steam inspection car, "Gertie Buck," and a collection of railroad memorabilia are located nearby.

Season: Year-round.

Hours: Daily, mid-May through mid-October, 10 a.m. to 5 p.m. Guided tours only the rest of the year, at 1 p.m. each day.

For further information write to the Shelburne Museum, P.O. Box 10, Shelburne, VT 05482 or call (802) 985-3346.

VIRGINIA

THE ARTS DEPOT
THE VIRGINIA CREEPER TRAIL

This Virginia and Tennessee Railroad depot, built in 1890, was used as a freight station until it was abandoned many years later. In 1990, the Depot Artists Association began renovating the structure which they lease from the Town of Abingdon. The Depot now houses an exhibit and sales gallery, studio artists and rooms for performing and literary arts programs.

True rail fans can still watch trains pass by on the rails outside the depot.

Not too far away (but not a part of the Arts Depot) is a hiking, horse and bicycle trail built along the former right-of-way of the Virginia-Carolina Railroad and the Hassinger Lumber Co. extension. The total length of the "Virginia Creeper" trail is 34.3 miles.

Season: Year-round.

Hours: Arts Depot: Thurs.–Sat., 11 a.m. to 3 p.m. or by appointment.

For further information write to the Arts Depot, P.O. Box 2513, Abingdon, VA 24210 or call (703) 628-9091. For Trail or Depot information

write to the Abingdon Convention & Visitors Bureau, Cummings St., Abingdon, VA 24210 or call 1-800-435-3440 or (703) 676-2282.

THE CHESAPEAKE & OHIO HISTORICAL SOCIETY

Organized in 1969, the C&OHS is probably the largest organization devoted to the history of a single railroad, and a recognized leader in the field.

The C&O railroad began in 1836 as the Louisa Railroad in Central Virginia, quickly becoming the Virginia Central (1850) and expanding to the base of the Allegheny Mountains by 1856. That railroad was a vital link for the Confederacy during the Civil War. A few years later, in 1868, Collis P. Huntington, who was just completing the Central Pacific section of the Transcontinental Railroad, bought into the railroad and changed its name to Chesapeake & Ohio to help indicate its wider mission. After many more mergers and acquisitions, it became part of the CSX Transportation system, which is now the third largest railroad in the United States by route miles, and the largest in terms of revenue.

The C&O has quite a history, both in reality and in folklore. In reality, some of the most powerful steam locomotives of all time were developed here, including the most powerful ever built, the Allegheny type 2-6-6-6. In folklore, the folk song about ex-slave John Henry who supposedly worked on the 1870s expansion and beat a steam drill in a contest at Big Bend Tunnel, is known world-wide. Some of the historic railroads that have merged or affiliated with the C&O include the Hocking Valley Railway in Ohio, the Nickel Plate, the Pere Marquette Railway of Michigan and Ontario, the Baltimore & Ohio, Western Maryland, Chessie System, and the Seaboard System (itself a combination of the old Atlantic Coast Line, Seaboard, Louisville & Nashville, Clinchfield and other small lines).

The Society operates a full-time archive facility at Clifton Forge, Virginia, which houses interpretive displays and facilities for restoring several ex-C&O passenger and freight train cars and other equipment. Restored cars are often leased out to tourist excursion trains or other museums. They also publish a *C&O Historical Society Sales Catalog* which features originals and reproductions of numerous bits of railroading paraphernalia, books, videos, etc. It is suggested that you contact the Society ahead of time if you plan to visit, to insure that you will be able to see the most complete inventory of their rolling stock.

Season: Year-round.

Hours: Mon.-Sat., 8 a.m. to 5 p.m.

For further information write to the Chesapeake and Ohio Historical Society, Inc., P.O. Box 79, Clifton Forge, VA 24422 or call 1-800-453-COHS.

Interstate 101 President's Car at the Regional Tourist and Information Center.

EARLY HISTORICAL RAILROAD MUSEUM
NATURAL TUNNEL STATE PARK

The Natural Tunnel State Park opened in 1971 with the Natural Tunnel (built by nature, used by trains) as its main attraction. Camping, hiking, swimming and picnicking facilities are available, along with the Early Historical Railroad Museum, which features railroading memorabilia from the area.

Season: Late Spring through late Fall.

For further information write to the Natural Tunnel State Park, c/o LENOWISCO Planning District Commission, P.O. Box 366, Duffield, VA 24244 or call (703) 940-2674 or (703) 431-2206.

INTERSTATE CAR 101

The Big Stone Gap Tourist Information Center is housed in the restored Interstate 101 President's Car. Even though the car is not running, the history of #101 is of interest to rail fans.

Built in 1870 for the South Carolina & Georgia Railroad, #101 was sold along with the railroad to Southern Railway in 1899. It was subsequently rebuilt and placed into service as Office Car #117. After changing hands and being renumbered a few more times, it finally arrived in Big Stone Gap where it was restored and placed in service as the regional tourist information center.

As built, this car contained an observation room, two state rooms, a dining area, facilities for the porter, and a kitchen area. Today, most of the original fixtures are intact, including the lavatories, lighting fixtures, and even the speedometer in the rear observation room. Other fixtures have been fabricated to look like the original pieces, and the paint scheme matches the original.

Season: Year-round.
Hours: Open when tourist division is open.
Cost: No admission charge.
For further information write to Interstate 101 President's Car, Regional Tourist & Information Center, Big Stone Gap, VA 24219 or call (703) 523-2060.

MIKE'S TRAINLAND & LANCASTER TOY MUSEUM

Although mainly a toy train museum and gift shop, Mike's Trainland does feature the "Lancaster Outdoor Railroad Park," which is now home to Southeast Virginia Live Steams (SEVALS), a 1½" scale railroad club. The Park offers two different gauge tracks—one 15" and the other 7½". The 15" track is approximately 800 feet long, and the 7½" track will eventually be 2500 feet long. The 15" gauge railroad consists of a trolley car and two diesel locomotives with several cars. The SEVALS operate live steam engines, diesels and electric locomotives on the 7½" gauge track.

The park also features a station platform, engine shed and machine shop, and an authentic red caboose and hand car for visitors to climb aboard.

Even though there is not much authentic railroading equipment available, rail fans can see a lot of railroading history (including many pieces of railroading memorabilia) exhibited in the Train & Old Toy Museum.

Season: Year-round.
Hours: Mon.–Thurs. and Sat., 10 a.m. to 6 p.m.; Fri., 10 a.m. to 9 p.m.; Sun., 12 p.m. to 6 p.m. Thanksgiving to December 23: Mon.–Sat., 10 a.m. to 9 p.m.; Sun., 10 a.m. to 6 p.m.
Cost: Train Rides: $1; Museum, donations only.
For further information write to Mike's Trainland & Lancaster Toy Museum, 5661 Shoulders Hill Rd., Suffolk, VA 23435 or call (804) 484-4224.

NORFOLK SOUTHERN

The history of the Norfolk Southern Railway is being kept alive by rail fans around the nation. The Southern Railway began sponsoring steam specials (excursions) in 1966. Later, Norfolk and Western Railway helped carry the program, and helped to restore two steam locomotives for these excursions.

As the tourist train excursion industry grows, the Norfolk Southern Corporation continues to be a leader in the field. Through co-sponsorship with

smaller organizations, they can now offer various excursions for their members and other interested rail fans. The Norfolk Southern Corporation offers one-day or two-day excursions on former Norfolk & Western and Southern Railways lines. All trains are steam powered, but various coaches are used, depending on the sponsor. All trips are sponsored by another group or groups.

The unique set-up of this group makes it essential that passengers write for schedules and specific fares information.

Season: Weekends, April through mid-November. A special Christmas excursion co-sponsored by the Chattanooga Choo-Choo was instituted in 1994.

For further information write to Norfolk Southern Corporation, Steam Operations Dept., 110 Franklin Road, S.E., Roanoke, VA 24042-0002 or call (703) 981-5741.

OLD DOMINION RAILWAY MUSEUM
(formerly Richmond Railroad Museum)

The Old Dominion Chapter of the National Railway Historical Society is currently finalizing plans to move the museum's exhibits from their present location into the Hull Street Station of the Southern Railway, located at First and Hull Streets in South Richmond. When completed, the Station House Museum will also contain a library, and future plans call for the addition of passenger and freight railroad cars.

Currently, the museum is housed in a "painstakingly restored" 1937 RF&P Railway Express Agency car, and features photographs and artifacts of various Richmond railroads. Other rolling stock on display includes a 1926 0-4-0 Porter steam locomotive, a 1956 Fairmount inspection car, a 1959 Seaboard Coastline caboose, and a 1969 Seaboard Coastline steel boxcar.

Season: Year-round, weekends only.

Hours: Sat., 11 a.m. to 4 p.m.; Sun., 1 p.m. to 4 p.m.

Cost: Admission is free, donations are appreciated.

For further information write to the Old Dominion Railway Museum, c/o the Old Dominion Chapter of the National Railway Historical Society, P.O. Box 8583, Richmond, VA 23226 or call (804) 233-6237 or (804) 745-4735.

U.S. ARMY TRANSPORTATION MUSEUM

This 15,000 square foot museum (inside footage) houses military and civilian forms of transportation dating back to 1776. On the five acres outside sit railroad rolling stock, trucks, aircraft and a number of other types of transportation vehicles.

Of special interest to rail fans is Locomotive #607 (a Lima 2-8-0), a narrow gauge Vulcan 0-6-0 engine, a U.S. Army medical ambulance car, a Berlin duty train sleeper, various pieces of Army rolling stock, a German caboose and tank car, and a French 40 & 8 boxcar.

Season: Daily. Closed all Federal holidays except Memorial Day, July 4, and Labor Day.
Hours: 9 a.m. to 4:30 p.m.
Cost: No admissions charge.
For further information write to the U.S. Army Transportation Museum, Building 300, Besson Hall, Fort Eustis, VA 23604-5260 or call (804) 878-1115.

VIRGINIA MUSEUM OF TRANSPORTATION

Founded in 1963 as the Roanoke Transportation Museum, Inc., the Virginia Museum of Transportation was designated as the official transportation museum of the Commonwealth of Virginia in 1983. An extensive railroading collection is a main feature of this museum. Items on display include a 1910 Baldwin steam locomotive, an 1897 Baldwin, a 1944 Lima, a 1923 Baldwin, many passenger cars, freight cars, cabooses, and trolley cars, the first N&W diesel locomotive, and much more.

Many special events are held at the museum, including an annual "Exposition Flyer" Steam Excursion offered during the Roanoke Railway Festival in October.

Season: Year-round. Closed Thanksgiving, Christmas, New Year's Day and Easter.
Hours: Daily, 10 a.m. to 5 p.m., March through December. Hours vary the rest of the year. Be sure to contact the museum before visiting.
Cost: Adults, $4; seniors, $3; youth (13-18 yrs.), $2; children (3-12 yrs.), $1.75; under 3, free. Contact the museum for train fare.
For further information write to the Virginia Museum of Transportation, 303 Norfolk Ave., S.W., Roanoke, VA 24016, or call (703) 342-5670 or Fax (703) 342-6898.

WASHINGTON

ANACORTES RAILWAY

This family-owned tourist railroad is one of the smallest narrow gauge (18") steam passenger railroads in the world (as opposed to a miniature railway). The railway offers a ¾-mile ride from the historic Great Northern Depot to downtown Anacortes along the city's waterfront and tree-lined parkways in luxurious Maine/Wales-style passenger cars. The cars feature cherry-wood interiors, red velvet cushions, plush carpeting and marble fireplaces. Turntables rotate the locomotive at each end of the line. A limited number of cab rides are available.

Special events are held a couple of times each year, but visitors can always visit nearby attractions, including the ferry to the San Juan Islands.
Season: Mid-June to Labor Day.
Hours: Weekends and holidays, with frequent departures from 12 p.m. to 4:30 p.m.
Cost: $1 per person.
For further information write to the Anacortes Railway, 387 Campbell Lake Rd., Anacortes, WA 98221 or call (206) 293-2634.

CHEHALIS-CENTRALIA RAILROAD ASSOCIATION

Under a contract with the Mt. Rainier Scenic Railroad, the Chehalis-Centralia Railroad Association offers passengers a 12-mile, 1 ¾-hour trip between South Chehalis and North Centralia over former Milwaukee Road trackage. Longer trips are offered on selected Sundays featuring dinner stops at area restaurants. An extended trip to Ruth, Washington, is also available.

Equipment used for these trips includes: Locomotive #15, a 1916 Baldwin 2-8-2 former Cowlitz, Chehalis & Cascade; former Puget Sound & Cascade #200; two open-window heavyweight coaches and an open-air observation car. Restored Union Pacific C-5 cabooses house the ticket office and gift shop.

Passengers can board at either the Chehalis or Centralia stations. Be sure to contact the Association for exact schedules and boarding locations.
Season: Memorial Day weekend through Labor Day.
Hours: Weekends and holidays. Leave Chehalis at 1 p.m. and 3 p.m.; leave Centralia at 2 p.m. and 4 p.m. Special trains depart at various times.
Cost: Regular excursions round-trip: Adults, $6.50; children (3-16 yrs.), $4.50. One-way: Adults, $3.25; children, $2.25. Fares vary for special trains.
For further information write to the Chehalis-Centralia Railroad Assoc., 1945 S. Market Blvd., Chehalis, WA 98532 or call (206) 748-9593.

LAKE WHATCOM RAILWAY

The Lake Whatcom Railway offers passengers a seven mile, 1½-hour round trip from Wickersham through a tunnel, along Mirror Lake, through a scenic forest, and back. The train runs over trackage originally laid by the Bellingham Bay & Eastern Railroad in 1902, later to become a Northern Pacific branch line.

Equipment used by the railway includes: Steam Locomotive #1070, a 1907 ALCO 0-6-0, former NP; the 1910 Pullman parlor car, "Dunlop"; the 1912 Pullman coach, "Clearview"; a 1925 Pullman coach, now coffee-shop coach; the 1926 Pullman business car, "Madison River"; and a baggage car.

Regularly scheduled train rides are available in the summer, along with motor car rides at the station. Several special events are offered throughout the

year, but these all require advance reservations, so be sure to contact the railway well in advance of your visit.

Season and hours: Train: Mid-June to late August, 11 a.m. & 1 p.m., Sat. & Tues. Motor Cars: Same dates, 3:15 p.m. only. Special events and unscheduled special trains are often offered, so be sure to contact the railway about your planned visiting date.

Cost: Train: Adults, $10; children (2-17), $5. Motor car rides: $1.50; special events and special train fares vary.

For further information write to the Lake Whatcom Railway, Box 91, Acme, WA 98220 or call (206) 595-2218.

MT. RAINIER SCENIC RAILROAD

This standard gauge, steam-powered railroad currently offers two different excursions. The regularly scheduled 14-mile, 1½-hour round trip over a secluded right-of-way on the south slope of Mt. Rainier runs several times a day. A 20-minute layover at Mineral Lake offers passengers a chance to disembark for sight-seeing and return on a later train. The "Cascadian Dinner Train" takes passengers on a four-hour round-trip to Eatonville or Morton, offering an elegant five-course dinner aboard a restored Union Pacific dining car. Live music is available on all trains.

Equipment owned by the railroad includes Locomotive #5, a 1924 Porter 2-8-2, former Port of Grays Harbor; #10, a 1928 Climax, former Hillcrest Lumber Co.; #11, a 1929 three-truck Shay; a 1912 Heisler (the first successful three-truck Heisler built), plus many other locomotives, both restored and under restoration. Two commuter coaches, an open-air car, a dining car and a former Alaska Railroad lounge/observation car are also on the roster.

Season: Daily, mid-June to Labor Day; weekends, May and September.

Hours: Regular Excursions run 11 a.m., 1:15 p.m. and 3:30 p.m. Dinner trains run at 1 p.m. in spring and fall and 5:30 p.m. in summer. Be sure to send for a schedule for exact boarding times.

Cost: Regular Excursions: Adults, $6.95; seniors, $5.95; juniors (12-17 yrs.), $4.95; children (under 12), $3.95. Dinner train: $55 (reservations required).

For further information write to the Mt. Rainier Scenic Railroad, P.O. Box 921, Elbe, WA 98330 or call (206) 569-2588.

PUGET SOUND RAILWAY HISTORICAL ASSOCIATION SNOQUALMIE DEPOT

The historic Snoqualmie Depot was built in 1890 and is now the home of the Puget Sound Railroad Museum. Many artifacts and pieces of memorabilia from this railroad are on display.

The Puget Sound Railway Historical Association offers regularly scheduled train trips on most summer weekends and special events during October and December. Passengers have a choice of riding in one of two passenger coaches or a combination coach owned by the museum. These cars are usually pulled by Locomotive #7320, a 1952 Fairbanks-Morse, former Weyerhaeuser diesel logging engine. The association also owns Diesel Locomotive #909, a former Kennecott Copper, and a few steam locomotives which they are working on restoring.

Season: Memorial Day through Labor Day, plus special Fall and Winter events.

Hours: Vary. Be sure to contact the association for specific dates and times.

Cost: Train: Adults, $6; seniors, $5; children, $4. Museum: No admission charge; donations welcome.

For further information write to the Puget Sound Railway Historical Association, c/o Snoqualmie Depot, P.O. Box 459, Snoqualmie, WA 98065 or call (206) 888-0373.

"SPIRIT OF WASHINGTON" DINNER TRAIN

This 44-mile, 3½-hour dinner train excursion offers gourmet cuisine and award-winning wines along with the breathtaking scenery of Mount Rainier, the Olympic Mountains and the Seattle Skyline. Passengers ride aboard one of seven vintage cars, including three dome cars, a round-end observation car and an open-platform car.

One of two diesel F-7A locomotives pulls the train from Renton to the Chateau Ste. Michelle Winery in Woodinville.

Dinner train excursions are scheduled regularly, while Murder Mystery trains are offered occasionally.

Season: Year-round.

Hours: Dates and hours vary according to season and excursion chosen. Be sure to contact the train offices for exact dates and times.

Cost: Dinner: Parlor seating, $57; dome seating, $69. Lunch/brunch: Parlor seating, $47; dome seating, $59. Contact the train offices for cost of Murder Mystery Trains.

For further information write to the "Spirit of Washington" Dinner Train, P.O. Box 835, Renton, WA 98157 or call 1-800-876-7245.

YAKIMA VALLEY RAIL AND STEAM MUSEUM
TOPPENISH DEPOT

The Toppenish Depot, built in 1911 by the Northern Pacific Railroad, has been restored and is now the home of the Yakima Valley Rail and Steam Museum

and Gift Shop. A freight house (converted to the engine house) and a section foreman's house are also on the grounds.

Currently, the museum operates standard gauge diesel-powered freight and passenger service on the former Northern Pacific White Swan branch line, but plans call for the restoration of a former Northern Pacific, 1902 Baldwin 4-6-0 (#1364) steam locomotive, which will be used for passenger excursions.

The passenger excursion currently offered by the museum is a 20-mile round trip from Harrah to White Swan. Passengers may ride in one of two 1920s P-70 heavyweight coaches, a 1947 Northern Pacific coach, or a combine from the New Haven line.

Season: Museum: Year-round. Train: April through October.

Hours: Museum: Daily in the summer; weekends in the winter. Train: Sat., 11 a.m.; Sun., 1 p.m.

Cost: Museum: Adults, $1; under 18, free (accompanied by parent). Train: Adults, $8; children, $5; family fare, $25.

For further information write to the Yakima Valley Rail and Steam Museum, c/o Toppenish Depot, P.O. Box 889, Toppenish, WA 98948 or call (509) 865-1911 or (509) 865-3262 (Chamber of Commerce).

WEST VIRGINIA

CASS SCENIC RAILROAD STATE PARK

In 1911, West Virginia led the nation in number of miles of logging railroad line with over 3,000 miles at that time. Today, only 11 miles of that line remain. All 11 miles are located in and around the town of Cass in the state park there.

The Cass Scenic Railroad runs on the same line that was built in 1902, and the passenger cars are the old logging flatcars which have been refurbished and made into passenger coaches. Several steam locomotives are on the Equipment Roster, two of which are of the "super power" design. One of these is the last one ever built and the largest still in existence (weight—162 tons).

The town of Cass itself (around which the park is built), restored to look much as it did in its original state, offers a country store, the train station, and now a museum, among other things. Visitors should plan to spend some time here before boarding the train.

Passengers are offered a variety of choices for rides. Regular excursions include an eight-mile, 1½-hour ride to historic Whittaker Station, or a 22-mile, 4½-hour trip to Bald Knob. Both excursions are round-trip, returning to the park. Other special events are offered throughout the year, including Saturday night dinner trains and holiday trains.

Season: Regular Season: May to September; Fall Season: September through October.

Hours: To Whittaker Station: Both Seasons: Departs Cass at 11 a.m.,

1 p.m., and 3 p.m., with additional trains on holidays; 9 a.m. in the Fall and 5 p.m. if warranted. To Bald Knob: Regular Season: noon; Fall Season: noon, but no Monday train.

Cost: Regular fares to Whittaker Station: Adults, $9; children, $5. Regular fares to Bald Knob: Adults, $13; children, $7. (Ticket includes admission to Cass Showcase, Wildlife Museum & Historical Museum.) Dinner trains (by reservation only): Adults, $25; children, $15. Holiday trains: Adults, $11; children, $6.

For further information write to the Cass Scenic Railroad State Park, Box 107, Cass, WV 24927 or call 1-800-CALL WVA or (304) 456-4300.

MARLINTON, WEST VIRGINIA C&O RAILROAD STATION

Those interested in keeping old railroad stations from being demolished have created other uses for them. In Marlinton, the Pocahontas County Tourism Commission operates out of the Old C&O Railroad Station. An antique caboose sits on the tracks outside the station.

Season and hours: Open daily during regular business hours.

For further information write to the Pocahontas County Tourism Commission, P.O. Box 275, Marlinton, WV 24954 or call 1-800-336-7009.

THE NEW RIVER TRAIN
POWHATAN ARROW STEAM TRAIN
THE COLLIS P. HUNTINGTON RAILROAD HISTORICAL SOCIETY, INC.
HUNTINGTON RAILROAD MUSEUM

The Collis P. Huntington Railroad Historical Society sponsors various exhibits and train excursions, including the Huntington Railroad Museum, the New River Train and the Powhatan Arrow Steam Train.

The Museum is located at Memorial Boulevard and 14th Street W. in Huntington. The outdoor museum features a C&O Mallet Freight Locomotive #1308 (a Baldwin H-6 built in 1914 by American Locomotive), a C&O Caboose #90665 (the first of the Clear View Cupola style with wood body later sheathed in steel—fully restored), an 1880s-style wood frame handcar, a wooden one-man "Scooter," an old steel-wheel Flat Car, an H.K. Porter 0-4-0 Saddle-tank steam Switcher, a 15-ton Burro Railroad Crane, a Fairmont gasoline Motor Car, and a number of signals.

At their "South Yard" the museum exhibits the #7003 Union Pacific Half Dome Coach, #6108 "Seaboard" Dining Car, two C&O Day coaches designed for the "Chessie" flagship that never ran, a maintenance-of-way dormitory

car, one modern box car, an army hospital car and two cabooses (from the VGN and Nickel Plate railroad).

Other pieces of equipment are on their rolling stock roster, but may be stored or loaned out to another museum at various times. For a complete roster, rail fans should write to the museum.

The historical society is named after Collis Potter Huntington, who, among other accomplishments, helped construct the Central Pacific Railroad which completed the transcontinental rail system. He also built the line that connected the Chesapeake Bay area with the Ohio River at his "new city" of Huntington, West Virginia. The New River Train steam excursions offered by the Historical Society run over this last piece of track. Other excursions include a Norfolk Southern Excursion (diesel) from St. Albans, West Virginia, to Cincinnati, Ohio, for a Reds' baseball game, and more.

There is no regular schedule of daily trips on this railway, but the special excursions are offered on a regular basis—many are offered one day only. As the museum and historical society are expanding, so are the excursions offered. For a complete list of excursions and a schedule, we suggest you write to the Historical Society.

Season: Summer & Fall.
Hours: Vary.
Cost: Varies with excursion, with prices ranging from $55 to $249.

For further information write to the Collis P. Huntington Railroad Historical Society, Inc., 1429 Chestnut St., 2nd Floor, Kenova, WV 25530-1235 or call 1-800-553-6108 or (304) 453-1641.

POTOMAC EAGLE
EAGLE CANON PASSENGER CAR COMPANY, INC.

The Potomac Eagle is a weekend tourist train which operates on the West Virginia Railroad Maintenance Authority's South Branch Valley Railroad using equipment owned by the Eagle Canon Passenger Car Co. Eagle Canon Passenger Car Co. began operating its own public excursion in 1989 in Ohio on the Indiana & Ohio Rail System, and has run both excursion and corporate trains ever since.

The name Eagle Canon (pronounced "canyon") came from the railroad name of its first car, the "Eagle Canon," an ex–Denver & Rio Grande West. The car was actually one of four Pullman Standards built as lunch-counter lounge cars in 1946 for the Chesapeake & Ohio Railroad as part of a large order (part of which was eventually canceled). The name helps to identify the train with the area in which it runs—an area in which bald eagles seem to abound, with sitings reported on nearly 90 perent of Potomac Eagle runs during the 1993 season.

At present, ECPX owns 22 cars, three lounge cars, a sleeping car, three baggage cars, a dining car, 10 open window coaches, two cabooses, a camp

car, a combine and a gondola with added bench seats. They also broker two other cars and lease out the sleeper and the two lounge cars. Many of the cars are committed to the Potomac Eagle operation and to the Great Smoky Mountains Railway. Several other units are awaiting restoration.

The Potomac Eagle Scenic Railroad operates diesel-powered passenger excursion trains from the Wappocomo Station one mile north of Romney, West Virginia. These trains offer a three-hour narrated excursion through beautiful West Virginia countryside. Regular or first class ("Classic Club") services are available. Saturday Evening Dinner Trains are offered in the late summer, while several special events are offered at other times throughout the season.

Season: Mid-May through end of October.

Hours: Special events generally depart at 9 a.m.; dinner trains depart at 6 p.m. Regular excursions depart at 10 a.m., 12 p.m. or 2 p.m.

Cost: May through September: Adults, $16; seniors (60+), $14; children (3-12 yrs.), $10; Classic Club, $40. October: Adults, $19, seniors, $17; children, $12. Contact the Potomac Eagle for special events fares.

For further information write to the Potomac Eagle, P.O. Box 657, Romney, WV 26757 or call 1-800-22-EAGLE (32453) or (304) 822-7464.

WEST VIRGINIA NORTHERN RAILROAD

The Kingwood Railway Company, incorporated in 1882, built the rail line used by the West Virginia Northern Railroad today. Originally a narrow gauge, but widened to standard gauge in 1894, the railroad was not as successful as had been hoped. After several name and owner changes, the line finally was bought by Kingwood in April of 1994 for use as a scenic railroad.

Passengers ride aboard vintage coaches through the mountains and coal country of Preston County. Plans call for steam power by April of 1995, eventually using two of the original steam locomotives that ran on this line. The locomotive to be used in 1995 is a 1941 Vulcan 0-4-0 Switcher.

Season: Weekends, year-round.

Hours: 10 a.m., 1 p.m. & 4 p.m. Charters available through the week.

Cost: Adults, $10; seniors, $8; children (3-12 yrs), $5.

For further information write to the West Virginia Northern Railroad, Kingwood Northern, Inc., P.O. Box 424, Kingwood, WV 26537 or call (304) 329-3333.

WISCONSIN

"CAMP FIVE"
CAMP FIVE LOGGING MUSEUM & BLACKSMITH SHOP
(see also **LUMBERJACK SPECIAL**)

Passengers ride aboard the Lumberjack Special (see listing) to Camp Five. Once there, visitors can see an audio-visual presentation at the Logging Museum &

Blacksmith Shop, take a 30-minute "Green Treasure Forest Tour" by Guided Surrey, see an animal barn and petting corral or nature center with mounted display, view a 30-minute "Steam Engine" documentary, take an ecology walk through the natural Arboretum, or visit the "Cracker Barrel" 1900 Country Store Gift Shop. Food is also available at the Choo-Choo Hut snack bar.

Many pieces of railroading memorabilia and a few pieces of equipment can be seen at the camp.

Season: Mid-June to late August, and weekends mid-September to mid-October.

Hours: Round-trips to and from Camp Five operate 10 minutes each way from 11 a.m. hourly to 2 p.m., and at 4 p.m.

Cost: Adults, $12.50; students (13-17 yrs.), $9; children (4-12 yrs.), $4.50. (Maximum family rate, $35). Taxes not included. Camp Five admission price includes a free ride on the Lumberjack Special. An optional pontoon trip through the Natural Wildlife Refuge is also available for adults, $2; children (4-12 yrs.), $1.25.

For further information write to Camp Five, 1011 Eighth Street, Wausau, WI 54403 (Winter address) or the Camp Five Museum Complex, Hwys U.S. 8 & 32, Laona, WI 54541, or call 1-800-774-3414 or (715) 674-3414 or (715) 845-5544 (Winter).

CIRCUS WORLD MUSEUM

The Circus World Museum in Baraboo is at the site of the original Winter Quarters of the Ringling Bros. Circus (1884-1918). It has been designated as a National Historic Landmark. Since trains were such an integral part of Circus History, the museum features a huge Circus Train Exhibit and Presentations, including a scale model of a Ringling Brothers and Barnum & Bailey Circus Train (circa 1940).

A number of Rail Cars are on exhibit on the museum grounds, including the Ringling Bros. and Barnum & Bailey Circus Advertising Car #1 which was built in 1942 for the U.S. Army, but purchased by the circus in the late 1940s. The car's interior depicts the living quarters of the circus's advertising "advance" crew, as well as numerous exhibits on circus advertising methods.

Also on display is a rail car from the Al G. Barnes & Sells-Floto Combined Shows, the last Ringling Bros. and Barnum & Bailey ring stock car, two flat cars loaded with circus parade wagons and two flat cars used in the CWM's daily circus train loading demonstrations. The flat cars are especially interesting as they were basically twice the length of ordinary flat cars of the day. Circuses created this double-length flat to save money on the per-car fees charged by the railroads.

The CWM transports 75 of its antique circus wagons to Milwaukee each July for the "Great Circus Parade," a horse-drawn circus street parade produced by the Circus World Museum. The "Great Circus Train" carrying the equipment includes 19 restored flat cars, two stock cars carrying horse teams for loading and unloading, five coaches and a caboose.

The museum also offers Circus Train loading and unloading demonstrations twice daily during the summer, showing how the flat cars were loaded and unloaded for performances.

Season: Year-round, including some live presentations. Other live-show presentations: daily, first of May through Labor Day.

Hours: "Theatre of Illusion": 1:30 p.m., daily (additional shows at 7 p.m., July 23 through Aug. 20). "Gunther Gebel-Williams" Shows: Various times throughout the day. "Big Top" Shows: 11 a.m. & 3 p.m. (plus 8 p.m. in Summer).

Cost: Summer season: Adults, $10.95; seniors (65+), $9.95; children (3–12 yrs.), $5.95.

For further information including winter prices write to the Circus World Museum, 426 Water Street, Baraboo, WI 53913-2597 or call (608) 356-8341 or Fax (608) 356-1800.

DECAPOD 950
SOO LINE DEPOT

Engine #950 was built in 1900 by the Baldwin Locomotive Works for the Buffalo and Susquehanna Railroad as their engine #113, but due to financial differences between the two companies, the Susquehanna did not purchase it. It was purchased by the Soo Line and became their number #600. It was the largest steam locomotive in the world when it was built, and could not be used on all lines because of the light rails used on many lines.

In 1912, it was renumbered #950 and sent to Superior, Wisconsin, where it was rebuilt and updated. After several more moves, it finally "returned" to Ashland where it now sits outside of the 100-year-old restored Soo Line Depot there.

The old Soo-Line Depot was renovated in 1987 and named the most historically significant renovation in the state of Wisconsin for that year. It now serves as a restaurant and museum.

Season: Year-round.

For further information write to the Ashland Area Chamber of Commerce, Bay Area Civic Center, 320 Fourth Avenue West, P.O. Box 746, Ashland, WI 54806 or call (715) 682-2500.

THE EAST TROY ELECTRIC
RAILROAD MUSEUM

The East Troy Electric Railroad Museum offers visitors various special events throughout the year, along with a regularly scheduled 10-mile trolley ride. Passengers on any of the rides travel through Southeastern Wisconsin's beautiful countryside over the longest continuously operating stretch of original interurban trackage of any museum in the country.

In addition to the trolley rides, a two-hour dinner train ride is offered six times from May to October aboard the "Ravenswood." This Art Deco styled car, decorated with fine mahogany woodwork, clamshell wall fixtures and brass table lamps, travels from East Troy to "The Elegant Farmer," Wisconsin's largest farm market.

At the museum itself, visitors may tour a carbarn, visit the station and gift shop and view numerous historic railroad displays.

Season: Weekends, May through October (closed holidays).
Hours: Vary according to excursion chosen.
Cost: Varies according to excursion chosen.
For further information write to the East Troy Electric Railroad Museum, 2002 Church St., East Troy, WI 53186 or call (414) 542-5573.

FENNIMORE RAILROAD MUSEUM

This museum is dedicated to preserving the history of railroading in and around Fennimore, Wisconsin. Inside the building, which has been made to resemble a turn-of-the-century depot, are many railroading artifacts. Included are a ticket office with telegraph paraphernalia, a ticket window, an original pot-bellied stove, many pictures of narrow gauge historical landmarks, several miniature trains, and more.

Outside the museum is a 1907 Davenport 2-6-0 locomotive (similar to the last narrow gauge locomotive used on the 16-mile track between Fennimore and Woodman on January 30, 1926), its tender, and an original box car. The train that ran on this line, nicknamed the "Dinky" (probably because it was a narrow gauge), operated from 1878 to 1926 (longer than most narrow gauges), and was famous for a horseshoe curve that made it possible to climb the steep slope from the valley to the ridge west of Fennimore. The line was a remnant of a 92-mile system, the rest of which was converted to standard gauge in 1882.

Season: Memorial Day to Labor Day.
Hours: 10 a.m. to 4 p.m. (or by appointment).
For further information write to the Fennimore Railroad Historical Society Museum, 610 Lincoln Ave., Fennimore, WI 53809 or call (608) 822-6144 or (608) 822-6319.

KETTLE MORAINE STEAM TRAIN
"Pioneer Express"

The Kettle Moraine Steam Train No. 9 was once the pride of California's McCloud River Railroad. The locomotive built in 1901 by Baldwin now powers the "Pioneer Express" over the former North Lake Branch of the Milwaukee Road between North Lake and West Merton on its eight-mile, 50-minute round-trip journey.

Kettle Moraine Railway

Season: Every Sunday from first Sunday in June through third Sunday in October & Labor Day.
Hours: Train departs 12:30 p.m., 2 p.m. and 3:30 p.m. (Extra 11 a.m. run offered in October).
Cost: Adults, $7; children (3–11 yrs.), $3.50; under 3, free.
For further information write to Steam Train, Box 247, North Lake, WI 53064 (return stamp appreciated) or call (414) 782-8074 or (414) 966-2866.

LUMBERJACK SPECIAL STEAM TRAIN
(*see also* CAMP FIVE MUSEUM COMPLEX)

Passengers board the Lumber Jack Special at the old Soo Line depot at Snyder's Landing, Wisconsin, for a 17-mile round-trip to Camp Five (see listing for Camp Five). The depot was purchased from the Soo Line and moved 32 miles to Snyders Landing, Connor's mill site. It still has many of the original furnishings, including an elm bow, which allowed passing train conductors to catch dispatches from the depot agent.

The steam-driven train runs on the Laona and Northern Railway, whose history dates back to 1902. It has been operating under that same company name ever since, except for 22 days during World War II when the Government, under Executive Order 9412, "took possession and control of certain

Visitors board the "Lumberjack Special" at Camp 5 after a busy day at the historical, educational and ecological compound.

transportation systems and common carriers by railroad, including the 'Laona and Northern'" (December 27, 1943 to January 18, 1944).

Equipment on the roster includes one steam locomotive (the "4-Spot"), two coaches and three cabooses. The "4-Spot" was built in 1916 by the Vulcan Iron Works, Wilkes Barre, Pennsylvania, for the Birmingham Rail & Locomotive Company. The "Rat River" car (originally coach #976) was built in 1912 for the Soo Line by the American Car and Foundry Company. The other passenger car, the "Otter Creek," was built in 1911 by Barney and Smith as coach #994 for the Soo Line.

The three cabooses, now named for logging camps, are "Camp 5," "Camp 7," and "Camp 8." Camp 5 was originally the Soo Line's Caboose #147; Camp 7 was originally Mesabi and Iron Range Railroad's Caboose #589; and Camp 8, an 18-passenger cupola style caboose, was originally #59 of the Duluth and Iron Range Railroad.

Season: Mid-June to late August, and weekends mid-September to mid-October.

Hours: Round-trips to and from Camp Five operate 10 minutes each way from 11 a.m. hourly to 2 p.m., and at 4 p.m.

Cost: Camp Five admission price includes a free ride on the Lumberjack Special.

For further information write to Lumberjack Special, c/o Camp Five, 1011 Eighth Street, Wausau, WI 54403 (Winter Address) or the Camp Five Museum Complex, Hwys U.S. 8 & 32, Laona, WI 54541, or call 1-800-774-3414 or (715) 674-3414 or (715) 845-5544 (Winter).

MID-CONTINENT RAILWAY HISTORICAL SOCIETY, INC.

Mid-Continent is an outdoor living museum depicting the typical short line railroad way of life. Educational exhibits and displays are featured, along with an operating train.

The depot at Mid-Continent was built in 1894 by the Chicago & North Western Railway at Rock Springs, three miles west of North Freedom. In 1965, it was moved to the museum where it was restored and made into a usable depot and museum gift shop. Other buildings on the property include a Soo Line watchman's tower, an old tool house (on which a panel recognizes the work of a women's section crew during World War II), and water tanks.

Four excursions through scenic Baraboo River Valley are run behind an authentic steam engine every day, rain or shine. First Class & Dinner Trips and other "special events" are available on specified weekends. Be sure to write to the Museum for specific information.

Equipment used on the excursion is rotated, so each ride is a unique experience. Units most often used include the following: Dardanelle and Russellville #9, built in 1884 by the Baldwin Locomotive Works as New Orleans & North Eastern's #232 (preserved as it was in the 1950s); Chicago & North Western's #1385, built in 1907 by the American Locomotive Company's Schenectady Works (preserved as it was retired in 1956); Saginaw Timber's #2, built in 1912 by Baldwin for logging service; Delaware Lackawanna & Western's Coaches #557, #563, and #595, built in 1914 and 1915 by the Pullman Co. for suburban passenger service in New York and New Jersey; and Chicago & North Western's Baggage/Coach #7409, built in 1915 by Pullman Co. for use in commuter service in the Chicago area.

Other pieces of equipment owned by the museum include the following: Chicago & North Western's Narrow Gauge Box Car #10, built before 1900; C&NW's Narrow Gauge Baggage/Coach #1099, probably built in the 1870s for the Des Moines & Minneapolis Railroad; French National Railways' Good Wagon, used during World War I for transporting troops in Europe (France donated one car to each state's American Legion 40 et 8 Society); a Milwaukee Road Inspection Car, a Dodge 4-door sedan built in 1946 with special wheels to ride on the tracks; Western Coal & Coke's Locomotive #1, built in 1913 by the Montreal Locomotive Co. for freight service; Pennsylvania Railroad's Box Car #4831, built in 1901 by the Pressed Steel Car Co. as Iowa Central's #04492 (used in the movie *Mrs. Soffel*; and many more, making a roster of equipment with over 30 pieces on the list.

Season: Daily, mid-May to Labor Day; weekends until mid-October.

Hours: Museum: 9:30 a.m. to 5 p.m. Trains: 10:30 a.m., 12:30 p.m. 2 p.m. and 3:30 p.m. Special events times vary.

Cost: Adults, $8; seniors, $7; children (3-15 yrs.), $4.50; family fare, $22. Special events fares vary.

For further information write to the Mid-Continent Railway Historical Society, Inc., P.O. Box 55, North Freedom, WI 53951 or call (608) 522-4261.

NATIONAL RAILROAD MUSEUM

The National Railroad Museum was founded in 1956, making it one of America's oldest and largest railroad museums. More than 70 locomotives and railroad cars are on exhibit, along with numerous bits of railroading memorabilia and archives. Many units are equipped with stairs, indicating that visitors may enter them. A one-mile train ride around the grounds and guided tours are available.

Also on the museum grounds are the Frederick J. Lenfestey Reception Center and the Hood Junction Depot. The 8,500 sq. ft. Reception Center opened in 1989 and includes a wide screen theatre (showing "Rails to America"), exhibit hall (showing 1/12 scale dioramas and an exhibit on "The Social and Economic Impact of Railroads"), gift shop, library, offices and restrooms. The Hood Junction Depot was built by the American Shortline Railroad Association in 1961 (patterned after one at Langley, South Carolina), and now houses the Green Bay Area Model Railroader's Club and a 25' by 72' HO scale model train display.

Included in the more than 70 pieces of railroad equipment are the Union Pacific "Big Boy" (the world's largest steam locomotive), the "Aerotrain" (an experimental 1950s Rock Island train), and the streamlined "Dwight D. Eisenhower" (a British-built 4-6-2 locomotive), along with Eisenhower's WWII staff train and cars. A total of 12 locomotives are on display, ranging in size from a small narrow gauge Shay engine to the "Big Boy."

Season: Museum: Year-round. Closed Thanksgiving, Christmas and New Year's Day. Trains: run Summer season only (May 1 to October 31).

Hours: Museum: 9 a.m. to 5 p.m. Trains: 10 a.m., 11:30 a.m., 1 p.m., 2:30 p.m. and 4 p.m.

Cost: Adults, $6; seniors, $5; students (6–15 yrs.), $3; under 6, free. Admission costs include train ride and guided tours.

For further information write to the National Railroad Museum, 2285 S. Broadway, Green Bay, WI 54304 or call (414) 437-7623 or (414) 435-7245.

NICOLET SCENIC RAIL
NICOLET BADGER NORTHERN RAILROAD, INC.

The Nicolet Badger Northern Railroad has run scenic excursions on the Nicolet Scenic Rail for more than 10 years. Part of the rails used were once an important C&NW Branch Line. The excursions run in all seasons, but the route may vary. The winter train operates three weekends only, on a 41-mile, four hour route through the Nicolet National Forest to Long Lake and back (a New Year's Eve brunch trip is also available). The Fall excursions (late August through October), travel from Laona to Long Lake, where the train stops for a 90-minute lunch, and then goes on to Tipler, where it starts its

return journey back to Laona. The summer route runs south between Laona and Wabeno Monday through Saturday from late June through late August.
Season: Year-round.
Hours: Fall, 11 a.m.; Summer, 10:30 a.m.; Winter, varies.
Cost: Fall: Adults, $28; seniors (60+), $25; children (3-12 yrs.), $18 (Fall reservations are required). Summer: Adults, $11.50; seniors, $10; children, $8; family package, $33. Winter: prices vary.
For further information write to the Nicolet Scenic Rail, P.O. Box 310, Laona, WI 54541 or call 1-800-752-1465 or (715) 674-6309 or Fax (715) 674-2175.

OSCEOLA & ST. CROIX VALLEY RAILWAY

The Osceola & St. Croix Valley Railway is a non-profit organization dedicated to returning passenger railroading to the St. Croix Valley. Two round-trip excursions are provided—Osceola to Marine on St. Croix in Minnesota and Osceola to Dresser.
Season: End of May through end of October, Sat. and Sun. only, plus Memorial Day, Independence Day and Labor Day.
Hours: Round trip to St. Croix departs at 11 a.m. & 2 p.m. Round trip to Dresser departs at 12:45 p.m. and 3:45 p.m.
Cost: To St. Croix: Adults, $10; seniors (65+), $8; children (5-15 yrs.), $6. To Dresser: Adults, $7; seniors (65+), $5; children (5-15 yrs.), $3.
For further information call 1-800-643-7412.

RIVERSIDE & GREAT NORTHERN RAILWAY

(Although this railroad is neither "narrow" nor "standard" gauge, we thought it worthy of inclusion because its longevity and the dedication of its workers, especially its builders, has made it a truly historic part of American railroading history.)

The Riverside & Great Northern Railway was started in Janesville, Wisconsin, in the late 1940s and moved to its present location in the Wisconsin Dells in 1953. Built by Elmer Sandley and his son, Norman, on the old right-of-way of the LaCrosse and Milwaukee Railroad, the railway ran from 1953 to 1980. In 1990, the Riverside & Great Northern Railway Preservation Society, Inc. reopened it for operation as a tourist attraction.

The three-mile train ride travels through the beautiful Wisconsin Dells countryside. The half-way point at Western Springs is one of the highlights of the trip as passengers are able to watch the train being turned on a turntable there.

Rolling stock on the roster of equipment includes: #82, 4-4-0 Sandley

built in 1957; "Tom Thumb" built in 1940 by Sandley; Sandley coaches #301, 302, and 303, built in the 1980s; Excursion car #201, built in 1975 by the Sandleys; #214 Ballast car, built in 1990 by R&GN; a Sandberg Caboose, built in 1993; and miscellaneous work flats. Several buildings also sit on the grounds, many open to the public.

Season: Mid-May through mid-October.

Hours: Memorial Day through Labor Day: runs continuously from 10 a.m. to 5:30 p.m.; other days, 10 a.m. to 4 p.m.

Cost: Adults, $4; youth (4-15 yrs.), $3; under 4, free.

For further information write to Riverside & Great Northern Railway, P.O. Box 842, Wisconsin Dells, WI 53965 or call (608) 254-6367.

WYOMING

NO. 4004 "BIG BOY" STATIC DISPLAY

The 4-8-8-4 "Big Boy" is the world's largest steam locomotive ever made. Twenty-five of them were built in 1941 for the Union Pacific Railroad, whose tracks from Cheyenne to Ogden, Utah, and other places in the West required a larger, heavier locomotive to move the train over the rugged terrain.

The "Big Boy" #4004 on display outside at the Holiday Park in Cheyenne is one of a few of this type left. It was retired from service in 1958 and eventually wound up in this location.

Season and hours: Year-round, outside.

Cost: No charge.

For further information write to the Cheyenne Parks & Recreation Dept., 610 West 7th St., Cheyenne, WY 82007 or call (307) 637-6423.

WYOMING/COLORADO RAILROAD'S SNOWY RANGE EXCURSION

The Wyoming/Colorado Railroad departs from the Wyoming Territorial Park and runs through western Laramie Valley, passing over the Overland Trail, and through the small towns of Centennial and Albany to Lake Owen. Passengers debark at Centennial, an old mining town, for lunch.

The track used by the railroad is famous for the fact that it pigtails around three and one half complete circles, taking the train to an eventual elevation of over 8,000 feet. This feat is shared with only one other railroad—a line built in India more than a century ago.

Rolling stock operated by the Wyoming/Colorado includes two FP7 locomotives (purchased from the Alaska Railroad), three coach cars, three first class cars and two open-air gondolas.

Wyoming Colorado Railroad

Season: End of May through October plus special events.

Hours: Departs 10 a.m.; returns 4:30 p.m. on Tues., Thurs. and Sat. A Sunday train is added in the summer.

Cost: Adults, $32.95; seniors (65+), $29.95; children (under 12), $17.95; first class, $49.95. Group rates and special excursion rates vary. Reservations are recommended.

For further information write to the Wyoming/Colorado Excursion Train, P.O. Box 1653, Laramie, WY 82070 or call (307) 742-9162.

WASHINGTON, D.C.

SMITHSONIAN INSTITUTION

Located in the National Museum of American History (one of the museums of the Smithsonian) is the Railroad Hall where visitors can see exhibits depicting the best in railroading history from the 1820s to the 1960s. Several models are on display along with numerous pieces of well-restored original equipment. Some of the pieces at the museum include Locomotive #1401 (a 1926 ALCO 4-6-2, former Southern Railway); "John Bull" (an 1831 Stephenson 4-2-0, former Camden & Amboy), "Jupiter" (an 1876 Baldwin 4-4-0, narrow

gauge); "Pioneer" (an 1851 Wilmarth 2-2-2 former Cumberland Valley Railroad) and more. Before visiting the museum, we suggest you send for the government's Information Leaflet No. 455, which describes the museum's exhibits.

Season: Year-round. (Closed Christmas Day.)
Hours: Daily, 10 a.m. to 5:30 p.m.
Cost: No admissions charge.
For further information write to the Curator, Division of Transportation, National Museum of American History, Smithsonian Museums, Washington, D.C. 20560.

Appendix A:
Other Sites of Interest

Listed below are the names of amusement parks, county parks, or other tourist attractions that offer train rides as a part of their line-up of attractions. Many of these are pulled by authentic steam locomotives, and some are replicas. If your main objective is to ride behind an authentic steam locomotive, be sure to correspond with the park before visiting.

ADVENTURELAND
P.O. Box 335
Des Moines, IA 50316
(515) 266-2121
 A smaller scale replica of a steam-powered train takes passengers on a short ride around the park.

"CEDAR POINT" & LAKE ERIE RAILROAD
P.O. Box 5006
Sandusky, OH 44871-8006
(419) 626-0830
 Several authentic steam engines pull various trains on 15-minute excursions through the land of the Old West in Cedar Point Amusement Park.

CLINCH PARK ZOO & MARINA TRAIN
625 Woodmere Avenue
Traverse City, MI 49684
(616) 922-4910
 Offers rides on a ¼ scale replica of a 4-4-2 steam locomotive.

"DISNEYLAND" RAILROAD
P.O. Box 3232

The Dollywood Express, an authentic coal-fired steam train, takes visitors on an exciting five-mile journey through the foothills of the Great Smoky Mountains at the Dollywood entertainment park in Pigeon Forge, Tennessee.

Anaheim, CA 92803
(714) 999-4565

Passengers can ride around the edge of the park aboard replicas of vintage cars pulled by authentic steam engines, some dating back to 1894. Some of the engines are Disney Imagineering replicas.

DOLLYWOOD & THE "DOLLYWOOD EXPRESS" TRAIN
1020 Dollywood Lane
Pigeon Forge, TN 37863-4101

Trains run every 30 minutes, pulled by authentic Baldwin 2-8-2 Steam Locomotives "Klondike Katie" (originally #192) and "Cinderella" (originally #70). These engines were built in 1943 and 1939 respectively for the U.S. Army and were used in Alaska during World War II to haul troops and lumber.

FIESTA TEXAS
P.O. Box 690290
San Antonio, TX 78269-0290
1-800-FIESTA-T

A narrow gauge steam train takes passengers around the park.

FUNLAND AMUSEMENT PARK
Rt. 1
Caribou, ME 04736

"GEORGIA'S STONE MOUNTAIN" RAILROAD
P.O. Box 778
Stone Mountain, GA 30086
(404) 498-5700

Authentic steam engines pull the trains that take visitors on a short trip around the base of the mountain.

JACKSONVILLE ZOOLOGICAL GARDENS
8605 Zoo Road
Jacksonville, FL 32218
(904) 757-4463 or Fax (904) 757-4315

Operates a 24" gauge train around the park.

"OMAHA ZOO" RAILROAD
3701 S. 10th Street
Omaha, NE 68107
(402) 733-8401

A genuine 1890 Krauss 0-6-2T steam locomotive and a replica of a Union Pacific steam engine pull passengers on a 20-minute train trip around the zoo grounds.

A ride on the Opryland Railroad is a perfect way to see all the action at the Opryland showpark.

OPRYLAND, U.S.A.
2802 Opryland Drive
Nashville, TN 37214
(615) 889-6600

Two vintage steam locomotives, built in 1910 and 1920, and one newer engine, built in 1977 especially for Opryland, take passengers on a tour through much of Opryland's 120 acres. A narration gives passengers a good overview of the park and its attractions.

SILVER DOLLAR CITY
Branson, MO 65616
(417) 336-7100

Passenger cars are pulled behind genuine steam engines through parts of the park.

SILVERWOOD THEME PARK
N. 26225 Hwy. 95

Athol, ID 83801
(208) 772-0515

Trains carry passengers on a 3 ½-mile, narrow gauge track. The authentic steam engines were built in 1915 by H.K. Porter Co. and in 1928 by Baldwin.

SIX FLAGS OVER MID-AMERICA
P.O. Box 60
Eureka, MO 63025
(314) 938-5300

This narrow gauge railroad uses replicas of authentic steam engines to pull the trains. These engines, however, are propane-fueled steam locomotives.

TWEETSIE RAILROAD
P.O. Box 388
Blowing Rock, NC 28605
(704) 264-9061

A restored narrow gauge railroad which once ran from nearby Boone, North Carolina to Johnson City, Tennessee, is now the center of this theme amusement park.

"WASHINGTON PARK & ZOO" RAILWAY
4001 S.W. Canyon Road
Portland, OR 97221
(503) 226-1561

Passengers can ride around the outskirts of the zoo on this replica of a 30" gauge steam train.

Appendix B: Harvey House Restaurants

Probably the most popular train excursions today are the "Dinner Trains" which offer passengers delicious dinners served by elegantly clad waiters and waitresses in the most elegant (and usually vintage) surroundings possible. People need to eat, but most of us prefer to eat in the nicest surroundings possible, and would like to be treated like royalty while doing so.

Such is the case today, and so it was when railroads first began running in the United States. Unfortunately, most trains did not offer good food service in the early days of railroading. In fact, trains often stopped at a station for only 10 minutes or so while customers tried to get fed. Oftentimes, the surroundings were dirty, and service was sloppy at best. At worst, passengers were cheated by unscrupulous cafe owners who conspired with train crew members to blow the boarding whistle immediately after customers had paid for their meals, but not yet eaten them. Equally bad was the chance that a customer who did have time to eat would end up with ptomaine poisoning.

Such was the case when, in 1878, Fred Harvey was hired by the Santa Fe Railroad line as manager of the Topeka, Kansas, depot restaurant. He improved services so much that railroad executives decided to put him in charge of all restaurants on their line. Very quickly, word spread about "The Harvey House Restaurants," and thus began the fame of the Santa Fe Railroad.

What was it that the Harvey Houses offered that made them so popular? First of all, Fred Harvey had strict standards. He instituted a "proper" dress code for customers, and insisted that the restaurants themselves meet "proper" standards. All restaurants had to be freshly painted in cheerful Indian colors. Tables were to be elegantly set with fine linens, fine china, polished silver, sparkling glasses, and fresh bouquets of flowers. Fresh

water was brought in in tank cars and served very cold for drinking, or very hot in the freshly brewed coffee. The food was top quality and served in generous portions.

Perhaps his most famous act was the hiring of what came to be known as "The Harvey Girls." He placed ads in newspapers back east advertising for "Young women of good character, attractive and intelligent, 18 to 30, to work in Harvey Eating Houses in the West." The salary was $17.50 per month plus room and board. The girls "boarded" in the dormitories above the restaurants. They were not "prisoners" however, as Harvey provided them with a chaperoned "courting parlor" for visiting with their gentlemen friends.

The dress code for the Harvey Girls was very strict. The uniform consisted of a black dress, black shoes and black stockings. A little black bow was tied under the dress's little Elsie collar, while a crisp white apron and white hair ribbon gave the girls a friendly, yet professional look. They were taught proper conduct and service, including the fact that all items carried into the dining room had to be carried in on a tray!

Customers marveled at the exemplary service. Harvey's excellent management techniques were such that several hundred passengers could be "wined and dined" at a stop in less than an hour. To do this, he had the train's conductor send a telegram from the last telegraph stop before the restaurant detailing the number of passengers aboard and their preferences for either lunch counter or dining room seating. Then, a mile or so from the restaurant, the engineer would blow the train's whistle to alert the chef and the girls, who had the first course on the table as the passengers walked into the restaurant. A waitress immediately took drink and entree orders, and just as quickly the drink girl came around and poured each customer's choice of beverage. Unobtrusively, the first waitress had moved the customer's cups to indicate their drink preferences. The code established by Harvey was: a cup right side up in the saucer meant coffee; upside in the saucer meant hot tea; upside down and off the saucer meant milk. (This code is generally followed in most fine restaurants today.)

The Harvey House Restaurants also occasionally featured hotel services, newsstands and other amenities desired by the passengers. Railroad executives from various lines began to realize that railroad travel was more than just getting from one spot to another. Customers wanted to enjoy the ride. Harvey Houses changed the outlook of train travel altogether.

A few of these Harvey Houses are still in existence today. Restoration was completed on the Hugo Depot Harvey House Restaurant in 1983 in Hugo, Oklahoma. It is operated by the Frisco Depot Museum there, and now serves breakfast and lunch.

(For more information, write to the Frisco Depot Museum, Hugo, Oklahoma.)

Appendix C: Associations and Publications of Interest to Rail Fans

ANDOVER JUNCTION PUBLICATIONS
P.O. Box 1160
Andover, NY 07821
 Publishes several books on railroading. (Send for order form.)

ASSOCIATION OF RAILWAY MUSEUMS, INC.
P.O. Box 3311
City of Industry, CA 91744-0311
(818) 814-1438
 "Professional society for organizations having the common goal of preserving railway heritage through the acquisition, rehabilitation, restoration, operation, protection, and display of historic railroad and street railway equipment."

"LOCOMOTIVE & RAILWAY PRESERVATION" MAGAZINE
c/o Interurban Press
P.O. Box 6128
Glendale, CA 91225
1-800-899-8722 or (818) 240-9130
 Bi-monthly publication of historic railway preservation.

MODEL RAILROAD ASSOCIATION
4121 Cromwell Road
Chattanooga, TN 37421
 Of special interest to model railroaders.

NATIONAL RAILWAY HISTORICAL SOCIETY
P.O. Box 58153-S
Philadelphia, PA 19102
(215) 557-6606 or Fax (215) 557-6740

Of interest to anyone who likes "riding, photographing or reading about trains." Possibly the world's largest and best known non-profit rail society. (Active since 1935.)

RAILWAY & LOCOMOTIVE HISTORICAL SOCIETY, INC.
115 I Street
Old Sacramento, CA 95814
 "The oldest organization in the U.S. dedicated to railroad history and preservation."

Steam Passenger Service Directory
Great Eastern Publishing
P.O. Box 246
Richmond, VT 05477
1-800-356-0246
 Lists Steam passenger excursions in the United States and Canada.

TRAIN
(TOURIST RAILWAY ASSOCIATION, INC.)
P.O. Box 460537
Aurora, CA 80046-0537
1-800-67-TRAIN or (303) 680-6217 or Fax (303) 680-6231
 Serves "the growing needs of tourist rail lines, railroad museums, excursion operators, private car owners and suppliers...." Membership includes bi-monthly magazine, "Trainline."

Glossary of Railroading Terms

against the current opposite direction from the normal "current of traffic"; against the grain or against the breeze

air brakes use compressed air to apply the brakes to all wheels in the train; designed so that a loss of air in the system will automatically stop the train

beat her on the back run a locomotive fast and hard

bend the rail throw a switch, bend the iron

binder brakes, usually a hand brake

bleed drain all the air out of the brakes on a car

boomer drifter, working for several railroads during his life

brains conductor

brakeman conductor's assistant, usually two per train; original duty was primarily to run along the tops of the cars to set hand brakes to slow or stop the train; assisted in coupling cars and aligning switches and generally helping the conductor to watch the train

branch feeder line to the mainline, usually consisting of light track and small trains

bumper anything used to stop a car from rolling off the end of a track

caboose (cab, hack, crummy, way car, car) car designed to house the conductor and brakemen on a freight train crew. Originally a "caboose" was a cook's galley on a ship. It comes from the Dutch "Kabin Huis." Although cabooses were a fixture on most freight trains in the past, few commercial trains use them today, as crew sizes have shrunk and observation functions are replaced by electronic devices.

car toad (car knocker, car tink) car inspector, derived from the squatting position taken to see under the cars

chain gang ("pool work" in the West) list of men working extra trains over a certain portion of a division

clock air gauge in locomotive or caboose

conductor (big ox, captain, brass hat) train crewman in charge of the train and its crew; responsible for the operation of the train in terms of schedules, orders, proper handling of cars and safety of passengers or freight

cornfield meet head-on wreck

cocked switch half-thrown switch

couplers devices which link cars and

engines together; automatic couplers link up when pushed together and uncouple by the action of a lever on the side of the car

current normal direction of traffic on a multi-track main line

cushions (varnish) cars which run with passenger cars, such as baggage, express and mail cars

cut block of cars; to uncouple, make a cut

cut-off uncouple; laid off due to lack of work

days demerits; accumulating 90 "days" is usually cause for dismissal.

deboard (passengers) get off the train

dehorn demote; take away one's authority

derail to run off the track; a device to protect the main line on a side track by derailing a car or cars

die on the law to be caught away from the terminal at the end of 12 working hours; having to leave the train for another crew to take over

drag slow, heavy freight train

drop (Western term) to pull cars with engine; uncouple the cars, speed up the engine and run over a switch, throw switch and allow cars to go into other track; the object is to get the cars on the opposite end of the engine

engineer (hogger, hoghead, eagle eye) train crewman who operates the locomotive, second in responsibility only to the conductor

extra train not in the timetable; to work different jobs left vacant by others; a stretch of track that is a by-pass

extra board list of men working extra

fireman (fire boy, tallow pot) engineer's assistant on the locomotive; on coal-burning engines, his main job was to move tons of coal from tender to firebox; also responsible for proper maintenance of the fire and boiler pressure and helping the engineer to observe signals

flagman rear brakeman; also rear man, rear shack

flimsy a train order, so called because it is printed on lightweight paper

flying switch (Jerk) same as "Drop" (Eastern term)

4-4-0 Whyte Wheel Classification for steam locomotives; leading-driving-trailing

freight cars designed to carry cargo, configured in many different ways — box cars, flat cars, tank cars, gondolas, hopper cars, refrigerator cars, etc.

gauge distance between inner surfaces of the rails (see more exact explanation in the text). Standard gauge is generally 4' 8½"; narrow gauge is generally 3'.

goat switch engine

hand bomber hand-fired steam locomotive; muzzle loader

hayburner coal/oil lamp

head man head breakman; headshack

high ball go ahead; take off; all clear to go

high iron main line

hog law law limited number of hours, in a 24-hour period, that a man may work; cut from 16 to 12 in 1974

hold 'em (plug 'em, big hole 'em) emergency command to stop

homeguard man who stays in the same yard or same division all his life

hostler engineer assigned to move engines within a roundhouse or engine-serving area

hot box overheated axle bearing

job any position of employment,

GLOSSARY

not title, usually assigned by number: Job #850; same man can handle several "jobs" each month

join the birds jump off the train

joint (make a joint) a coupling

line-up to throw a switch; to have all switches thrown for a particular route; list of trains due to arrive or depart; switch cars to suit a list

link (cross-over) a train crossing over between two parallel tracks

locomotive (engine) self-propelled vehicle which pulls the cars

marker light at end of train, showing red to the rear to protect the train; also designates the train is complete

mud hop clerk who walks between the tracks to check cars in a yard

on the ground off the track

on the spot to stand idle

passenger cars any car designed to carry passengers, such as parlor cars, dining cars, sleeping cars, etc.

pull the air to apply air brakes in an emergency

pull the pin to uncouple cars; to quit, resign, or get rid of

railcars railroad cars with a built-in power unit

roundhouse structure for storage and servicing locomotives, usually built in an arc over the fan of tracks which radiate out from a turntable

sand house where sand is stored for locomotives; gossip gathered while sitting in the warm sand house during inclement weather

section hand crewman who works on construction or maintenance of track

set out (set off) to leave cars

siding (the hole) side track connected to main track by switches at both ends, usually providing a place for trains to meet or pass one another

slack the space between cars left because of the crude system of coupling early train cars (using links and pins); as the locomotive accelerated or decelerated, the "slack" ran in or out, causing the train to lurch

snake switchman; term comes from the large "S" in the middle of their buttons

split switch switch damaged by a train running through it the wrong way

spot to place a car (cars) in place for loading or unloading

spur side track connected to main track at only one end, usually providing a place for loading or storing cars

stove steam locomotive

switch moveable part of the track which allows cars and engines to be diverted to another route

switchman crewman working in a yard, rather than on a train, who aligns switches and assists in coupling cars

tag written or typed list of cars showing where to pick up, spot, or set out cars

tie up go off duty at end of day

track the parallel steel rails laid on wooden ties, which rest on crushed stone ballast

train technically, a group of cars powered by a locomotive and authorized to operate on some part of a railroad; any other group is called a string or "cut" of cars

trucks apparatus into which the wheels are mounted and which support a car or engine; the steel wheels are then guided along the rail by a lip or flange cast on their inner edge

turntable device used to turn engines and head them onto different tracks, usually located in a roundhouse; consists of moveable bridge mounted in a pit and powered to

turn in a full circle (rarely used today)

wind air as used in air brakes

wye triangular arrangement of track used to reverse cars and engines by backing them into one leg of the triangle, then running them forward down the other leg

yard system of tracks, often quite large, where trains are made up or taken apart, cars loaded or sorted, engines serviced, etc. Some yards function specifically as coach yard, engine terminal, etc.

yard board yard limit sign

Index

Abilene & Smoky Valley Railroad 50
Adrian & Blissfield Rail Road 72
Adventureland 183
Age of Steam Railroad Museum 150
Alaska Central Railway 6
Alaska Railroad 6, 7
Alaskan Engineering Commission 6
Alaskan Northern Railway Company 6
All Saints Episcopal Church 57
Allaire State Park 93
Allegheny Mountains 119, 120, 125, 160
Allegheny National Forest 126
Allegheny Porgage Railroad National Historic Site 119
Allen County Historical Society 112
American Locomotive Co. 32, 33, 71, 78
American Shortline Railroad Association 178
Amtrak Historic Railtour 120
Anacortes Railway 164
Anchorage 7
Annual Rail Festival 20
Anselmo Mine Industrial Park 83
Any Friend of Nicholas Nickelby Is a Friend of Mine (movie) 42
Appalachian Trail 102
Arcade & Attica Steam Railroad 95
Arden Trolley Museum 122, 123
Arizona Central Railroad 12
Arizona Railway Museum 10
Arkansas & Missouri Railroad 12, 13
Arkansas Railroad Museum 13, 14
Arts Depot *see* Virginia Creeper Trail
Atchison Rail Museum 50, 53

Atchison, Topeka & Sante Fe 7, 52, 95
Atlantic Coast Line Railroad 105
Austin & Northwestern Railroad *see* Hill County Flyer 150
Auto Train Corporation 7
Avondale Railroad Center 120

B&O Railroad Museum 62, 63
The Babe (movie) 42
Baldwin Locomotive Works 51
Baltimore & Ohio 76
Baltimore & Philadelphia Railroad 34
Barnert, Nathan 92
Barney & Smith Manufacturing Co. 52
Barretts Tunnels 80
Bath Heritage Days 60
Battle of Shiloh 78
Bay Area Electric Railroad Assoc. 23
Belfast & Moorehead Lake Railroad 62
Bellefonte Historical Railroad 121
Berkshire Scenic Railway Museum 64
"Betty B" 73
Big Bend National Park 142, 153
"Big Boy" 29, 178, 180
Big Domes 7
Big Four Railroad 43
Big Shanty Museum 37
Big South Fork National River and Recreation Area 53
Big South Fork Scenic Railway 53, 143
Big Stone Gap Tourist Information Center 161
Biloxi Blues (movie) 13, 39

197

INDEX

"Birney" Car 23
Black Hills 85
Black Hills Central Railroad 141
Black Hills National Forest 141
Black River and Western Railroad 91
"Blue Goose" 18, 24
Blue Heron Outdoor Historical Museum 53
Blue Mountain & Reading Railroad 122
Blue Range Engineering 83
Bluegrass Scenic Railroad & Museum, Inc. 54
Boat Car 23
Bonanzaville, U.S.A. 105
Bonner County Historical Museum 40
Boone & Scenic Valley Railroad 47, 48
Boothbay Harbor 61
Boothbay Railway Village 58
Boston and Maine Railroad 13, 89
Branson Scenic Railway/Branson Depot 79
Brill Company 18
Broad Pass 6
Broadway Dinner Train 143
Bronson, Charles 102
Buckeye Central Scenic Railroad 110
Budd Cars 74, 99
Budd Company 7, 56, 74
Bull Run 60
Burlington Northern Railroad 13, 76, 108
Butte, Anaconda and Pacific Railroad 83

"The Caboose" 37
California State Railroad Museum 15
California Western Railroad 15, 16
Camp Five Logging Museum & Blacksmith Shop 171, 175
Canadian National Railways 85, 97
Canadian Pacific Railway 31, 59
Candy, John 98
Cape Cod Scenic Railroad 65
"El Capitan" 7
Carmack, George Washington 9
Carson and Colorado Railroad 18
Carthage, Knightstown & Shirley Railroad 43

Casco Bay 60
Casey Jones Railroad Museum State Park 78
Casey Jones Village 143, 144
Cass Scenic Railroad State Park 168
Catoctin Mountain Limited 63, 64
Catskill Mountain Railroad 96
Cedar Point & Lake Erie Railroad 183
Center for Transportation & Commerce 151
Central City, Colorado 32
Central of Georgia Railroad 37, 38
Central Oklahoma Rail Club 118
Central Pacific Railroad 15, 86
Central Railroad of New Jersey 54
Chamberlain, General Joshua 60
Champagne Trail Excursion Train 97
Charlie Tagish 9
Chattanooga Choo Choo 163
Chattanooga Choo Choo Holiday Inn 145
Chehalis-Central Railroad Association 165
Cherokee Indian Reservation 102
Chesapeake & Ohio Historical Society 160
Chicago & Northwestern Railroad 47
Chicago, Detroit & Canada Grand Trunk Junction Railway 71
Chicago, Milwaukee, St. Paul & Pacific Railroad 42, 43
Chicago Northwestern Railroad 68, 85
Chicago, Rock Island & Pacific Railroad 50
Chicagoan/Kansas Cityan 7
Choctaw County Historical Society 117
Church, Sally 127
Church, Ted 127
Cinders & Smoke 28
Circumnavigator's Club Car 24
Circus and Wisconsin Dells Tour 77
Circus World Museum 172
Clark, F. Norman 22
Clarkdale 12
Clark's Trading Post 91
Cleveland, President Grover 96
Cleveland Terminal & Valley Railway 110
Clinch Park Zoo & Marina Train 183
Coastal Heritage Society 37

INDEX

COE Rail 70
Coeur d'Alene Railway and Navigational Co. 40
Cog Railway Co., Inc. *see* Mount Washington Cog Railway
Cohocton Valley Farm Museum 97
Cole Land Transportation Museum 58
Collierville Heritage Railroad Display 145
Colorado Historical Society 30
Colorado Midland Railroad 26
Colorado Railroad Museum 24, 25, 26
Colton Belt Rail Historical Society 14
Columbus & Ohio River Railroad 111
Columbus Historical Museum (and Society) 94
Connecticut Valley Railroad Museum 33
CONRAIL 98, 133, 134, 137
Continental Divide 31, 83
"control cab" 54
Conway Scenic Railroad 88
Cookeville Depot Museum 146
Coopersville & Marne Railway Co. 66
Copper Canyon 152
Corinth, Mississippi Train Depot 78
Cowan Railroad Museum 146
Crane, L. Stanley 104
Cripple Creek & Victor Narrow-Gauge Railroad 26
Crossroads Village & Huckleberry Railroad 66
Cumberland & Pennsylvania Railroad 64
Cumbres & Toltec Scenic Railroad 26, 27, 28, 95
Cuyahoga Valley National Recreation Area 111
Cuyahoga Valley Scenic Railroad 110

Daisy Flyer 22
Datin, Richard, Jr. 18
Death Valley Railroad 18
Decapod 950 (Soo Line Depot) 173
Delaware Lackawana & Western Railroad 13
Delaware Osego Corp. (NYS&W) 7
Delaware Ulster Rail Ride 97

Delaware Western Railroad 34
"Delaware's Working History Museum" 34
Denali National Park 7
Dennison Railroad Depot Museum 111
Denver & Rio Grande Railroad 26, 28
Denver & Rio Grande Western Railroad 28
Denver, Boulder & Western Railroad 26
Depew, Chauncy 112
Depot Arts Association 159
Depot Restaurant (ME) 62
DeQuincy Railroad Days Festival & Museum 57
Devil's Gate Bridge 30
Dickey County Historical Park 105
Dickinson County Heritage Center 50
Dinner train, first 48
Disneyland Railroad 183
Division of Parks and Recreation 78
Dixiana, No. 1 21
Dollywood Express 184, 185
Drake Well Museum 129
Duluth-Lakefront Tour 74
Duncan, John F. 139
Durango & Silverton Narrow-Gauge Railroad 28, 29, 126

Eagle Canon 170
Early Historical Railroad Museum 161
East Broad Top Railroad 122, 123
East Troy Electric Railroad Museum 173
Edison, Thomas 71
Eisenhower, Dwight D. 50, 56
"El Capitan" 7
Electroliner 42
Elgin & Belvidere Electric Railway 41
Elkhorn City Railroad Museum 55
Elkhorn Mountains 119
Ellicott City B&O Railroad Station Museum 63
El Paso & Southwestern Railroad 94
Engine #604 (The Empire Car) 123
EnterTrainment Line/The Catoctin Mountain Limited 63
Erie & Kalamazoo Railroad 72
Erie Railroad 76

INDEX

Essex Steam Train & Riverboat Ride 32
Eureka & Palisade Railroad 86
Eureka Springs & North Arkansas Railway 14
Expansion Bridge, largest single span on rollers 8
Exposition Flyer 23

Fair, James 22
Fairbanks 6, 7, 8
Fairview Lift Bridge 110
"Farmer's Railroad" 135
Feather River Rail Society 16, 17
Federal Possession and Control Act 3
Federal Railroad Administration 83
Fenimore Railroad Museum 174
Fiesta Texas 185
Fillmore & Western Railway 17, 18
Flagler, Henry M. 36, 45
Florence & Cripple Creek Railroad 26
Florida & West Indies Railroad and Steamship Co. 35
Florida East Coast Railroad 36, 45
Florida Gulf Coast Railroad Museum, Inc. 35
Florida "Rails to Trails" 35
Floyd McEachern Historical Train Museum 101
Forney Transportation Museum 29, 30
Fort Berthold, Indian Reservation 106
Fort Bragg, CA 15
Fort Dodge Des Moines & Southern Line 47
Fort Fairfield Frontier Heritage Society & Museum 59
Fort Worth Stockyards 153
Franklin Institute 124
Fray Marcos Hotel 11
Fremont Dinner Train 85
Fremont Elkhorn Valley Railroad 85
French Lick Scenic Railway (The Tunnel Route) 44
Fried Green Tomatoes (movie) 39
Frisco 1630 42
Frontier Village 106
Funland Amusement Park 185
"The Funnel" 40

Galesburg Railroad Museum 41
Galveston Sightseeing Train 150
The Gambler (movie) 87
Garrison Dam 106
Gavin yard 109
"General" (locomotive) 37
Genesee Recreation Area 66
geographical center of North America 109
George, Florida and Alabama Railroad (Gopher, Frog and Alligator Railroad) 35
Georgetown Loop Railroad 30
Georgia's Stone Mountain Railroad 185
Gettysburg Railroad 124
Ghost Train of Old Ely 86
Glory (movie) 38
Gold Hill 88
Golden Spike & National Historic Site 6, 156
Gopher, Frog and Alligator Railroad *see* George, Florida and Alabama Railroad
Grand Adirondack Line of the Adirondack Scenic Railroad 97
Grand Canyon Railway & Depot 11, 12
Grand Trunk Western Railroad 43
Gray Line of Alaska 7
Great Johnstown Flood of 1889 120
Great Locomotive Chase 37
Great Plains Transportation Museum, Inc. 51
Great Smoky Mountains National Park & Railway 102, 171
Great Western Railway 17
Great Western Tours 7
Green Animals Topiary Gardens 140
Green Mountain Flyer 157
Greenville Area Railroad Museum 123
Gretna Historical Society 57, 58
Guilford Transportation Industries 61
"Gunsmoke" 141

Harding, Warren G. 6, 39
Harlin & Hollingsworth 13
Harney Peak 141
Harvey Houses 11, 117, 189
Hawaiian Railway Society 39

INDEX

The Hawk Mountain Line *see* WK&S
Heaven's Gate (movie) 40
Heisler Locomotive, world's oldest operating 21
Heisler Locomotive Works 127
Henry, John 160
Henry Cowell Redwoods State Park 21
Henry Ford Museum & Greenfield Village Railroad 68
Herber Valley Railroad 156
Heritage Village 106
Hesston Steam Museum 44
Hiawatha Floating Cafeteria 73
High Noon (movie) 20
Hill County Flyer (Austin & Northwestern Railroad) 150
Historic Civil Engineering Landmark 126
Historic Sandwich Village 65
Historical Museum of Anthony, Inc. 51
Hobo Feast 6
Hobo Railroad 89
Hocking Valley Scenic Railway 111
Hohenwald Train Depot 147
Holland America Line-Westours, Inc. 7
Honey Hill Junction 24
Hoosier National Forest 44
Horse Shoe Curve (Calif.) 24
Horse Thief Cave 127
Horseshoe Curve National Historic Landmark 64, 125
Huckleberry Railroad 66, 67
Hugo Heritage Railroad 117
Hungtington, Collis P. 160, 169
"Hustle Muscle" 74

I&O Scenic Railway 112
Icelandic State Park 108
Illinois Central Electric Railway Museum 41
Illinois Central Gulf Railroad 78
Illinois Central Railroad 85
Illinois Railway Museum 41, 42
"The India" 44
Indian Echo Caverns 127
Indiana Railway Museum 44
Indiana Transportation Museum 45

Interstate Car #101 161
interurbans 41
Iowa Star Clipper Dinner Train 48
"The Iowan" 47
Iron-Horse Train Rides 44
Ironwood Depot Museum/Old Depot Park 68, 69

Jacksonville Zoological Gardens 185
Jesse James (movie) 87

Kadoka Depot Museum 141
Kalamazoo, Lake Shore & Chicago Railway 69
Kansas City, Osceola & Southern Railroad 80
Kansas City Southern Railroad & Depot 57, 80
Kansas City's Argentine Yards 51
Kansas Museum of History 51
Kate Shelley Memorial Park & Railroad Museum 48
Kennecott Corp. 86
Kentucky Bourbon Festival 55
Kentucky Railroad Museum, Inc. 55
Kettle Moraine Steam Train (Pioneer Express) 174, 175
Kiamichi Railroad 177
Kinzua Bridge 126
Klondike Gold Rush National Historical Park 9
Knox, Kane, Kinzua Railroad 126
Kristofferson, Kris 40
Kyle Railways, Inc. 26

L&N Depot & Railroad Museum 147
Lake Short Railway Museum 127
Lake Superior & Mississippi Railroad 74
Lake Superior Museum of Transportation 74, 75
Lake Taneycomo 79
Lake Whatcom Railway 165
Lakefront Line 74
Lamoille Valley Railroad 158
Lancaster Outdoor Railroad Park 162
Laona and Northern Railway 175
LaPorte County Historical Steam Society, Inc. 44

INDEX

Laramie Valley 180
Last Bonanza Railroad 86
Last Chance Tour Train 82
Laws Railroad Museum Historical Site 18, 19
Leadville, Colorado & Southern Railroad Co. 30
A League of Their Own (movie) 42
Leavenworth, Lawrence & Ft. Gibson Railroad 52
Leelanau Scenic Railroad 70
Lewis Creek Canyon 24
Licking River 110
Lincoln Park Railway Exhibit 112
Little River Railroad 45
locomotive, first on rails 136
Locomotive #451 106
Locomotive #470 59
Long, Maj. Stephen 85
Long Island Railroad 100
Long Lake 178
Lookout Mountain Incline Railway 148
Louisiana State Railroad Museum 57, 58
Louisville & Nashville Railroad 55
Louisville, New Albany & Chicago Railroad 54
Louisville Southern Railroad 54
Lowry, Mack 114
Lumberjack Special 171, 175, 176

McHenry Railroad Loop 106
McKinley Explorer 7
Mad River & NKP Railroad Museum 113
Madera-Sugar Pine Lumber Co. 24
Madison Railroad Station 45, 46
Mahoning Valley Railroad Heritage Association 75
Maine Central Railroad 59, 60, 61
Maine Coast Railroad 60
Maine Narrow Gauge Railroad Co. & Museum 60
Mandan Depot 106
Manitou & Pike's Peak Railway Cog Wheel Route 26, 31
Marienville Area Railroad and Historical Museum 126

Marlinton, West Virginia C&O Railroad Station 169
Martin, Steve 98
"The Meath" 41
Memphis & Charleston Railway 78
Mercury and Chase Railroad 5, 6
Michigan Southern Railroad 45
Michigan Star Clipper Dinner Train 70
Michigan Transit Museum 71
Middletown & Hummelstown Railroad 127
Midland Historic Railroad 52
Midnight Sun Express 8
MidSouth Railroad Corp. 79
Mikado Class Engines 28, 32, 110
Mike's Trainland & Lancaster Toy Museum 162
Minnesota Zephyr Ltd. and Transportation Museum 76
Mirror Lake 165
Missouri & North Arkansas Railroad 79
Mobile & Ohio Railroad 78
Moffat Tunnel 31
Monan 54
Montana Historical Society 82
Montana Tech Mineral Museum 83
Moosehead Lake Railroad 60
Mormon Trail 85
Mount Elbert 30
Mount Hood Railroad & Depot 118
Mount Rainier Scenic Railroad 165, 166, 167
Mount Rushmore 141
Mount Shasta 24
Mount Washington Cog Railway (Cog Railway Co., Inc.) 89
Mountain Division 22
Mrs. Soffel (movie) 177
Muni "Magic Carpet" 23
Museum of Alaska Transportation & Industry 7, 8
Museum of Railroad Technology 15
My Old Kentucky Dinner Train 55, 56

Napa Valley Wine Train 19
National Historic Mechanical Engineering Landmark 148

INDEX

National Museum of American History 181
National Museum of Transport 79
National Park Service 53, 134
National Railroad Foundation & Museum 140
National Railroad Historical Society 97, 99, 139, 163
National Railroad Museum 77
National Railroad Museum (NC) 102, 103
National Railroad Museum (WI) 178
National Register of Historic Places 8, 11, 18, 26, 37, 52, 56, 57, 69, 85, 89, 94, 106, 109, 111, 118, 122, 126, 141, 145, 146, 147, 148
The Natural (movie) 98
Natural Tunnel State Park 161
NC & ST. L. Railway 5
Nebraska Zephyr 42
Nenana Railroad Depot 8
Nenashna 8
Nevada Northern Railway Museum 86
Nevada Smith (movie) 18
Nevada State Railroad Museum 87
Neversweat & Washoe Railroad, Rocker Depot & Yard 83
New Brunswick Railway 59
New Hope & Ivyland Railroad 128
New Jersey Museum of Transportation, Inc. 93
New River Train (Powhatan Arrow Steam Train, etc.) 169
New York & Lake Erie Railroad 98
New York Central Railroad 72, 76, 96, 97
New York Museum of Transportation 98, 100
New York Susquehanna & Western Railway Corp. 99
Newport Star Clipper Dinner Train 139
Nicolet National Forest 178
Nicolet Scenic Rail (Nicolet Badger Northern Railroad, Inc.) 178
Niles Canyon Railway 19
Norfolk Southern 162
Norman Rockwell Museum of Art 78
North Carolina Transportation Museum 104, 132

North Dakota Railroad Museum 107
North East Kansas Model Railroad Club 50
North Georgia Live Steamers 38
North Shore Scenic Railroad 74, 75
North Star Rail, Inc. 77
Northern Pacific Railroad, Depots & Railroad Museums 44, 76, 108
No. 4004 "Big Boy" Static Display 180

Oahu Railway & Land Co. 39
Oakland electric railway cars 23
Ocean Gate Museum 92
Ohio & Erie Canal 111
Ohio Central Railroad Sugarcreek Service 113
Oil Creek & Titusville Railroad 128, 129
Oklahoma City Train Show 118
Old Colony & Newport Scenic Railway 140
The Old Depot 38
Old Depot Museum 53
Old Dominion Railway Museum 163
Old Road Dinner Train & Excursion Train 72
Old Wakarusa Railroad 46
Olympic Mountains 167
Omaha Zoo Railroad 185
Ontario-Midland Rail Excursions 99
Opryland, USA 186
Orange Blossom Special 103
Orange Empire Railway Museum 20
Orphan Train 14
Orrville Railroad Heritage Society (and Depot) 114
Osceola & St. Crois Valley Railway 77, 179
Osterwald, Doris B. 28
Overland Trail 180
Owego and Harford Railway 101
Owl's Head Transportation Museum 61
Ozarks 13, 14, 79

Pacific locomotive #110, smallest gauge built 45
Paramount Pictures 18

INDEX

Paterson Museum 92
Pennsylvania Railroad 34, 56, 76, 132, 137
Penrose, Spencer 31
Pere Marquette Railroad 66, 69
Perils of Pauline (movie) 128
Perkinsville, AZ 12
Petroleum Centre 129
"Petticoat Junction" 20
Pike's Peak 31
Pine Creek Railroad 93
Pioneer Express *see* Kettle Moraine Steam Train
Pioneer Heritage Center 108
Pioneer Tunnel Coal Mine Railroad 129
Pioneer Village & Museum 108
Pittsfield Historical Society/Depot House Museum, Inc. 61
Planes, Trains and Automobiles (movie) 98
Porsburg, Darlene 107
Porsburg, Kenneth 107
Portola Railroad Museum 16
"potato capital of the world" 59
Potomac Eagle 170
Powhatan Arrow Steam Train 169
Prairie Pioneer Dinner Train 52
Prairie Village 142
Princess Alaska Land Tours 8, 9
Promontory, Utah 156
Puget Sound Railway Historical Association 166
Pullman Company 13, 39, 45, 48, 85, 86, 112, 115, 127, 129, 132, 143, 152, 177

Quaker Oats Co. 114, 116
Quaker Square Hilton 115
Quaker Square Railway Co. 114, 115
Quaker Square's Depot Restaurant 114
Queen Anne's Railroad 33, 34

Rail Tours, Inc. 130
Railcamp & Train 28
Railroad & Pioneer Museum 152
Railroad Fair 82
Railroad grade, steepest narrow-gauge in North America 21
Railroad History Festival 6

Railroad Museum of Long Island 100
Railroad Museum of New England 33
Railroad Museum of Pennsylvania 130
Railroad Museum of Texas 151, 154
Railroad Park Resort 20
Railroader's Memorial Museum 125, 131, 132
Railswest Railroad Museum 48, 49
Railtown 1897 State Historic Park 20
Railway Exposition Co., Inc. Museum 56
Ramsey & Dakota County Historical Tours 77
Raton Pass 51
Reader Railroad 14, 15
Reading Co. Railroad 133
Red Clay Valley, Inc. 34
Redford, Robert 98, 102
Requa, Mark 86
Richmond Railroad Museum 163
Ringling Brothers Circus 172
Ringling Brothers Museum 78
Rio Grande Ski Train 31
Rio Grande Southern 1931 Galloping Goose No. 2 26
River and Rail to Galena Tour 77
River Street Train Museum (Savannah) 38
Riverside & Great Northern Railway 179
Roanoke Railway Festival 164
Roaring Camp & Big Trees Narrow-Gauge Railroad 21, 22
Robbins Crossing 111
Rochester & Genesee Valley Railroad Museum 100
Rock Island Railroad 85
Rocky Mountains 18, 26
Rogersville Depot Museum 148
Rolling Fork River Valley and Iron Horse Festival 55
Romance on the Rails 63
Roosevelt, President Franklin Delanore 24
Roosevelt Zoo 109
Royal Zephyr Dinner Train 33, 34
The Runaway Train (movie) 8

Sacramento Northern Railway Co. 23
St. Croix River Valley tour 77

INDEX

Saint Croix Valley 179
St. Louis County Heritage & Arts Center 75
St. Louis County Parks & Recreations Dept. 80
St. Louis Iron Mountain & Southern Railway Co. 81
San Diego & Arizona Railway & Railroad Museum 22
San Francisco Chief 7
San Francisco Limited 22
San Juan Mountains and National Forest 26, 28
San Lorenzo River Canyon 22
Sandley, Elmer 179
Sandley, Norman 179
Sandpoint, Idaho, Bonner County Historical Museum 40
Sandy River & Rangely Lake Railroad 61
Santa Clara River Valley Railroad Historical Society 17, 18
Santa Cruz, Big Trees & Pacific Railway Co. 22, 23
Santa Fe Depot Museum 50, 53
Santa Fe Railroad Depot 51, 52
Santa Fe Railway 50, 189
Santa Fe Southern 95
Santa Fe Trail & Historical Society 52, 80
Santa Train 6
Savannah's Historic Railroad Shops & Roundhouse Complex 37, 38
Scandalous John (movie) 141
Scenic Limited 23
Scenic Local 22
Scenic Ozark Railway Journeys 12
"Scenic Railway of the World" 9
Schwab, Charles M. 132
Seaboard Air Line Railway 35
Seashore Trolley Museum 62
Seminole Gulf Railway 36
Senora, No. 7 21
Seward, Alaska 6
Shade Gap Electric Railway 122, 123
Shady Slab Creek 24
Shelburne Museum 159
Shohola Caboose 134
Sierra Nevada Mountains 24
Sierra Railway Co. of California 20
"Silver Capital of the World" 40

Silver Creek & Stephenson Railroad 42
Silver Dollar City 186
"Silver Meteor" 103
Silvercreek Museum & Cooper Corliss Steam Engine 43
Silverwood Theme Park 186
Simmons, Zamon 31
Sinagua Indians 12
Six Flags over Mid-America 187
Skunk Train 15, 16
Slim Princess 18
Smithsonian Institution 13, 181
Smoky Hill Railway 80
Snowden Tunnel 110
Soo Line Depot & Transportation Museum 109
South Carolina Railroad Museum 140
South Pacific Coast Narrow-Gauge Railway 22
South Park Railroad 26
Southeastern Railway Museum 38, 39
Southern Michigan Railroad Society 72
Southern Orient Express DRC Rail Tours 152
Southern Pacific Railroad and Depots 18, 57, 58, 76, 94
Southern Railway 5, 38
"the South's largest transportation museum" 104
"Spirit of Washington" Dinner Train 167
Springs Valley Electric Railway 44
Spud Valley Railroad Club 105
Steam locomotive: oldest operating in North America 87; world's largest 178
Steam Locomotive 39 Restoration Project of Riverhead 100
Steam railroad, America's longest and highest narrow-gauge 26
Steamtown National Historic Site 134
Stephenson County Antique Engine Club 42
Stewartstown Railroad 135
Stillwater & St. Paul Railroad 76
Stillwater Depot & Excursions 76
Stourbridge Rail Excursion 135
Strasburg Railroad 136

INDEX

Sumter Valley Railroad Restoration 119
Suntan Special 22
Super Domes 8
Super Skunks 15, 16
"The Switzerland of Ohio" 113

Taft, President William Howard 23
Tahquamenon River & Falls 73
Tanana Valley Railroad 8
Tarantula Train 153
Tennessee Valley Railroad 148
Texas Limited 151, 154
Texas-Pacific Railroad 57
Texas State Railroad 155
Texas Transportation Museum 155
This Property Is Condemned (movie) 102
Tiny Town Railway 32
Tioga Scenic Railroad 101
Toledo, Lake Erie & Western Railway & Museum 116
"Tom Thumb" 180
Toonerville Trolley & Riverboat Trip 73
Towner County Historical Museum 109
Trainland U.S.A. 49
Transcontinental Railroad 156, 160
Transit Museum 62
Transportation and Industrial Museum 64
Tri County Historical Museum 49
Tripod Gift Shop 8
Trolley Train Rides & Railroad Depot Museum 71
The Tunnel Route *see* French Lick Scenic Railway
Tuolumne 21
Turner, George 32
Tweetsie Railroad 187

Ulster & Delaware Railroad 96
Ultra Domes 8
Under the Biltmore Clock (movie) 42
Union Canal 127

Union City Community Railroad Museum & Historic Depot 46
Union Pacific Railroad 16, 180
Union Station (Nashville) 149
Union Station Museum (Utah) 157
U.S. Army Transportation Museum 163
U.S. Potash Co. 18
U.S. Railroad Administration 3

Valley Railroad Co./Connecticut Valley Line 32, 33
Verde River Canyon Excursion Train 12
VIA Rail 85
Victor, Fisher & Western Railroad 14
Virginia & Truckee Railroad 87, 88
Virginia Creeper Trail (Arts Depot) 159
Virginia Museum of Transportation 164

Walsh County Historical Society 106
"Warwick Car" 96
Washington Park & Zoo Railway 187
Watonga Chief Dinner & Excursion Train 118
Watson, Jonathan 129
West Minnesota Steam Threshers Reunion 108
West Shore Rail Excursions 137
West Virginia Northern Railroad 171
Western Gateway Heritage State Park 65
Western Maryland Railway 63, 64
Western Pacific Railroad 16
Western Railway Museum 23, 24
Whetstone Valley Express 142
White Deer & Reading Station and Museum 138
White Mountain Central Railroad 91
White Pass & Yukon Route 9
White Pass Depot & Visitor Center 9
White Pine Copper Co. 86
White Pine Historical Railroad Foundation, Inc. 86
Whitewater Valley Railroad 47
Williams Depot & Grand Canyon Railway Museum 11

INDEX

Williston Depot 110
Willits, CA 15
Wilmington & Western Railroad 34, 35
Wilmington Railroad Museum 104
"Winter Holiday Train" 28
WK&S, The Hawk Mountain Line 136
Wood, Natalie 102
World Museum of Mining 83
World War I 3
World War II 4, 24

World's Fair 23, 46
Wyoming/Colorado Railroad's Snowy Range Excursion 180, 181
Wyoming Territorial Park 180

Yakima Valley Rail and Steam Museum 167
Yellowstone Park 85
Yosemite Mountain-Sugar Pine Railroad 24
Young's High Bridge 54
Yreka Western Railroad 24